CREATING CUSTOMER CONNECTIONS

HOW TO MAKE CUSTOMER SERVICE A PROFIT CENTER FOR YOUR COMPANY

JACK BURKE

MERRITT PUBLISHING, A DIVISION OF THE MERRITT COMPANY
SANTA MONICA, CALIFORNIA

Creating Customer Connections
How to Make Customer Service a Profit Center for Your Company
First edition, 1997
Copyright © 1997 by Jack Burke

Merritt Publishing
1661 Ninth Street
P.O. Box 955
Santa Monica, California 90406

For a list of other publications or for more information from Merritt Publishing, please call
(800) 638-7597. Outside the United States and in Alaska and Hawaii, please call (310) 450-7234.

Library of Congress Catalog Number: 97-076108

Burke, Jack
Creating Customer Connections
How to Make Customer Service a Profit Center for Your Company
Includes index.
Pages: 317

ISBN: 1-56343-149-1
Printed in the United States of America.

Acknowledgments

The information in this book has been derived from lessons that I've learned over the past quarter century in business and from lessons that others have been willing to share. I owe a special debt of gratitude to the numerous experts, business people and consultants who have willingly exchanged their thoughts, ideas and experiences during the course of my research.

There also have been hundreds of people who have been involved in shaping my concepts of customer service, marketing and communications. Although I could never manage to mention them all, there are a few who deserve special recognition: Bill Feldhorn, George Nordhaus, John Nuzzo, Hank Sabbatis and—in particular—Rudy Wood, who was a special mentor for a number of years.

Special mention also is due to my wife, Jo Ann, who has stood beside me through success and failure. A business partner and my dearest friend, she had the patience to proof my initial drafts of this book—and the courage to point out opportunities for improvement.

I also would like to express my appreciation to a great editor, James Walsh, who helped make this book everything it could be; a super literary agent, Trent Price, who believed in the book and myself from the very beginning; and Merritt Publishing for making it a reality.

Those are the thank you's, the acknowledgments. The dedication of this book is to a man who harbored an unfulfilled, lifelong desire to write. His literary legacy was limited to a memorial on the short life of a brother, wartime correspondence with his family and periodic family newsletters in his retirement years. A consummate student of human nature, his greatest gift was to endow me with his curiosity and encourage me to pursue my dreams.

Dad, this book is in memory of you.

Jack Burke
Thousand Oaks, California
September 1996

Creating Customer Connections is the eighth title in Merritt Publishing's "Taking Control" series, which seeks to help business owners deal with a host of extraordinary risks facing the modern business enterprise. To keep these books—and the series as a whole—well focused, the editors at Merritt Publishing welcome feedback from readers.

CREATING CUSTOMER CONNECTIONS
TABLE OF CONTENTS

INTRODUCTION: DEFINING TERMS

Martin Bury, after a 40-year career as an automobile dealer, wrote about his experiences in the book *The Automobile Dealer*. Analyzing lost customers, Bury arrived at some statistics that could open the eyes of a marketer or customer service person from any industry.

Over a four-year time period, here are the reasons businesses lose their customers:

- One percent will die.

- Three percent will move out of the area.

- Five percent will be lured away by other salespeople.

- Nine percent will be lured away by lower prices.

- Fourteen percent will leave because of unresolved complaints.

- Sixty-eight percent will leave because of poor service, discourteous treatment or indifference.

The moral to these statistics: Providing courteous, helpful service can cut client losses by more than two-thirds.

But good customer service is not good enough. Customer satisfaction is not—by itself—enough. Success in business requires an integrated marketing and communication approach that will result in the cultivation of a nexus between a company and its customers.

Nexus is one of my favorite words (right up there with *oxymoron*). Before you run off to the dictionary, I'll tell you that my old friend Webster defines

Nexus—a means of connection

nexus as "a means of connection; link." A noun, it stems from the Latin verb *nectere*, meaning to bind or connect.

For many companies, the phrase *client nexus* is an oxymoron—the combination of two opposites, like bright darkness or, as the old joke goes, military intelligence.

Recently, I read one of the best examples of this oxymoron that I've ever heard of or seen. A major manufacturer of plain-paper fax machines has an 800 number to call for customer service. However, if you call that number, you're referred to a 900 number—a toll call that includes a $10 service fee, no matter how long the call lasts.

The company initiated the service fee to discourage its customers from making what it considered unnecessary service calls. The sheer stupidity of that policy negates the need to say much about it at all.

But I can't resist at least one quick point. There's no such thing as an unnecessary client service contact. The fact that a client feels he or she needs help enough to try to get in touch with you means the contact is necessary. Most of the time, this contact will mean that something in your system hasn't worked for this person: Your product isn't functioning as expected, your instructions weren't clear, your salesperson pushed too hard—or didn't explain enough.

Worse yet—better, actually, but the fax machine maker wouldn't understand this—the client may be contacting you to buy more goods or services. If you don't provide the contact, you'll lose the sale.

Clients and Customers

As long as we're defining terms, you will notice that I frequently use the term *client*, rather than *customer*. Either term works in most situations for most companies—I just prefer to use *client* whenever I can.

Client signifies an ongoing business relationship, while a customer might only be a one-time buyer. *Client* also suggests a level of professionalism on all sides of the business relationship.

Integrating Customer Service and Client Satisfaction

Businesses spend millions of dollars every year—in fact, every day—on customer satisfaction, only to find out that the people buying their goods aren't encouraged—or are actually discouraged—from becoming a true client. The nexus never developed!

This book is about the connections you need to make with customers in order to turn them into clients. The goal of all marketing must be the cultivation of client nexus. Through that, your product or service becomes integrated into the client's personal or business lifestyle.

Several years ago, I found a small company that manufactures embossed foil stickers that say things like: "Thank you! We appreciate your business." The stickers are brightly colored—with rainbows, happy faces and the like. I use these stickers as envelope seals, enhancements to letters and attachments to invoices. It might seem like a silly thing, a minor thing.

But I've found that my invoices get a higher priority when I'm able to make the payable clerks smile.

The one silly, little item has become part of my business style. What's more, a nexus has developed between the manufacturer of the stickers and his client—me.

On a larger scale, Ford capitalized on the pre-existing nexus that had been formed with people who had purchased Mustangs over the past 30 years. This nexus became the basis for the company's introductory marketing campaign for the launch of the redesigned 1994 model Mustang.

Throughout the United States, Mustang Club events featured sneak peeks at the yet-to-be-released '94. Ad campaigns were developed focusing on past Mustang memories. When the car finally came out, it was a big success. Mustang enthusiasts embraced it—and bought it.

Ford recognized the nexus with its clients and capitalized on it.

Over the years, other companies have managed to combine product and lifestyle. Think of that little

Master the
past in order
to plan for
the future

alligator on millions of pieces of clothing. It disappeared for a while, and its maker faltered. Now, the alligator is making a comeback—as a super-premium brand. Catalog marketers like L.L. Bean and Land's End have turned a niche outdoor market into a lifestyle statement.

In each of these instances of nexus, the business has made a connection with the client that goes beyond the basic *I sell/you buy* exchange. The business has integrated its interests with the client's interest. It's nothing new—but it definitely isn't commonplace.

Auto manufacturers have been doing this since the beginning. And not just with Mustangs.

I had a great aunt who owned more than 30 Buicks during her lifetime. She never even considered a different vehicle—purchasing her final 440 Buick Wildcat with bucket seats when she was in her eighties. To her, the words *Buick* and *car* were almost the same.

One newspaper advice columnist (my local paper carries several—and I can never remember which story came from whom) recently published a series of articles on cars that became members of a family. Perfect example!

The Nexus Is a Long-Term Process

The client nexus begins long before a sale, with your corporate image. It extends long after the sale, through client advocacy and service. Sales isn't the isolated function it used to be; it's part of the nexus.

Good salespeople used to boast they could sell anything—that's not so anymore. In almost every industry, consumers are better informed and have more choices than ever. They make their decisions carefully. You have to prepare to earn—and continue to earn—their business.

Neither solitary sales nor random post-sale efforts to maintain customer satisfaction will enable a business to prosper in today's economic realities. Business, like history, is an ongoing evolutionary process that requires a mastery of the past in order to plan for—and deal with—the future.

Another important element of a client nexus is the

emotional bond established between a customer and a company after the customer has used a product or service—and found that it provides an added value. This emotional bond leads the customer to buy repeatedly—or, better yet, exclusively—from that supplier, to recommend that supplier to friends and family and to withstand the blandishments of other providers.

Establishing the nexus requires that the goods or services provided by the organization regularly meet or exceed that customer's expectations. The nexus develops when customers believe that the goods and services an organization provides regularly produce more benefit to them than the costs incurred—net customer value—especially as compared to the competition.

To understand the client nexus fully, we must expand on the usual approach to customer satisfaction. Simply pursuing customer satisfaction results in an incomplete understanding of the nexus. Customer satisfaction is about attitudes; the nexus is about behavior.

By rethinking customer service, a company can increase its sales and profitability. Better customer service can only increase the perceived value of the product or service that you sell. It also gives you an extremely competitive advantage. Satisfied customers are more likely to tell others about your company.

Basic Principles Before Trendy Concepts

Today's business management gurus and mavens, particularly with the mind-boggling capabilities of automation, often lead us into uncharted conceptual territories for new answers to old problems. Most get lost somewhere in that uncharted place.

Even when they work, many of these new concepts are merely repackaging of the old ideas. There's no doubt that, during the 1980s and 1990s, packaging has become a major component of sales and marketing.

Now I'm not against anything new—but a strong grasp, understanding and implementation of the basic elements of running a business are essential to any potential success with new concepts.

Provide net customer value

Understanding the basics

A good example: While trendy transactions like mergers, restructurings and downsizings are often necessary, a growing consensus in the business community argues that most—as many as two-thirds, by some counts—fail.

And even for those mergers or restructurings that actually work, there is often negative impact—in terms of customer dissatisfaction, employee defections and declining productivity.

What's the problem? Inherent as change is in today's world, major change often is a source of disruption to customers and employees caught up in a merger or restructuring.

Customers often see change as a reason to bolt—or they can be driven away by customer service problems that occur because of cultural clashes after a merger, or because of the burgeoning workloads of those who remain after a downsizing.

Understanding the basics of doing business is like calculating the square root of a number, which—at least under the old math of my youth—meant finding the essence of a number, its origin, its basic beginning. If your company is to evolve into a client nexus, the basics are critical. Creating a nexus with your clients, like marketing in general, encompasses every facet of your business. To accomplish either with any success, you must become one with your client.

There's no magic formula for building a high-quality customer service operation. The effort mostly requires common sense and a grasp of some business basics. In short, customer service should help your business:

1) become involved in and maintain a high level of visibility within your marketplace;

2) keep your product or service in front of the consumer with continuity; and

3) once a sale is made, nurture the relationship to turn a customer into a client.

Point No. 1 and point No. 2 are self-explanatory. They deal with public relations, promotion and advertising. Point No. 3, however, goes back to surpassing expectations. People down in New Orleans

refer to this as *lagniappe*, a little bit extra. Bakers call it a baker's dozen. Other industries talk in terms of value-added benefits. Whatever the name, the meaning is the same: surpassing expectations.

If you serve lagniappe to every single client, you're on your way to cultivating a client nexus.

Automation and the ability to have a sophisticated database registry of your clients has made it easier to maintain continual contact and grow sales. After all, the easiest (and most profitable) sale is made to an existing client.

This gets us back to the most practical reason to worry about establishing a nexus with your clients or customers. It's your lifeline to the future. It means repeat sales and referral sales. Most importantly, it creates a network of clients extolling the virtues of your product or service.

We've all seen this type of spontaneous communication. You're standing in a checkout line and the person behind volunteers some unsolicited bit of information about a product that she just loves. My wife, who is the proud owner of a new Ford Mustang (hence the example I used earlier), seems to preach its virtues to anyone who'll listen.

Only through a client nexus can a company experience this type of loyalty. It cannot be bought. It must be earned—and earned continuously.

Airlines have tried to buy loyalty with frequent flyer programs. However, the very fact that so many have instituted the programs has defeated their purpose. The programs haven't created a nexus; they aren't even lagniappe anymore. They are now an expectation—like car rebates. Customers have assumed frequent flyer miles to be their right. The best an airline can do is increase the size of its benefits and loosen the terms of its program.

This is competing on price, which can be a legitimate marketing approach, but is the opposite of what this book is about. This book is about competing on service—which is, in my opinion, a much better way to go.

Repeat sales and referral sales

Communication is the key to marketing

Competing on Service Requires Communication

As for the melding of marketing and customer service, it is an integral match supported by a common element: communication. You can have communication without marketing (maybe), but marketing without communication is impossible. Customer service is all about communication.

Even most personal communication is marketing of a sort. The most objective reporter is marketing his or her capabilities to an audience. Cocktail chatter often markets one individual's image to another. Even fights between friends or lovers are usually about advocating positions or beliefs.

When you think about it, nearly all communication has a marketing agenda, conscious or unconscious.

I'm batting around these notions of communication and marketing because I feel customer service—client nexus—is the most basic form of marketing. But there's a big challenge in that word *marketing*. Defining it is like describing a color to a blind person. It's an almost overwhelming word.

Simply put, marketing is everything your company does—internally and externally—in order to do business. Sales, advertising and customer service are specific niches within the business world. Marketing relates to everything.

Communication, on the other hand, is the exchange of knowledge, opinion or facts from one to another. Note the word *exchange*. Communication is not a one-way process; it's a two-way intercourse. Many businesses, to their eventual detriment, only communicate outwardly. Business communication must be a shared exchange with your prospects, clients and employees.

And business communication, like any communication, is a fluid process. As you read this book, consider everything we discuss an ongoing process—not a one-time project. Depending on the exact circumstances of your organization, periodically review your customer service system—never going beyond a year without a full review.

Diminishing Brand Loyalty

Brand loyalty has always been a part of the psychological makeup of the typical American consumer. To an extent, we've all bought into it at one time or another.

A challenge you face as a seller of goods or services today is that consumer brand loyalty is diminishing.

One reason for this lapse in brand loyalty is the growing similarity of products within each product class. Quality has become a priority for most businesses, so products—across the board—have become more reliable and more consistent.

One unforeseen consequence of this so-called *quality revolution* is the reduction of many products and services to commodity status. To counteract this leveling effect, companies bend over backward to differentiate themselves by providing customer value.

With the lines between products becoming blurred, vendors are forced to distinguish themselves in any way they can. The good news is that vendors in search of an answer to product differentiation are starting to focus their efforts on improving their customer support services. The bad news: Many of these companies have no idea what they're doing.

Ultimately, I've found there's a three-stage approach to creating customer satisfaction:

- deliver beyond expectation;
- continually improve processes; and
- regenerate yourself.

We'll consider each of these—in significant detail—throughout this book.

The Information Funnel

A group of terms you'll see popping up throughout the book is *funnel*, *funnel-like*, etc. This is a useful concept used by philosophers, Jesuit priests and other critical thinkers. When you are gathering information, envision the process as a funnel—moving from the general to the specific.

However you contact customers—in person, over

A similarity in products has led to improved customer service

Cross check prospect lists with customer lists

the phone or by survey—build each new question or statement on the preceding one. Gradually, as the information swirls through the funnel, it will reach the poignant and specific information that you need.

A memorable *reverse* example is the typical telemarketing call that I receive quite frequently from Los Angeles area newspapers:

Ring ...

Me: Hello.

Them: Mr. Burke (usually mispronounced, but their script says to say the name), I'm calling from the *LA Sentinel.* (Note: Apparently their name isn't important.) Would you like to receive our newspaper on a specially priced, six-week, money-back-guarantee trial?

Me: Sure, is it less expensive than your normal subscription?

Them: It sure is (they're excited now, they have a buyer)! In fact, you can save $10 from our normal rates. Can we start tomorrow?

Me: You bet. Just give me enough time to cancel my regularly priced subscription first, so I can save all that money.

Them: Uh ... (long pause) ... Do you already get the *Sentinel?*

Me: Yes, but I'll cancel it in a few minutes.

Them: Well, you don't qualify. This is only if you're not getting our paper. Thank you.

Hang up.

This all-too-common scenario results when a company starts at the bottom of the funnel, rather than the top. It could be avoided if the company bothered to cross-check its prospect lists against its own customer lists first.

This type of approach—"Boy, have I got a deal for you!"—can actually cost you more business than it generates.

If you were using a funnel approach on a list that still hadn't been cross-checked, that same call might go something like this:

Ring ...

Me: Hello.

Them: Hi, this is John Smith from the *Los Angeles Sentinel.* Is Mr. Burke available? And I hope I'm pronouncing that correctly.

Me: Yes. I am and you are.

Them: Mr. Burke, I'd like to spend just a couple of minutes asking you a few questions. Is this a convenient time for you?

Me: Sure.

Them: Are you currently receiving our newspaper?

Me: No. I'm not.

(If the answer is yes. The telemarketer should have an optional funnel available: "That's great, do you receive it seven days a week or just weekdays or weekends? Are you happy with our service?")

Them: How long has it been since you've read one of our issues?

Me: Maybe about a month.

Them: Does the paper you're reading now meet all of your needs? Does it tell you what's going on in the world and in your neighborhood?

Me: It does pretty well on the world level. But I would like to see more news from within my community.

Them: You'll be happy to know that we've made some changes. Every day, there's a special page featuring news from your area. On Sundays, we devote a whole section to your neighborhood. Would you like an opportunity to check out our coverage?

Me: Well, I might. Any special deals?

Them: Funny you mentioned that. As a matter of fact, we have ...

By funneling from the general to the specific, you discover needs and wants and problems and pains that are key to developing a real relationship with your customer. So, whatever the occasion, think in

Funnel from general to specific

A self-perpetuating process

terms of a funnel when you are gathering information, trying to make a sale—or servicing an existing customer.

And this, of course, gets back to the idea of the client nexus. It's an ongoing process that combines marketing intelligence, sales prospecting and customer service.

Some Final Thoughts

Sales & Marketing Management magazine has defined customer service as all of those activities that enhance or facilitate the sale and use of one's product or service. That's a good, broad definition.

Since I majored in communications in college, my life has taken a circuitous route from news broadcasting to the upper echelons of major corporate management to entrepreneurial endeavors. Throughout it all, the ability to communicate effectively has been the critical factor in successful management, sales and marketing.

In this book, the result—in part—of numerous articles I've written on both marketing and communications, I hope to rekindle your excitement. I want you to look at your business with a fresh perspective on the possibilities created by communicating and serving customers well.

I hope that in arriving at this fresh perspective, your vision and understanding of customer service- oriented marketing and communications will grow to encompass its many valuable—and profitable— nooks and crannies. Setting up your company to serve customers well and create client nexus will become a self-perpetuating process. It's one of the parts of business that you can set in motion—and sit back and watch.

As the Scots historian and philosopher Thomas Carlyle wrote:

> What an enormous magnifier is tradition! How a thing grows in the human memory and in the human imagination, when love, worship, and all that lies in the human heart, is there to encourage it.

CHAPTER ONE: KNOW YOUR CORPORATE CHARACTER AND IDENTIFY YOUR CUSTOMERS

> The four cornerstones of character on which the structure of this nation was built are: Initiative, Imagination, Individuality and Independence.
>
> —*Edward Rickenbacker*

In the forests of South America exists an isolated, pre-Columbian civilization known as the Kogi. The Kogi are thinkers with a very complex and rich intellectual structure. They believe that the universe was first an intellectual life force, known as Aluna. Creation, in turn, was brought about through the thinking—the imagination—of Aluna.

The Kogi also define Aluna as memory and possibility. So, in the Kogi cosmology, first came an idea, then the process of thinking through all the possibilities of that idea and—finally—a plan.

Most small businesses can take a lesson from this progression. Unfortunately, when it comes to building a business, action comes before the thought.

Perhaps we're all to blame. After all, modern business is about moving quickly. Action is king. Speed is essential. Be pro-active. Beat the competition. Even a bad campaign is better than no campaign. Meet the deadline. The faster, the better.

The gurus of marketing expound on the how and the what. Here's how to market in the yellow pages;

Wave the RED flag

here's what to do to build your image. Yet, seldom will you hear anyone delve into the definition of image. Or explore who—in a business sense—you really are.

Defining Your Corporate Character

As individuals, our formative years are lessons in developing character. We learn from our parents, our teachers, our churches. Many of us are involved in organized activities—like team sports or scouting—where we are first taught the attributes of character, and then proceed to build that character through action.

First we were taught the ideal, then we were given a plan.

In terms of creating a client nexus, teaching the ideal means defining who your company is—and what this means to the people and companies with whom you do business.

Direct mail specialist Herschel Gordon Lewis talks about staying in character with your image. He often cites the example that the image of Albert Einstein does not project the concept, "Have I got a great deal for you!"

A good example of uncharacteristic marketing: The stretch during the 1960s and 1970s when banks used to give away free gadgets for opening an account. To my mind, that created an image of carnival-like hucksterism that didn't support the staid, conservative, stable image that banks try to manage. It was sort of like a used car dealer giving away tickets to the opera. Neither promotion is in character.

It would be very easy at this point to say, "So what is your image?" But how many businesses can really answer that question? How many corporate meetings have ever been held to determine the essence of the corporate image?

Too few, at least in my opinion.

Defining your image need not be a dilemma. Merely wave the RED flag: Research, Evaluate, Determine. I've found the RED flag analogy extremely helpful in nearly every business—and, for that matter, per-

sonal—situation. Like a red traffic signal, it reminds me to stop and research the situation, evaluate the data and determine a course of action.[1]

Since I've been known to jump occasionally into projects based on gut-level emotions, the RED flag has proven to be a tremendously valuable safeguard. Sometimes it can prevent ill-conceived actions. Other times it can help mitigate the loss and sometimes even turn it around.

Whatever the situation, we all need a stop sign at times.

Research

Here's a little test that anyone can take. Ask each of your employees, including yourself, to anonymously define what they perceive the image of your company to be. I would suggest a format of one or two sentences, followed by five or six descriptive words. For instance, an employee of an insurance agency might reply:

> Our company has an image of stable reliability. Words that apply to our company are friendly, experienced, stable, secure, reliable.

Compile all the replies, except yours. List any of the descriptive words that are found more than once, and compile a list from the most frequently used word to the least. Group the descriptive sentences that seem to be similar, again from the most common to the least.

Now compare that list with yours. If you have better than a 50-percent match, congratulations—you have the essentials of a defined image. On the other hand, if the comparison looks like two different entities, you need to go to work on defining your corporate character.

For the truly brave at heart, repeat this project a second time with 10 of your best clients. I mention bravery, because it takes courage to face the truth. In many cases, they will have a totally different image of your company than you do.

Somewhere in the midst of all these perspectives lies your true character. Your challenge—and the

[1] Throughout this book, I'll make reference to various worksheets, charts, etc. There's a section devoted to these in the back. See page 247 for a complete list.

Develop a mission statement

point of this exercise—is to reconcile it with your marketing, sales and customer service programs.

Evaluate

Armed with the data from your survey and the various components of your current marketing program, you need to move on to some serious evaluation.

A mission statement is the perfect starting point. If you have one, how does it relate to the results of your survey? (If you don't have one, go back to the basics of developing a mission statement before proceeding further.)

A mission statement (what your company plans to accomplish in the course of doing business) and the definition of your corporate image are not identical—but they must work together. The main question is whether your corporate image is suited to the accomplishment of the mission.

If your mission statement centers on providing quality service, but your image is high-volume/low-cost, there may be a dichotomy that needs to be addressed. If your mission is long-term stability, but your marketing emphasis and direction are changing constantly ... I think you're getting the idea. These things must be compatible.

It is now time to begin evaluating each of the components of your client nexus in much the same way. Don't start with your latest advertising campaign. Save that for last. Begin at the beginning, as if you were a new company.

My company, Sound Marketing, serves as a good example. I chose the name because it represents audio productions used in marketing, customer service, training and education. As a noun, sound reflects the audio orientation of what I do; as an adjective, it means healthy, reliable and good. Sound Marketing reflects both the image and mission I've chosen for the company.

Next, I wanted to have a logo that reflected my commitment to the company's focus. To achieve this, I hired an award-winning designer of music albums—rather than a traditional graphic artist—to create a logo.

The designer came up with an S logo that intimated perpetual motion and creativity, coupled with a conventional block-style print that dropped the crossbar in the letter A. The result: a logo that synchronized with the image I wanted—fluid, creative, a little offbeat, but not too wacky.

Over the years, I've only made one minor change to the logo. I switched the background color from a bit-too-conservative gray to a more vibrant blue.

I tell this story to reinforce the need to start your evaluation process with the basic manifestations of your business: your company name, your logo, your mission statement, your office decor, the way your staff interacts with people. Do these things reflect your real corporate character?

From there, move on to evaluate more specific tools: your brochures, newsletters and flyers, your direct mail pieces, yellow page ads, print and media advertising, customer service scripts. You may be surprised at how frequently there is a divergence between image and execution.

Determine

When you've completed the research and the evaluation, it's time to make a determination. Easier said than done! If you are lucky, you may only need some fine tuning adjustments to either the way you see yourself (your image) or the way your clients see you (your marketing and customer service).

More often than not, though, you'll find some gaping differences between the two. So which do you change?

Normally, I recommend sticking to your image and changing your marketing and customer service. However, there is an exception—as always. Refer back to the results of the survey of your 10 best clients. Does their image of you coincide with your image of you? If it doesn't, you may want to think about changes to your definition of yourself.

Following the old 80/20 rule (80 percent of your business usually comes from 20 percent of your clients), their image of you is the image with which they choose to do business. In other words, it works. And since these are your preferred clients, you may

Determination leads to action

want to adapt your visualization of your image to meet theirs.

Determination leads to action—so determine what will be done, who is responsible for doing it and when it will be accomplished.

You're now on track to market your organization effectively because that marketing will represent, polish and build the image you are trying to maintain.

A Case Study: Chandler-Frates & Reitz

One company that has undoubtedly defined and truly understands its corporate identity is an insurance agency in Tulsa, Oklahoma—Chandler-Frates & Reitz. This fast-growing agency has developed an unusual internal and external esprit de corps based on a famous quote attributed to Walt Disney: "Whatever you do, do it so well that the people who see you do it come back to see you do it again—and bring someone with them."

To really get a handle on the agency, which was founded in 1935, you need to understand the background of the owner, Jack Allen.

In the early 1970s, Allen had been recognized as Marketing Representative of the Year for The Hartford Insurance Company. Shortly afterward, he left The Hartford to join an agency in Tulsa—where he failed to have the success to which he'd become accustomed in the home office.

In fact, as Allen tells it, "I was a miserable failure. I just didn't get it. I had all that technical knowledge, and I knew how the insurance part of it worked, but I didn't know how the relationship part of it worked."

After another stint at another agency, Allen received a call from Leonard Reitz—a local insurance industry big-shot who convinced him that leaving the business would be a mistake. Reitz had been impressed by Allen's work in competitive situations, and was willing to teach what he knew about building client relationships (the down-home way of saying *nexus*). The gist of these lessons: Take the time to understand your client, ask lots of questions, and respond to the answers.

Allen joined the agency in 1976 and never looked back. To make a long story short, Allen explains, "I was able to build a good book of business because somebody believed in me and reached down and offered me their arm—instead of me trying to fight my way up. I can't tell you how grateful I am to Leonard Reitz for the way he treated me and other people. He showed me something about humanity—lessons that I have never forgotten."

Allen learned these relationship lessons well. He bought the agency in 1984 from Leonard Reitz. Today, he jokingly refers to the "love letters" he receives from his employees. And a happy staff seems to correlate with good business—the agency's commission revenue has increased from a little more than a half-million dollars in the mid-1980s to a projected $7 million in 1996.

Allen says, "Our success is based on the basic philosophy that you find exceptional people and give those successful people the opportunity to use their strengths."

Now that you know the agency and the man behind it, you'll better appreciate the fact that this agency has a painting which was commissioned to depict the corporate culture.

P.S. (Pat) Gordon, a well-known local artist, usually includes personal objects in his commissioned paintings. By including objects that have meaning to the person he's painting, Gordon believes he can better tell that person's story.

When Jack Allen approached him about doing a corporate painting for Chandler-Frates & Reitz, Gordon answered that he didn't design corporate logos. A good salesman, Allen knew better than to give up on the prospect. He explained that he didn't want a logo. He wanted a painting that represented his agency's corporate culture—just as though it were a person.

Eventually, Gordon warmed to this idea and agreed to take the commission.

In the weeks that followed, Gordon visited the agency's offices and spent time with people within the organization to get a feel for what was important to them about the company. In fact, sticking

A happy staff correlates with good business

Creating a corporate portrait

to the grass roots, he never talked directly with Allen about the project.

"I didn't hear from him for about four to six weeks, until he called and said he was ready to talk about the painting," Allen recalls. "I showed up at his office and he had already drawn the entire painting ... and was halfway through painting it. We—as an organization—can take credit for the things that came together in the painting; I can't take credit for the painting itself. It was [Gordon's] view of us."

Titled *Whatever You Do*, the watercolor painting was Pat Gordon's first corporate portrait. After spending time at CFR's headquarters, he gathered concepts—and several actual objects—that Allen's people held dear. The painting uses these ideas and things as symbols:

- several fresh oranges represent fresh ideas and a healthy work environment;

- a vase represents the Chandler-Frates & Reitz family;

- a bouquet of flowers in the vase represents the individual personalities at CFR;

- an eight ball from a billiards set represents the caliber of employees—it's an old saying in the agency that CFR hires only 8's (on a scale of 1 to 10) or better;

- a diploma represents CFR's commitment to education—virtually all employees are involved in a program to further their insurance and business knowledge, and the agency also supports the local Adopt-A-School program, the Tulsa Education Fund and the Oklahoma State University School of Business;

- a stack of old-fashioned 45-rpm records represents the jukebox in the CFR office, which is played in recognition of good news—often an agent writing new business or a staff member attaining an educational goal;

- a bell represents Allen's habit of ringing a bell whenever important things happen, such as landing a big piece of new business;

- a slice of cherry pie represents the agency's compensation philosophy that, when everything works, everyone gets a piece of the pie; and

- a child's snowball toy from Disneyland represents the agency's Disney-inspired business philosophy.

Although this may sound a bit corny in the retelling, the portrait had a legitimate and positive effect on Allen's staff. As Allen tells it, once they saw the portrait, his people understood on a fundamental level that they were part of a system. It was like putting the company's character down on paper—in fact, that's literally what it was.

Hanging there in the CFR offices, the portrait serves as a kind of conscience—reminding everyone that everything they do is part of the company as a whole. This kind of support makes dealing with a telephone call from an upset client easier to handle.

Building Continuity in Your Image

If you look closely at most businesses, their marketing efforts are a hodgepodge of good, creative ideas without much cohesion.

We see ad campaigns, community alliances, sporting sponsorships, telephone advertising, stationery, company logos, customer support functions and all the various components of marketing. But how often is there any sense of continuity among these things? How often do all of these components work together to reflect the corporate image?

Second only to defining your corporate character, continuity of message is one of the most critical elements in establishing a client nexus.

Before I talk about what continuity is, I'll use the old speech-maker's trick of talking about what it isn't. It isn't only some high-end, big-dollar advertising issue. And it isn't some kind of rigid script or set of requirements you give service reps. Most of all, it isn't an abstract platitude you talk about in management meetings—and then forget when you walk out of the room.

Review your operational mannerisms—from the value-added benefits you supply your clients to the

Concentrate on the core values

operator answering the phone to your sales team's industry relationships.

If your image is that of a friend to your clients, how frequently do you make contact with them? A friend would occasionally call or stop by to visit—even if there's no specific business to discuss. I call these contacts *howdy visits*.

On the other end of the spectrum: If your image is that of a well-organized and efficient machine, do your salespeople have to sit on their briefcases to close them? Are they not up-to-date on state-of-the-industry trends? There's nothing more foolish than the efficiency expert who's not efficient.

Do you portray yourself as a caring, service-oriented firm, but have a telephone operator with a tendency toward moody brusqueness?

Do you market full-service, but fail to maintain hours that are convenient for the lifestyles of your clients?

Do you position your firm as an advisor to the leaders of business, but fail to belong to the Rotary or other organization where such leaders congregate?

Continuity is the realization that customers—even your best customers—will spend only a limited amount of their day thinking about your product or service ... and even less time thinking about your company. You have to take full advantage of the time that they do spend thinking about you.

The best way to do this is to reduce the things you do and the way you do them to a few basic concepts—more than one, fewer than six.

Different people call these different things: core values, essentials, key factors. Whatever the jargon, the point remains the same: How would you describe your company and its business in just a few lines?

(I've heard this process explained, separately, as "How would Sylvester Stallone describe your business?" and "How would Hemingway describe your business?" Depending on your literary inclination, either one can work.)

A few lines is all your clients will associate with you. Even sophisticated consumers equate no more

than two or three concepts with any single brand. While you don't have absolute control over these associations, you have considerable influence—so choose your lines carefully.

And you should start with your initial direct contact. If you use a lot of advertising, that will probably be the initial contact—and the advertising industry is very good at maximizing initial impact. But most small to mid-size companies don't do a lot of advertising. Their first direct contact with clients is often a phone call, mail piece or sales visit.

Identifying Your Customers

Most companies' marketing executives speak positively and profoundly when discussing customer service.

On the surface, this looks and sounds good. The truth is, however, that many companies develop a mentality that stresses the products they make over the people they serve. This often leads to the development of products and services that do not meet the specific requirements of the customer or the end user.

Companies that listen to customers and understand their problems are those that will find solutions. In the process, they provide customer value and build a client nexus.

There are five major steps in the customer understanding process:

1) customer identification;

2) planning the data collection;

3) collecting the data;

4) measurement; and

5) implementation.

The approach outlined in these steps is quite different from the typical market research approach that has served as the basis for most of our current understanding of customers and their needs.

The starting point is to clearly identify the customer, including everyone who affects the buying decision. This is not as straightforward as it might seem at first—especially when other businesses are the customers.

Raise customer expectations

Today, decisions made by only one individual are quite rare. Many current management strategies—empowerment, employee involvement and self-directed work teams—will expand this pool of decision makers and their influence. You'll often find procurement agents, contracting officers, multiple layers of management and even boards of directors involved in the process.

Question: How do you offer high-quality customer service to all these people?

Answer: Concentrate on guiding the process along the client nexus.

Selecting a product is seldom a solitary task. Great sales help at the local department store often makes the difference between time wasted in aimless wandering down the aisles and an informed selection between products with similar features. The hosts on QVC or Home Shopping Network and the 800 operator at a catalog company play the same intermediary role for product demonstration or idea suggestion. It's not so different in the business-to-business marketplace. The smart company is there to answer questions—or ask them—at any time.

A caveat: Going through a complete customer understanding process is both time-consuming and expensive. It also can disrupt the often fragile relationship between the customer and the supplier. Your salespeople may resist this kind of thing as marketing or customer service intruding on their territory. You may hear the old argument that by asking about how well you're serving the customer, you're implicitly raising the customer's expectations about your service.

My answer to these arguments: Yes. Raising expectations is what keeps the client nexus alive.

When asked about service issues, customers often will express some of their needs and expect a positive response to this expression. This rising level of expectation is what keeps you in the game as a provider of value-added goods or services.

The Customer Survey: Who Do You Trust?

Another key question: Which customers should you include in a service analysis? Clearly, current customers will provide important information. But so will former customers—those that have been lost over the years for one reason or another. These former customers can provide additional data that gives several different perspectives.

Also important are competitors' customers—those who are implicitly stating that they do not think you can meet their needs. Talking candidly to these customers is important, especially since their opinion is too often discounted. "They only care about price" or "They really aren't interested in quality" are frequent comments. But if you listen, you often will hear more substantive reasons.

Nothing is so critical to success as increasing the net value that you provide to the customer. Thus, measuring these increases in net customer value provides a critical success indicator of a company's vitality.

The payoff for customer understanding is in its application to strategy development and implementation. Once the customer understanding process is complete, at least for the time being, then your strategic planning team needs to be convened to receive, digest and apply the findings of this analysis.

Without such an implementation step, there is no reason to begin the customer understanding process. One reason that such implementation often fails is that the customer understanding process reveals truths that the company cannot—or will not—face.

Each customer interaction is unique. The goal of customer visits is to understand this unique interaction in two ways. The first goal is to determine how the customer decides his or her best value; the second, to begin the process of discovering how to provide unanticipated value in the future.

Increase the net value

Know why the customer uses your product

A review should focus on understanding the customer's core values. This may mean studying the customer's annual reports and other relevant documents, the customer's mission statement and the like. You need to understand the customer's corporate goals, culture and driving forces. This understanding will give you a starting point for understanding the customer's perspective.

A data collection checklist should help focus discussion on issues of customer value. Because each customer relationship is unique, each checklist will be unique—but there will be many consistent issues and topics for your business.

Identify and Understand Your Customers

In collecting data by survey or by phone, you must first determine the information you intend to gather. The following questions can help you ascertain whether you are covering all the bases.

- Do you know why the customer **uses your product**? What need does it fill? What problem does it solve?

- Do you know why the customer **chooses your product**? Unique benefits? Competitive advantages?

- Do you know **what brought** this customer to you? Advertising? Referral? Public relations articles? Prior use?

- Does your product **create new or additional problems**? Need for tech support? Warranty service? Operational problems?

- Could your product be **easier to use** or purchase? Product improvements? Streamlined ordering process?

- Do your customer's needs **surpass your service capability**? Customer service improvements? More personnel? New technology?

- Does your customer **view the relationship** in a positive manner? Satisfaction levels? Developing nexus? Referrals? Endorsements?

- Do you know what your **customer values** the most? Product? Service? Delivery? Relationships?

- Do you know if your customer is **planning any changes**? New products? Outsourcing? New facility? Personnel?

- Do you know your customer's **decision-making process**? Levels of authority? Ownership involvement? Purchase managers?

- Have you **asked your customer** such questions as: How do you compare to the competition? What could you do to increase their purchase commitments? What would cause them to leave?

- Have you **involved your customer** in your business practices? Advisory board? Surveys? Brainstorming sessions? Meetings?

These questions cover a number of the major points of information that you need to know about your customers in order to develop and nurture a nexus relationship with them.

If the questions have been carefully and thoughtfully prepared beforehand, the actual collection process should be straightforward. Collecting data in this open-ended fashion is quite different from a typical customer survey.

The topics on the checklist in the appendices will guide the discussion with the customer. The customer's responses require follow-up questions and interpretation to develop a full understanding of customer value. A checklist is only a guide to keep the discussion focused on the customer's fundamental needs.

Listening and Responding Effectively

Black & Decker Corp. provides an example of a company that identified different types of customers, listened to each and responded effectively. In the early 1980s, the company's data showed an erosion of its industrial power tool business to foreign competitors, such as Makita and Ryobi.

A follow-up process to sales and promotion

What customers were telling Black & Decker was that it needed to distinguish its industrial line from the entry-point line sold by the mass retailers.

By listening carefully, Black & Decker realized that it could not meet this customer need without abandoning the cherished Black & Decker label. The company did recognize, however, that these industrial customers were still connected to its then-dormant DeWalt brand name. Therefore, it introduced an enhanced DeWalt line of industrial-quality power tools to this market.

The DeWalt move was phenomenally successful, with sales of this line growing from zero to more than $250 million in less than three years.

This illustrates both the power of listening to your customer (and using that information) and how important connection can be as a driver of buying decisions.

Some Final Thoughts

Customer service is, of course, a follow-up process to sales and promotion—but it is every bit as critical in establishing your message. In fact, it may be even more important, because it can constitute a longer total contact over a longer period of time.

Customer service is also a great leveler. The differences between large companies and small ones can disappear.

Whether you're a giant hamburger chain or a one-person professional services vendor, the manner in which you communicate with and respond to your clients should be shaped by their needs as much as your resources.

Of course, there are limits here. You can't spend so much time and money serving clients that your business loses money. And the old clichés about smaller companies providing better customer service than larger ones have proved false in the competitive 1990s.

Still, customer service—unlike marketing and sales directed at finding new business—is always a function of the number of customers you have. That means you have considerable latitude in how you allocate your customer service assets. Throughout the rest of this book, we'll consider the various options.

CHAPTER TWO:
CHANNELING
CREATIVITY AND
THRIVING ON THE
TECHNOLOGICAL EDGE

> The merit of originality is not novelty; it is sincerity.
>
> —*Thomas Carlyle*

After understanding your corporate character and establishing a consistent image with (and of) your customers, you can start to get creative with your client nexus. The creative spark is the cornerstone of business. It's the essence of effective communication—which applies to everything from marketing to customer service.

On the other hand, at least in the business context, *creative* is an overused word. It's a catch-all that business people use to describe decisions that defy logic, plans that defy market data and ideas that defy easy response. It's often used as a euphemism for *bad*.

In many companies, creativity is equated with volatility or unreliability—so it's channeled into a few locations, usually near the top of the organizational chart. CEOs are applauded for their creativity. Marketing heads are expected to be creative. Product developers are tolerated for their creativity. For everyone else, it's better to be reliable and diligent.

Probably the worst result of all this is the fact that truly original and imaginative work will sometimes go overlooked or under-appreciated.

You can't budget creativity into a business plan

Creativity needs to be channeled, but not just to the corner offices. Your challenge, as a business owner or manager, is to make sure creativity flows from the right places. Sometimes this is the shop floor—sometimes it's the customer service department.

Creativity Is Opportunistic

The flip side of creativity coming from unexpected places is an equally important proposition: Creativity doesn't always come from where a bureaucrat says it's supposed to. It's spontaneous, unpredictable (as opposed to unreliable). You can encourage creativity, but you can't budget it into a business plan.

One of my pet peeves in business is the way some sales and marketing people talk about hiring out the creative—as if you can just pay a free-lancer to whip up relevant, original ideas.

A lot of marketing and advertising today would be better placed under the category of *mundane*: "typical of, or concerned with, the ordinary."

This stale marketing creativity seems to have evolved into new twists on old techniques. The creative brains toil at new and different ways to re-state an old message. A catchier print ad, a better letter, a more memorable commercial—the script may change, but it's the same play.

Even with a horizon of new electronic media, such as advertising via computer network and CD-ROM, originality and imagination seem to be sequestered in a closet.

Every so often, there is a breath of fresh air. Every so often, someone somewhere does something unique that provides them with a marketing edge in their community. Every so often, we get to see a unique and memorable piece of marketing. Every so often became a reality in Clarksville, Tennessee, during the winter of 1993.

Enhancing the holiday spirit was the goal of the Clarksville Area Chamber of Commerce's Christmas Decoration Contest, which included commercial establishments as well as residential. James W. Dunn of Clarksville's Dunn Insurance Inc. had

vetoed entering a float in the Christmas Parade due to the immensity of the task. However, he agreed that entering the commercial category of the decoration contest would be less demanding.

Little did he anticipate that this decision would result in getting Dunn Insurance's name on the front page of the local paper twice, plus a full front-page write-up. Not to mention extra publicity from a contest within the contest—and a new concept for the annual Christmas card.

In fact, from the grocery store to private parties, Dunn couldn't go anywhere without people talking about his agency's entry.

James gives most of the credit to his son, Jimmy Jr., who suggested a giant snowman in lieu of a more traditional outdoor Christmas tree. Centered on the agency's front sign, chicken wire, poly insulation and other odd materials were bonded with glue onto the post. Soon the arms of a giant, 15-foot snowman reached upward to hold both sides of the agency sign—seemingly waving to passersby. To add a dramatic touch, more than 2,000 white Christmas lights were attached to the interior chicken wire, providing a warm, glowing effect. And, of course, the sign was altered to read "Seasons Greetings" below the Dunn Insurance Agency name. Jimmy's design incorporated two faces on the snowman, one facing each direction of traffic.

Dunn chuckles as he relates the fact that the agency even got calls during the construction phase. It seems that they ran short of the poly insulation which covered the chicken wire, leaving the lower section of the snowman "exposed" until more insulation could be collected. The phones soon began to ring about the Clarksville flasher.

Jimmy's creativity was acknowledged by the community votes, and the agency won first place in the commercial category, resulting in the aforementioned publicity.

Now that's a nice story, definitely creative and the publicity was good.

However, it's not the end of the story—although it could have been. Rather than stopping with a first-place win, Dunn built on the existing publicity with

A snowman creates client nexus

Marketing was tied to a core belief in the community

his own Name the Snowman contest. The lure of a $50 savings bond generated more than 400 entries. The winning name, A Bondable Snowman, was suggested by a 12-year-old girl who lived more than 40 miles away. And, of course, both the contest and the winner generated additional publicity for the agency.

But we're still not at the end of this story. Dunn then gathered his entire staff for a group photo around the snowman and turned that photo into the agency's Christmas card.

This is what I call full-circle creativity in building a client nexus. Not only was the concept original and memorable, but the Dunn Agency continued to build on it.

Beyond this agency's successful use of a publicity opportunity was the enhancement of its client nexus—or, in this case, community nexus.

Insurance agencies, and most small businesses, live and die with their community.

Citizens of Clarksville deeply identified with their annual Christmas Decoration Contest. It was an extension of their personal beliefs and definition of themselves as a community. Dunn's marketing tied the agency to a core belief within that community.

As a result, the Dunn Agency was not just another business doing business within the community. It established a nexus that positioned it as a member of the community providing services to members of the community.

Just so this doesn't sound too cosmic, let me add that the phones at Dunn rang more than ever during the weeks of the contest. And most of these calls turned into business.

The question you should ask yourself is, "Would I have stopped at the winning of the contest?" Unfortunately, I think, many companies would have. Publicity is tough to measure in concrete terms, unless you work it to a point of obvious direct customer contact. If you can direct publicity this way—as James Dunn did—you can build on the client nexus.

Turning Abstract Goals into Measurable Results

Marketing is full of terms that sound great but are tough to nail down specifically. This is partly because the term *marketing* covers so much ground. It includes everything from generating leads for a sales force to gaining favorable attention for your company or product.

How often do you brainstorm for new ideas, take advantage of creative opportunities and maximize opportunities when they exist—only to be left wondering if the results were worth the effort? If you're wondering whether a marketing effort worked, then the answer is no.

My advice: Make sure any creative marketing idea includes some mechanism for direct contact with customers. This will give you a way to measure results.

Although this book is filled with marketing ideas, here is an example of what I consider creative customer connections:

> A Ford dealership in New Jersey builds its image around selected community charities. It starts with an annual reverse raffle co-produced with five local charities involving community youth, shelters for abused women and the local hospital.
>
> Although the raffle continues, the dealership goes on to produce two major concerts each year to generate additional revenue for charity. Co-sponsors include a local bank and a supermarket chain. During the promotion and ticket sale phase, every bank customer sees signs with the dealership's name. Every grocery shopper has a bag imprinted with the dealership name, too! That's one dealership in one community that has definitely overcome the negative perception of the car salesman.

As director of car sales for Hertz Corp., I developed a program for the leasing of used rentals to augment sales efforts. Not only was this long before

Include direct contact with customers

leasing became a fashionable alternative to traditional purchases—but we were talking used cars, not new ones. Traditional newspaper and radio advertising was not acceptable—there was just too much to explain, and the pitch needed a one-to-one approach.

We developed a quick training program to first teach our salespeople throughout the country about leasing. But, rather than relying on the initiative of individual sales personnel to talk about the lease plan, we needed to find a way to get the potential customer to ask them for more information. We solved that problem with a simple button, which we ordered in the thousands and distributed to all of our employees. All the bright yellow button said was *Ask Me*. Ask they did—and the total cost was minimal.

Creativity Can Focus on Form as Well as Content

Business cards and agency brochures are another example of a nice but mundane idea. A number of businesses have gotten creative by producing short audio or video programs that tell their story. These marketing productions get the prospect's attention and allow you to really introduce yourself, your company, product or service.

Granted, video can get expensive. But audio tapes are fairly reasonable and can be packaged in any number of ways—depending on your budget and your image.

There's an additional benefit to this type of creativity: business cards, brochures and letters often end up in a prospective client's wastebasket. Audio and video cassettes have a higher perceived value—they're seldom tossed.

I've received calls as late as a year after an audio mailing. The caller generally says, "It's been sitting on my desk for a year and I just got around to listening to it."

Sponsoring a local golf tournament or other sports event is another great way to market your company. It's done wonders for many major corporations on a national level. Why not duplicate their efforts on a local level? Bring in other businesses

as co-sponsors. Maybe a local car dealer can display a vehicle and buy hole-in-one insurance to cover a car giveaway. Local realtors and banks are also excellent co-sponsors who can help with the prizes. Not only is the publicity great, but you get a chance to network.

Closer to the office, what about your telephone system? Does a client on hold hear nothing, or are you using a local radio station for music-on-hold?

If you answered radio station, beware of two possible problems: Your clients and prospects may be listening to a competitor's commercial, and music industry rights groups can levy stiff fines if you have not purchased a licensing agreement to re-broadcast the music over your phone system.

Don't laugh. Many small, medium and large businesses have already been caught and fined. This dilemma's creative answer is a message-on-hold service. For relatively little expense, you can have a professional message tape produced that talks to your clients about your services while they're waiting on hold.

Do you fax information to clients and prospects? Do you use a cover page? You've probably answered yes to both questions. Now comes the big one, "Does your cover page list all the services and products you provide?" If not, and I'm guessing it doesn't, you're missing a creative opportunity to market your message.

The best part of creativity in the client nexus is that it can work a wonderful kind of alchemy. If you're innovative and in close contact with your customers, any development—even a bad one—can create opportunity.

How High-Tech Calls on Creativity

The traditional problems with technical support are magnified when you are dealing with the complex world of computer systems, where different components have been provided by different companies. The critical issue: finding who's responsible for which parts.

Once the customer has determined who made what, he or she usually runs into another problem: The

Any development can create an opportunity

Outsourcing reduces a company's support

people staffing a support services department aren't always the sharpest minds at the company.

This is an issue that applies to many companies—not just high-tech firms.

Most companies give technical support a low rung on the corporate ladder. People enter the technical support ranks to get a foot in the door. Then, they either move within the company or leave.

Some companies answer this problem by outsourcing the customer service function or hiring temporary employees, giving them minimal training and letting them loose on the telephones.

In either case, these are the people who have the least experience with a company's products. So, the quality of the company's support suffers—especially if it is selling complex products.

Also, burnout among support staff is usually high and, consequently, employee turnover is a problem. If support personnel turn over quickly, vendors are left to find new recruits, and the staff remains relatively inexperienced.

As one Silicon Valley executive complained to a trade journal: "The biggest and longest-standing problem is how to take experienced people and have them function in the support environment. How can you someday provide high-quality technical support and do it with relatively junior people?"

As an employer, you want to find people who have a knowledge of and an interest in your product—and who want to work with customers to solve problems.

Another issue is keeping them trained and up-to-speed with the times. Then there's the issue of keeping them happy, so they don't get frustrated with their environment.

Some useful suggestions:

- treat customer service staff as professional problem-solvers instead of switchboard operators;

- give them room in which to grow, career-wise;

- don't pigeonhole them by putting them on the telephones eight hours a day;

- let technical support people find where their interests lie and follow them;

- encourage them to do research, write technical bulletins, teach classes to external customers (as well as in-house employees) and do other activities related to customer service;

- emphasize constant learning as a prerequisite to career advancement;

- avoid the traditional tier system of directing service inquiries from least informed to most informed service rep;

- integrate the customer service department with other business functions (some computer companies actually rotate customer service reps to other divisions for temporary assignments to keep them up-to-date on product issues).

A Troubling Issue: Fee for Service

Technical support service for customers has grown into a major cost center for some high-tech companies.

Traditionally, technical support has been a free service. Most products bought even a few years ago offered a toll-free telephone number that users could dial to receive technical support service at no charge. To offer such a service, companies must invest in both human and infrastructure resources, meaning they have to hire and train support staff and provide that staff with the equipment they need to perform their duties—without actually generating any direct revenue from this effort.

As a remedy to the problem of the customer support department becoming a resource drain and as an avenue to provide better support, many companies—especially in the high-tech industries—have begun to charge customers for support services.

Caveat: I've already mentioned that fee-for-service customer support can create a strongly negative impression and result in a substantial loss of future business. Despite my feelings against fee-for-service, I understand that a company may believe that such an action is necessary.

Emphasize constant learning

Review the options before you charge for service

If you have to charge for service, take a moment to review the options. Make sure that this isn't a thinly disguised effort to increase profits. If it is, I guarantee that you will lose money—and turn off more customers than you support.

The challenge you will face, if it is a necessity to implement such fees, is three-fold:

1) to identify your market carefully to make sure that it will respond well to fees;

2) to determine what manner of fees there will be; and

3) to communicate clearly to your market what fees will be charged for which services.

The idea is not to generate funds for profit—but to reinvest in and to upgrade call systems, provide better training, make the technical support position more attractive to employees and add value to customer support.

Fee-for-Service Checklist to Determine Feasibility

In order to determine whether fees should be charged for support services, it is first necessary to investigate your internal operations.

- What are the actual expenses for your support services (wages, benefits, telephones, allocated space)?

- How much of your sales revenues are allocated to support services?

- Is your product properly priced for the market and the support services you provide?

- Can you justify a price increase on the basis of service?

- Have any of your competitors implemented fees for services? If so, what impact has it had on their sales and position in the marketplace?

- Does not charging fees provide you with a competitive advantage that would be lost if you charged for support?

- Have you discussed this with your top customers? What has been their reaction?

- Do you currently offer support through a toll-free 800 number? If so, could you avoid charging fees if you switched to a regular line where the customer absorbs the cost of the call?

- Are there other ways to provide support that would reduce demand on the support team (e.g., a technical support newsletter, technical service bulletins)?

- Will the generated fees be reinvested in support service improvements?

- Based on current levels of technical support service, if you were one of your customers, would you be willing to pay for this service?

- Will you need to improve service beforehand to justify the charges being contemplated? How much investment will be required by the customers?

- Can you differentiate levels of technical support required by the customers?

- At what point will you charge a fee? (Would you charge a new buyer a fee for support in getting your product up and running?)

- Is there a more cost-effective alternative to your current process of technical support (e.g., e-mail, an Internet web site or support forum?)

Internet Service Options

The prospect of reducing the cost of finding customers is a major lure of the Internet. As this process becomes more prevalent and better understood, costs may go up—but the Internet process also will become more efficient.

A second and similar opportunity comes in the area of customer service. If you can get through the switchboard to a real person to answer a question—correctly, the first time, with no voice mail delays—you're way ahead of the game. But how often does this happen today?

Would you be willing to pay for this service?

Offer databases that allow customers to discuss products

If a customer is able to call up your home page, find a topic of importance, and get an answer right away, he leaves contented, and yet he did all the work himself. If the answer isn't evident, then the customer posts a question to be answered. Customer service staffers can answer those questions quickly, on their own time, and more efficiently, rather than being pestered by the telephone.

With this process, the customer has a happier experience, the manufacturer cuts the costs of doing business, and a relationship that might blossom into repeat sales also develops.

"An explosive trend in the software services marketplace is the use of the Internet to deliver service and support," says Amy Osetek, a software services analyst with the Silicon Valley information company Dataquest. "Users seem to be excited about this expanding trend as they continue to desire more availability of Internet-based service options."

According to Osetek, "More and more vendors are moving toward electronic means to deliver software services. This can range from CD-ROMs, to Internet delivery, on-line documentation and fax-back services. Dataquest finds users will use electronic means of support 25 percent of the time, using telephone support the remaining 75 percent of the time. This number has increased from 16 percent last year, and users have expectations to use electronic services 32 percent of the time by 1998."

Looking to differentiate itself from the competition by offering advanced on-line services, Lotus Development Corp.'s Services Group unleashed an array of Internet customer support services during the summer of 1996.

The class of electronic support tools, available through Lotus's Interactive Web Support site, would save Lotus customers "time and money by rapid resolution of technical issues through peer-to-peer collaboration and on-line incident submission."

The new service offerings included:

- **Incident Submission Web**. Incident submission and resolution offered the Internet as an alternative to the telephone, providing customers with access to a document

history of an incident and its resolution. When logging an incident, customers would have the option of specifying whether the incident needed to remain private.

- **Peer-to-peer product discussion databases**. Lotus offered collaborative databases that would allow customers to discuss Lotus products with other customers and interested parties on the World Wide Web. Peer-to-peer database users could access the collective experience of their peers in resolving support issues—and share ideas and opinions on the use of Lotus products and services. Forum participants, also would have the opportunity to comment or pose technical questions to guest speakers, including product and industry experts.

- **Diagnostic software**. Lotus offered instant and transparent delivery of an automated diagnostic to customers. The program was an expert system-based problem solver that could automatically identify, diagnose and resolve many PC hardware, software and system configuration problems without the need to call for technical support.

Lotus's system is more focused—and more interactive—than most on-line customer support services. The typical technical support web site serves a variety of functions, but the main ones are providing more written documentation on product use and allowing some e-mail communication between customers and service reps.

This focus causes some problems, including the tendency to dump a lot of information onto the site—which makes it harder for customers to find the information they seek.

Information needs to be organized and presented in a usable format, which takes a lot of thinking and a lot of time.

Dataquest's Osetek looks forward to quantum changes in the very notion of customer service:

A new era is dawning in supporting customers and their technical issues. It will be

Test market ideas for very little cost

marked by the support call that never comes. Instead, remote repair software is poised to act as a call prevention mechanism that, until now, has been a dream....

As a cost-effective option, corporations can either disband their internal help desk function and outsource all software support to a third party at the client's facility or at a remote location. Corporations can also use a third party to augment the corporate help desk for specific products or during specific time periods and levels of problem severity.

Although many companies complain that the Internet is not a cost-effective business tool, some have found these two very important ways to use the services of the Internet to lower either their sales costs or their operating costs.

A final point: Because the cost of getting on the Internet, creating web pages and buying links is rather small today, compared to the cost of creating massive color print or video promotions, there still remains an opportunity to test market ideas for very little cost.

But some high-tech successes involve simple customer service issues.

Amdahl Corp., the California-based mainframe computer manufacturer, has turned its focus to the arena of computer system service and integration. The company succeeded so well in its initial steps toward becoming a service provider that, in early 1996, Amdahl signed a five-year, $150 million service contract with Computer Sciences Corp. to provide technical support for more than 450 data centers. Amdahl was servicing a service company.

The pact was the latest in a trend that saw mainframe makers such as IBM Corp. and Hitachi Data Systems Corp. shift into the maintenance field for smaller systems integration companies. This allowed the mid-level computer companies to concentrate on a variety of projects, such as maintaining their customers' local area networks or setting up e-mail systems.

While many of these systems would need maintenance anyway, the end of the century was a natu-

ral impetus. Because they use a two-digit year in their internal calendars, many mainframe-based installations—including accounting and on-line banking applications—can't understand the year 2000. They read it as 00, which would usually mean 1900.

As a result, programmers must begin editing billions of lines of code before the new calendar arrives. This translates into an enormous opportunity for mainframe-savvy companies to provide major service.

For an organization that has 10 million lines of code written into its mainframe and one date reference per 25 lines of code, it would take one programmer making 10 fixes per hour about 20 years—40,000 working hours—to correct all the code. The cost to fix these codes, with a programmer earning $55,000 per year, is about $1.1 million ... for just one organization.

"This will be the largest expenditure in history where there will be no tangible business gain. It's a correction," said Robert Simko, an analyst at the California-based International Technology Group. "It's judicious for [Amdahl] to invest in professional services, because that's where all the money is in terms of large corporate computing."

The company's transition to service-related endeavors was reflected in its rank and file. "People are always surprised when I tell them about 60 percent of the 10,000 Amdahl employees are working in the customer service division," said Doug Richardson, Amdahl's vice president of marketing for customer service. He expected the service division to increase in the immediate future—though mainframe production would still constitute about 50 percent of the company's business.

Some Final Thoughts

There are hundreds of ways to market your company creatively, and most of them are far less expensive than traditional advertising.

Develop an opportunistic eye within your community. Conduct a brainstorming session with employees a couple times per year, and make it exclusive to new and unique methods of marketing. Main-

Conduct a brainstorming session

tain strong relations with your Chamber of Commerce and other groups that cater to your particular market.

But, above all, get everybody involved. Many of the opportunities that you encounter will come from the least likely source, so it pays to have everyone keeping a watchful eye. Finally, when you do identify an opportunity, maximize it.

CHAPTER THREE: WHICH SALE FIRST? AVOIDING THE PRODUCT TRAP

Make yourself necessary to somebody.

—*Ralph Waldo Emerson*

All too often, businesses get caught up in the product trap. From initial advertising to customer service follow-through, the product takes center stage. It dominates all communication with the marketplace.

After spending all kinds of time and money on promotion and support, the company wonders why it didn't get the sale. Or, if it did, why it didn't retain future business from its clients.

The answer is simple: The company made the wrong sale first. By selling the product first, it lost sight of the most important sale—its franchise and its people.

During my high school years, I worked weekends and summers in a car dealership. I was always amazed by the rapport that the dealership's most successful salesperson had with his clients. Most of his clients had bought a number of cars from him; many brought their friends in to buy from him. Women greeted him with kisses—even the kids loved him. As a result, month after month, year after year, he always led the dealership in sales.

Finally I asked him, "Why are you so successful at selling cars?" He quickly replied with an answer that has stayed with me ever since, "I don't sell cars, Jack. I sell myself."

Build trust and security

This is a time-honored realization among professional salespeople. But it's not always something that customer service people embrace. It should be.

Customer service may not have the ability to make the face-to-face appeal that a car salesperson does. But it can personalize its approach.

When you sell yourself and your company first, you create trust, confidence and rapport. When trust, confidence and rapport are high, pressure is low. And since every action has an equal reaction, the opposite is true: Pressure is high when trust, confidence and rapport are low.

Does your customer service operation build trust and security with your clients? Although we generally gauge success by the reaction of our customers, it is first necessary to look within to see if our customer service staff has the proper tools with which to work. Here's a simple checklist:

1) Do your customer service team members know the history of your company, enabling them to convey a sense of tradition and heritage to the client?

2) Has each member of your customer service team been introduced to key management and operational staff?

3) Does each member of your customer service team understand how the company works and who is responsible for what?

4) Do you have a training program enabling customer service personnel to actually work in, and become familiar with, the various operations in the sales, manufacturing and shipping departments?

5) How frequently does top management spend time in the customer service department?

6) Are customer service personnel truly "empowered" to resolve problems?

7) Is creativity in customer service rewarded or recognized?

8) Is your customer service team kept abreast of marketing campaigns, particularly with regard to advertised "promises"?

9) Are customer service personnel invited to attend other departmental meetings that might have an impact on their performance?

10) How frequently do you compliment your customer service personnel?

Sell Value First and the Rest Will Follow

Selling value is the key to successful business—value is the foundation of the client nexus. And there are few things that impress clients more than a high level of attention.

Let's say that you were interested in buying a boingo. ABC Boingo and XYZ Boingo both offered the same boingo—however, when you were shopping around, the salesperson for ABC Boingo walked you back into the company's boingo service department. He made a point of showing you its investment in specialized equipment and trained personnel to assure that your boingo would keep on boingo-ing properly. Then, the salesperson introduced you to ABC Boingo's management staff—which was dedicated to making the world a better place through boingos. Finally, after you had learned all about ABC Boingo, the salesperson extolled the features of ABC's boingo and quoted the price at which you could become a boingo owner.

XYZ Boingo, on the other hand, just says, "Here's the boingo and we'll give you a great deal!"

Which company created a greater sense of security? To which company would you give your boingo business? If you answered ABC Boingo, you'd probably even be willing to pay a premium to gain the service behind the product!

Creating a sense of security in the client is an important requisite to a service-oriented sale. It's even more important when it comes time to keep that client and build on that sale.

This sense of security can actually be a simple thing—conceptually, at least. It's a matter of perceived reliability, honesty and hard work. The difficulty comes in the execution—in maintaining contact with even small-dollar-volume clients, making technical support accessible and spending the time

Focus attention on customers and their needs

and money to assure that the client's impression of your company is that you're responsive.

As a participant in one insurance industry focus group said: "I don't have a lot of time to spend thinking about [insurance]. I want to do business with an agent who will look out for me—will keep an eye on my account even when I don't. I'll pay extra for this. It's worth it. I just want to be sure I don't get ripped off."

Mastering "Perceived Quality"

Quality initiatives also must be based on a good understanding of perceived values—or you risk making improvements that are irrelevant to the customer and can even decrease customer value.

Increasing net customer value requires focusing attention on customers and their needs.

In *Northbound Train* (AMACOM, 1994), management expert Karl Albrecht defines value as "the customer's perception of specific need fulfillment ... [it is] the outcome people seek, not the thing or experience they pay for."

In *Managing Customer Value* (Free Press, 1994), Bradley Gale defines value as "market-perceived quality adjusted for the relative price of your product. [It is] your customer's opinion of your products (or services), as compared to that of your competitors."

In other words, only customers themselves can give you clear and direct data on their needs—and the degree to which you have met those needs, especially as compared to your competitors.

According to a 1996 survey conducted by *Catalog Age* magazine, 37 percent of the respondents who receive more than five catalogs a week (21 percent of the total) cite better customer service as the main reason they shop via catalog.

That last point says a lot about the state of customer service in this country. Avoiding face-to-face contact becomes a way to improve service!

Perceived quality, which for durables includes both product and service quality, is a major driver of customer satisfaction. It's one of the most impor-

tant issues your customer service operation must address.

As the Japanese management consultant Noriaka Kano argues, it's useful to differentiate three levels of perceived value:

- The **expected level** is the level that is normal or modal to that business or industry. At this level, the company provides those goods and services that customers have come to expect.

- The **desired level** includes features that add value for the customer but simply are not expected because of company or industry standards. Once an organization establishes a desired level of customer value, failure to maintain that level can be dangerous.

- The highest level of customer value is the unanticipated or **unexpected level**. Here the organization finds ways to add value that is beyond the customer's expectations or even desires, at least on a conscious level. This can include unusually prompt service, greater willingness to find a way of resolving a customer's problems, additional services at no extra charge or anything else that unexpectedly meets customer needs.

There is another way of thinking about unanticipated levels of customer satisfaction. Customers have many needs that are well below their threshold of awareness—latent needs. Who knew that we needed VCRs before they were commercially available? How many of us knew we needed the ubiquitous fax machine 10 years ago? Were we aware that we needed on-line computer services, such as CompuServe or America On Line before they appeared? Or cellular telephones? How many of us think that we need the video telephones now on the horizon?

Knowing the answers to these questions would allow us to increase customer value.

Even as the number of banks continues to decline nationwide, the number of branches is going up, and consumers are increasingly using ATMs and writing checks, according to the Federal Reserve.

Tap into customers' latent needs

Customer service shifts in the banking industry

"The current era in banking is perceived by consumers as one where big banks take over friendly neighborhood banks, eliminating customer service," said Richard Widdows, who co-wrote a retail banking study at Purdue University in 1995.

Coinciding with the merger frenzy, big banks increased the minimum balance requirements for checking accounts by $300 between 1993 and 1995.

And, in the same time period, nearly 80 percent of all banks began charging an average of $1 for use of other bank ATMs.

Fees weren't the only sore spot with banking consumers. Some people also wanted to be able to address account glitches, loan applications and other matters locally, instead of waiting for answers from regional offices.

All of these factors "suggest that the demand is large for old-fashioned banking," the Federal Reserve wrote in a report that examined banking from 1980 to 1994.

"One of the really simple ways to compete with these banks is to make the bank decision-makers available without going through the bureaucracy," said Harmon Spolan, president of Jefferson Bank, a regional institution based in the metropolitan Philadelphia area.

Independent banks also have held their own against consolidation by offering free checking, breaks on ATM fees, higher yields on some accounts and friendlier loan and mortgage programs.

When automated teller machines first caught on at banks, human tellers came to be seen as an anachronism that many institutions wanted to phase out.

Not anymore. Even as more and more transactions are being handled by ATM and telephone, bankers increasingly are valuing the human touch that only living tellers can provide. As a result, bank retail executives are looking for tellers whose primary talent is selling bank services, rather than counting money.

This means that tellers have to be better at problem-solving than in the past, and also need to be smoother with irate customers.

Also, banks are starting to view their branches more like retailers would. They're measuring sales per square foot and per employee, and are trying to boost sales efficiency by asking tellers to look for potential sales leads.

In one important respect, being a teller is much harder than it was a decade ago—tellers today are more likely to be part-time employees. This trend is the result of efficiency needs. Bank executives say the transition to more part-time work helps them cut costs and improve customer service by boosting staffing at peak times.

The Levels of Customer Connection

Several marketing experts have described five increasing levels of customer connection. With some variation, these are:

- **Preference**: "Let's try them this time."

- **Favor**: "All things being equal, they get the order."

- **Commitment**: "They are our supplier."

- **Reference**: "You ought to buy from these guys."

- **Exclusivity**: "No one else has a chance to get an order."

The levels of connection reflect increasing levels of trust and commitment. At the preference level, there is little trust or ongoing confidence; the customer is often seeking a supplier in which to invest trust. At the favor level, there is a continuing, albeit modest, level of trust and confidence. When trust and confidence have been earned over time, customers ordinarily become committed.

At the fourth level, people recommend products or services to others based on their confidence that the value they received is not unique to their experience, but rather that their experience is representative of the net customer value provided by that supplier and that supplier's product(s).

While everyone would like to be at the fifth level, that's not usually possible. Indeed, it is rare to find this level of connection, given the competitive nature of most marketplaces. What is important, how-

Provide easy access to information

ever, is to discover the current level of connection and to develop strategies for increasing, or at the very least maintaining, the current level.

Quality cannot be divorced from the day-to-day running of the business. Quality must be part and parcel of the millions of transactions that we perform each week. A focus on customer satisfaction, continuous improvement and a visible recognition of individual and team performances is a winning formula.

Under competitive pressure, many companies are tempted to backpedal in the drive for quality. And some people believe that quality actually adds to cost. A get-it-right-the-first-time approach reduces the often significant cost of correcting mistakes in our business.

Federal Express (FedEx) has as its mission having a completely satisfied customer at the end of each transaction. We believe that the company's outstanding and continued success is a direct result of the commitment of rank-and-file FedEx employees to make this concept a reality. This commitment also is supported by the various FedEx systems and processes. For example, its tracking system enables employees to answer customers' queries, and its performance appraisal system rewards customer focus.

Frank Maguire, the president of Hearth Communications Inc. and a popular business speaker, was a senior vice president at FedEx during the 1980s. While he was there, Maguire created the communications and employee relations programs for the company's Call Center and general operations around the world.

The mission was simple: Give the customer access to all relevant information about his or her account seamlessly—with one phone call.

While the customer may not always like what he or she hears from a telephone call to FedEx—shipments do sometimes get delayed—that customer can always count on getting an answer. That reliability made FedEx the first service organization to receive the Malcolm Baldrige National Quality Award.

Keeping all this in mind, here are a few maxims that can help you make the right sale first.

1) **Create value before quoting price**. This goes for follow-up sales, as well as initial sales. Price alone is merely indicative of the product, and doesn't convey the entire picture to the client. By creating value, I'm not talking about the product. Take the time to sell the benefits and values that are unique to you and your company. Others might have the identical product or service, maybe even a lower price. But you and your company can provide the unique difference.

2) **Never quote price to an unsold buyer**. If you haven't made the first sale, you aren't ready to proceed to the second. This isn't such a problem for the kind of follow-up sales that a client nexus generates—but customer service professionals need to remember that the nexus comes first, before the follow-up sale.

3) **Know that a client sold on price will shop future business**. If all you are offering is price, that is the only thing your client can compare. Loyalty in this case is only as good as the lowest price. Although you may retain the business, you will fight for every renewal.

4) **Look for performance as the scorecard of your client's expectations**. Once you've made the first sale, it is essential to make good on what you've sold. In selling yourself, you create expectations that must be met and should be exceeded.

A Simple Nexus Tool: Toll-Free Calls

I am continually at a loss to understand businesses that spend hundreds or thousands of dollars on monthly advertising—yet fail to spend a few dollars for an inbound 800 line.

Ralph Waldo Emerson said, "Conversation is an art in which man has all mankind for competitors." This is certainly true of business communication—which is the lifeblood of the client nexus. Money

Toll-free lines create a sense of value

spent making your company accessible to clients is money invested well.

To my way of thinking, I'll always be willing to pay the price of a phone call placed to me by a prospect. And I'll pay even more for a call from a return customer. The great thing is that the mechanical costs of these calls are the same.

Considering the substantial costs involved in generating leads and turning them into sales, the expense of an 800 line is the least financial concern a business should have.

Why? Because, first and foremost, 800 lines create an impression that you care enough about your customers and prospects to pay for the call. To spend any money on advertising which doesn't include a toll-free number to call decreases the effectiveness of the ad and increases your cost per prospect. Plus, a competitive ad nearby might include that magical 800 number and seriously decrease the drawing power of your ad.

I've had some small business owners argue that they don't need an 800 line because they limit their business geographically to the local market. Therefore, it doesn't cost the customers anything to call them. On a superficial level, that argument might seem to make sense—but, in practice, it doesn't.

The reason is simple, psychological, mass-marketing-induced indoctrination. We are bombarded daily with hundreds of advertising messages that include "call our toll-free 800 line." This has created a sense of value in the subconscious mind of consumers. As a result, given a choice, even within a local calling area, the consumer is more likely to call an 800 number than any other.

An 800 line has saved my company a lot of money and business. About six months before I started work on this book, I moved into new facilities. Although it was only about a 10-mile move as the crow flies, the relocation placed us in a different phone region—requiring a new local phone number.

For a price, the phone company allowed me to arrange an interlock—by which calls to the old number would automatically transfer to the new one. But, aside from a monthly fee, I also had to pay

extra for every minute of every call that was processed this way.

However, my 800 numbers merely rolled over with no extra cost or concern. As the phone statement arrived every month, I was grateful that I made a decision years ago that my marketing efforts would focus on the 800 number—even within my local area. The cost for the inbound 800 calls was less than the cost of local interlock calls. Plus, I didn't have to spend a lot of advertising money to re-educate my customers and prospects about a new phone number.

Most businesses try to spread their base of clients to avoid the all-my-eggs-in-one-basket syndrome. However, most find that there are one or two clients who are critical to long-term success.

A letter to the editor in AT&T's Newsletter for 800 service customers, *Closer To The Customer*, mentioned a great idea for providing a true value-added service to key accounts. The writer indicated a desire to separate a particular client's calls from the other regular customers to assure a high level of personal service. At AT&T's suggestion, he installed a separate 800 line for this particular client. The client was impressed by the fact that he had his own personal 800 line to call this vendor. It was a hotline between the two.

Some Final Thoughts

Committing to making the right sale first is difficult for many reasons—one of which is that you have to check your ego at the door. Selling your franchise first means being responsive. Being responsive means listening carefully to criticism—and not getting caught up in it personally—even when you think you're right. Especially when you think you're right.

In today's high-tech business world of laptop computers, cellular phones, pagers and electronic Rolodexes, the business card remains a popular, even indispensable tool.

A well-designed and properly presented card is a miniature billboard that can boost sales and company morale. When someone clips a card to his or her Rolodex, repeat sales can result for years.

The business card—an indispensable tool

Commit to follow-up calls

Aside from a good design, the key to getting strong results with business cards is to hand them out endlessly. You never know where business is going to come from. We tend to forget that we're looking for people to do things for us, and that it's easier if you have a card than it is to look in the yellow pages. It's more personal, too, because you had contact with that person.

When Colorado-based Western Pacific Airlines wanted to turn its entire workforce into a huge marketing staff, it turned to an idea as old as the printing press—the humble business card.

Personalized business cards were distributed to every WestPac employee as part of a campaign aimed at "turning our sales department from eight to 1,200," said Thomas DeNardin, vice president of sales and marketing. "It shows that every employee is equally important."

Follow-up calls might be one of the best ways to solidify a business relationship with a customer. They allow you an opportunity to touch on two key motivators deemed very important to buyers. The first is buyer recognition. Recognize and thank the customer for his/her order. This can be done with a short letter or card, a personal visit or a telephone call.

Greeting cards for offbeat holidays can be a big hit, too. My dentist stopped sending Christmas cards, switching to Thanksgiving on the basis that he was truly thankful for the patients who supported his practice. Additionally, he felt that his cards got lost in the Christmas crush and Thanksgiving would be better noticed.

I've always been a strong proponent of greeting cards at holiday time. Each year, our company used to order imprinted cards for distribution to our clients, vendors and friends. We always sent them early so they would be the first to arrive and therefore be noticed. It's a nice touch and, as a result, we usually get some extra business during the holidays.

Several years ago, I received a telephone call complaining about the card that we sent. The caller was the president of a client company. He was also a friend. And he had been my boss a number of

years prior for a different company. The one-sided conversation went something like this: "Jack, I thought I had taught you better than this! I appreciate the fact that you sent me a greeting card, but the card was an insult! [He had always been known for frankness and bluntness.] Don't I deserve a few seconds of your time for a personal note—or even your signature? If you really care about your customers, give them your personal touch."

At first I was a bit put out by his call, but after settling down, I realized that he was right. Since then, not a single card goes out without a short note, a thank you or my signature. This is a small thing, but it makes a strong statement: I care enough to take the time to personalize.

The moral of the story: Shortly after the first personalized mailing, we seemed to get more business than in years before. (We didn't use a postage imprinter either—just went with stamps.)

Chapter Four: Product Versus Service and the Perils of Commoditization

> When I see a bird that walks like a duck and swims like a duck and quacks like a duck, I call that bird a duck.
>
> —*Richard Cardinal Cushing*

What is it that you sell: a product or a service? That is the conundrum, the rub, the question! It's the kind of business issue that generates whole books, management styles and gurus. Unfortunately, it's also the kind of business issue that's discussed and lectured on and written about so much it starts to lose any basic meaning.

Throughout the 1970s and 1980s, management gurus of all sorts talked up what they melodramatically called *the service revolution*. The extreme edge of this revolution preached that all business was ultimately service-based, and that technological advances would make every other aspect of business obsolete.

This isn't quite how things have turned out. Customer service is more important than ever—but the underlying issue of what it is that your company does remains an ongoing factor in any business. If you make widgets, the first customer service challenge is to make good widgets.

The problem comes if you do something less concrete than manufacturing—which is true of most small, growth-oriented companies. In these situations, defining what it is you do can be tough. To

Service is a part of the product

make matters even tougher, for many small companies, the definition changes all the time.

To better grasp the importance of this issue, let's take a look at some industries that have been faced with a similar dilemma.

Nuts and Bolts

Independently owned and operated hardware stores, like the True Value franchises, continue to dwindle into obscurity. Large discount and wholesale operators, selling on price point only, have battered them to death.

Now if you were to seek out a local, independent hardware store, the do-it-yourself handypersons frequenting the store would be quick to explain that the reason behind their visit was service. The genial, knows-almost-everything owner or clerk first explains how to handle the repair (the service) and then supplies the required parts (the product). Clients will acknowledge that the price of the product is higher than at the local discount outlet, but the service is what they're really buying.

That service may not be readily available elsewhere.

Loyalty to that type of service might lead you to believe that there is a future for the independent hardware stores—that they can compete with the big discount houses. And, indeed, a few might. But few independent hardware stores actually market service. They still believe that they are selling product. Just look at the ads in the paper or listen to your local radio station. "Three-Day Sale! Screwdrivers, 99¢! Paint, $9.99 per gallon!"

These small stores still insist on selling product, not service. And service is really their product! To the future dismay of the indies, some of the major home center chains are already beginning to market themselves as volume warehouses with small-store service.

To analogize, it's like Domino's Pizza marketing quality of pizza, instead of delivery speed. Speedy delivery built Domino's business in spite of its lack of high quality. Domino's management knew this— and marketed its speedy delivery.

The hardware stores haven't made this conclusion.

Their story is one of failure to adapt to a changing market. Unfortunately, there are many stories like it.

When was the last time you visited a service station? No, not the gas station where you inserted your credit card into the pump this morning and filled up the tank. I'm talking about the service station where an attendant can fill your tank—or change your oil, do your brakes, align the front end and mount your snow tires in the fall.

Not too many of those dinosaurs left, are there?

What happened? They were convenient. We knew the owner. And the prices were better than the local dealership! Marketing, however, began concentrating on the product—not the service.

Think back a quarter century. Remember the friendly televised faces of Texaco attendants. The advertisements concentrated first on the people and the service, brought together by the product. Now come forward about 10 years, and you'll remember that advertising began to center on the quality of the petroproducts, cleaning abilities for smoother-running engines and octane ratings that would give you that extra boost when needed.

The people and the service were missing.

The marketing geniuses at the big oil companies had assumed that, if people came to buy the gas, they would be exposed to the availability of other services—sort of like the osmosis method of education that extols sleeping with a book under your pillow. It didn't work! Then things got even more complicated as aggressive entrepreneurs capitalized on the missing link of service and began opening fast service centers that niched into specific areas, such as oil change and tune-up services.

As a result, full-service stations are a rarity due to an inability to manage duality in marketing both product and service, complicated by niche marketers. Today, most gas stations are limited to the vagaries of product and price exclusively.

The Constancy of Change

If you're wondering what this has to do with you, you're in bigger trouble than I thought. And it's

Full-service stations—a failure to market both product and service

Change is a reality

because so many business people don't consider these issues that confusion abounds. Purveyors of products sell their services. Service industries want to make their services into price-driven products. When confusion crosses over into the marketing, annihilation awaits.

If that sounds like a doomsday warning, it is! Times are changing, and the top business consultants are espousing AC&L as the critical choices facing business. *A* stands for accepting the realities of the marketplace, which results in either changing (the *C*) or leaving (the *L*).

So, if we accept that the realities of our market are different today, then let's see what has to change—since I hope none of us want to leave.

The first step is to analyze exactly what your company has to offer your clients. Are you selling a product or a service? And what kind of product or service are you selling?

Costing Customer Service

First, let me note that there is no simple rule or formula for building the cost of customer service into your pricing. Every business, every product is different.

Obviously every product or service has an innate hard cost—the material, labor and immediate overhead that constitutes your cost.

Beyond that, there are three *burdens*: sales (the costs relating to your sales department), service (the costs of servicing customers and product) and operations (all other expenses, such as management and office overhead).

Let's assume that your hard costs are $1 and build a typical pricing model:

Hard Cost	$1.00
+ Initial 50% Markup	$0.50
+ 25% Sales Burden	$0.25
+ 55% Operational Burden	$0.55
+ 15% Service Burden	$0.15
= True Cost	$2.45
x 1.75 Retail Markup	$4.29 Retail

If you already know your hard cost, sales burden, operations burden and appropriate markup margins, the question is how to place a numerical value on customer service?

The answer comes in two steps.

First, have your customer service team determine the cost of the average customer service call. This should include such items as telephone expense, labor and travel expense, if necessary. If you have a sophisticated cost analysis system, general overhead and office space allocations could be added to this.

Second, have your customer service team establish a weight number for each product or service you offer. Based on a scale of 1 to 10, with 10 being the highest, let them rate the customer service demand.

	Guide	Example
Hard Cost	$_____	$1.00
Retail Price	$_____	$4.29
Monthly Sales	$_____	$35,000
Weight Factor	_____	5
Average Service Cost	$_____	$12

$_____ x _____ = Weighted Service
Average Service Cost Weight Factor

(Example: $12 x 5 = 60)

_____ ÷ _____ = Customer Service %
Weighted Service Retail Price

(60 ÷ 4.29 = 14%)

$_____ x _____% = Customer Service
Hard Cost Customer Service % Allotment Per Sale

($1 x 14% = $.14)

This formula is not an absolute—every industry has its own standards—but it may serve as a general guide for your assessment of customer service ex-

Focusing on finances created other problems

pense in building your price structure. Common sense and judgment will be your final factors in making this determination. A continual process of review should be instituted to track actual customer service expenses against the allocated budget from your price/cost structure.

A Case Study: California Millworks Corp.

It is a rare occasion when I take on any consulting work. Yet there was a recent exception, for a friend, Joe DeMieri, who was experiencing trouble with his business, which manufactured wood doors and windows. I had been advising him on an informal basis for about a year, when he asked if I would consider a formal consulting arrangement. During the 10 years of his ownership, the company had grown tenfold, from about $1 million in sales to a high of $10 million. However, he was currently facing serious financial problems and diminished sales. Some of the problems were the result of expansion into a new facility just prior to the construction recession in California, including dramatic and unanticipated move-in expenses required by changing local ordinances, and the damages caused by the Northridge earthquake. Two critical issues were immediately evident:

1) in concentrating on the financial problems, sales and marketing were being ignored; and

2) due to the financial problems, stocking enough raw material to deliver finished product on a timely basis was nearly impossible.

Upon initial review, I came to the conclusion that the company was surviving in spite of itself. Both the inside and outside sales staff were on salary, rather than commission. There was no direct supervision from a sales manager, and the marketing manager position had been vacant for nearly a year. Distributors were upset, and there was a substantial backlog of warranty/service complaints. Yet the sales department continued to write orders—just not quite enough for profitability.

Faced with numerous opportunities for improvement, we decided to survey both the distributors

and the employees to determine specific areas of concern and to prioritize the order in which they would be addressed. The survey of distributors held some surprising results, boiling down to the fact that they were buying the product, despite the company. More than 50 percent replied that they represented the company's line due to the quality and variety of the product line and brand name recognition at the consumer level. Conversely, nearly all replies indicated that the biggest problems in doing business were poor communications (particularly voice mail), long lead times, late deliveries and customer service difficulties.

Now, how many of your clients would continue to buy your product if they had difficulty communicating with you, had to wait a long time for a delivery that usually would miss the delivery date anyway and knew that there probably would be delays in getting service after the fact? Yet that was exactly what was happening at California Millworks.

Perhaps it is the nature of people who build things for a living, but on the employee survey, nearly all of them rated product quality as their main concern—and, for many of them, it was also the reason they came to work there. There was a definite correlation between the personal self-esteem of the employees and the product. Because of this, there was a definite commitment to see the company survive.

Addressing the areas that needed change required creativity due to lack of finances. On the distributor side, we developed an ongoing communication process by mail and we got honest. In our first letter, we acknowledged the survey results, accepted responsibility for the problems and began outlining how they would be rectified. Several times each month, the distributors would receive letters updating them on the changes, as well as special sales offers. Plus, to build on the employee/product connection, each letter contained biographical sketches of the people behind the product. Everything was designed to make the distributor feel like a part of the family. The key was to make sure that once a change was announced, the company would live up to its word.

On the employee side, a number of changes were implemented. First and foremost, sales personnel

Employees rated product quality as a main concern

Procedures were developed for telephone and voice mail

were taken off salary and put on commission. Now they had a vested financial interest in every quotation and sale; failure to perform would impact their pocketbook. Needless to say, sales increased—as well as overall performance. Suddenly, sales reps began visiting distributors, training their salespeople and offering their services to assist with weekend sales. Additionally, we began holding monthly sales meetings to train, motivate and manage their efforts.

The production department, accepting the financial limitations and low level of raw material, developed a team concept that included every facet from sales to purchasing and shipping. Using a just-in-time approach, this team would review orders and production on a daily basis. Reports then indicated the status of every order and projected delivery date.

Now the distributors could get status checks that they could believe and rely upon. As for customer service, a new manager was named, new service technicians were hired and the backlog was quickly diminished. Finally, a bonus program was established so that every manufacturing and office employee could benefit from the overall performance of the corporate team.

Operationally, the biggest challenge was the telephone communications. An action team was appointed, and written procedures were established for telephone and voice mail. No caller would be put into voice mail, unless by request, and every message would be returned within one hour—even if only to acknowledge the call and let callers know that the company was working on an answer for them.

Thanks to the commitment and perseverance of the president and CEO, Joe DeMieri, the company was able to solidify the distributor base and increase sales. As a result, within six months the company was in a position to entertain prospective purchasers who had the financial depth necessary to add the final ingredient to recovery: capital. In early 1996, barely eight months after initiating the turnaround, the company was successfully sold to a competitor.

The Bottom-Line Impact of Responsiveness

In the long term, companies can't add value or profit by playing the price game. Instead, your knowledge of the business and your industry is the best tool for protecting your franchise.

The most important factor affecting a business unit's long-term performance is the quality of its products and services.

To deliver world-class service means treating each customer as an individual and catering to his or her individual needs. This standard impacts all of the business functions your company handles—customer service, technical support, salcs and marketing, order entry and administration, help desk and customer asset management operations.

Making all of these functions work coherently may force your organization to reconsider the way service is delivered across the entire customer life cycle—which is another way of describing the client nexus.

Increasingly, business analysts track customer service as a measure of a company's financial well-being. In 1996, cut-rate personal computer maker Packard Bell Inc. was rumored to be having money problems. One of the main signs critics pointed to was angry customers.

The lack of responsiveness was a sore point for well-informed, bargain-hunting customers—who were Packard Bell's core constituency. In a survey published by *PC Magazine*, the company ranked last in length of time on hold for customer service (15.7 minutes).

Frustrated consumers did more than just take their business elsewhere. They criticized the company on the Internet's World Wide Web; one web chat room was called "Sad Stories from Packard Bell."

This was a serious matter. The *Wall Street Journal* reported:

> Quality-control woes have led angry consumers to form on-line chat groups to air grievances. Even the company's own warranty dealers, under contract to provide under-warranty repairs, sometimes can't get

Treat each customer as an individual

Building a price for service

through on the telephone to resolve customer complaints. The result is a potentially damaging loss of credibility.

Most importantly, the negative image with customers damaged Packard Bell's ability to pick up crucial repeat sales. According to a survey conducted by the research firm Computer Intelligence InfoCorp., Packard Bell ranked first in capturing first-time home buyers in the U.S.—but it only tied for fourth place in selling additional computers to those buyers.

With many homes already containing computers, the market was shifting toward repeat business—"a big problem for Packard Bell," said an executive with Computer Intelligence.

Of course, senior management can—and often does—set a figure for a reasonable service charge based on the importance of a client nexus to the organization.

A Customer Service Problem: Commoditization

Customer service is always a key part of any business. But some businesses and industries go through periods of change—during which the definition of customer service can change dramatically. If your industry goes through this kind of change, you might be tempted to gut your customer service operation. But this move might be short-term gain and long-term folly.

Consider the insurance industry, for example. It is becoming very much price driven in terms of its product. This is often referred to as commoditization—the process of a value-added product becoming a commodity.

From a customer service perspective, the problem with products that have become commodities is that price becomes the controlling factor. Commodity markets compete on price above all else. They don't allow much room on the balance sheet for financing added value. In many cases, customers don't even want added value.

Simple kinds of insurance—coverage for your home, car or life—can be packaged into a commodity eas-

ily and sold on a direct-marketed basis. Price is the motivator, and consumers can save money.

As a result, an increasing number of insurance policies are sold by mail. Some policyowners never have an agent beyond an anonymous voice on a phone. Banks are experimenting with selling insurance through their ATMs. Gasoline companies are testing the concept of selling auto insurance coverage on a direct-mail basis to their credit card base.

To most consumers, one company's insurance product is identical to another's. That leaves price, convenience and loyalty as the deciding factors.

I've experienced these issues firsthand—from the consumer's perspective. I was very loyal to an insurance agent I'd used for years before I moved to California. When I moved to the Los Angeles area, I asked my old, familiar agent to get me a quote on several kinds of coverage—including auto insurance. He shocked me by quoting several thousand dollars a year for a standard package. In disbelief, I called around to several big, cut-rate insurance companies that sold coverage directly, without agents. They offered prices several hundred dollars a year less than my old guy's best price. At that point, my loyalty ended and I bought cheaper coverage elsewhere.

Broader perspectives lead to similar conclusions. 20th Century Insurance has captured a significant share of the good driver market in California by selling directly—and offering less in the way of customer service.

If you call for a quote, 20th Century mails you an application. A week or so after you return the completed form, the company returns you a quote. Even existing policy owners cannot call and receive quotations on how additions, deletions or changes will affect their premiums. If—as a policy owner—you make a claim, you do so over the phone or by mail.

(Telephone operators are not licensed agents or claims adjusters. The most they can do is take down information and relay it to professional staff.)

Efficiency is the extent of 20th Century's customer service. However, its success has proved that price factors can overcome service factors in some situations.

Price, convenience and loyalty— the deciding factors

Balancing customer service with price factors

But—and this is a big but—how long will this work? Despite the cut-rate company's clear focus on price, do customers understand they're giving up some level of service?

Put another way, does the consumer still expect to receive the same level of service he or she did when a neighborhood agent handled his business? When it comes to filing a claim, probably.

Can direct marketers like 20th Century provide that level of service and still maintain the cost savings that generate the business? Probably not. If they do bring the service to higher levels, their costs will rise—and so, eventually, will their premiums.

Mercury Insurance, another California insurance company, uses a traditional agent sales and customer service force—and manages to compete effectively with 20th Century. Mercury specializes in the same good driver market; it offers competitive—if slightly higher—rates.

Mercury's strategy is simple. Rather than marketing purely on price, it stresses that consumers can still get low rates and have an agent who will help them buy insurance and make claims.

Plus, Mercury found and attacked a weak spot in 20th Century's marketing—it penalizes families with teenage drivers. Mercury spends time and effort to sort out and reward the families with better driving records.

The point is that Mercury competes in a commodity market while emphasizing the service aspect of its product. It resisted the trend in its industry by balancing the legitimate value of good customer service with an awareness of commodity price factors. It identified a reasonable expense level for service—then sold this service to market segments that appreciate it.

Of course, different market segments, even within a single industry, can have different customer service needs. When it comes to the group of insurance policies that protect small businesses from liability and property losses, price is important, but service is critical.

Business owners need expert advisors to guide decisions and help manage risks and exposures. You

aren't likely to get that level of service from a post-card that says "Insure your business for $99 a month!" As a result, you don't see many postcards making such claims.

In fact, if businesses (even small businesses) bought on price alone, the world's largest insurance companies would quickly go out of business—since they seldom offer the least expensive coverage.

In the insurance industry, the brokers and agents who do best realize that their product is really the service of helping clients identify risks, buy the right combination of policies and get paid when they make claims. These services are what they sell. They don't try to sell policies as commodity products.

As a result, in the market segments in which insurance has become a commodity product—personal auto, homeowners, certain kinds of life insurance—fewer and fewer agents or brokers are doing business at all.

The Difference Between Marketing and Selling

Before we leave the insurance industry, we can use it as an example of one more issue that impacts the client nexus: the difference between marketing your business and selling your product.

A business acquaintance of mine who runs a successful Southern California insurance agency makes a big point of distinguishing between marketing and selling. He says that marketing creates the image that leads to a sale; the sale itself may rest on price, but the marketing needs to emphasize service.

My friend's marketing stresses his agency's expertise and the value-added benefits it can provide to businesses in two highly competitive fields—contractors and hospitals. Brochures, direct mail and advertising highlight the specialists within the agency, including their knowledge and years of experience in understanding these niche markets and associated risks.

The agency invites potential clients to join its team. Value-added benefits of membership on the team

Create an image that leads to a sale

include free consulting on human resources, regulatory compliance, discrimination problems, EEOC, workers comp, OSHA, wage and hour, discharge and discipline problems.

Clients also can take advantage of other services not specifically linked to business insurance. These include such things as personal credit reports, D&B reports, motor vehicle reports and an injury and illness prevention program.

Add to this mix industry-specific newsletters, compilations of insurance bid specifications, certificate requests by fax and periodic seminars on a variety of labor and employment issues, and you begin to understand why my friend is a success in his field.

Some Final Thoughts

Every business faces a specific reality of where it operates in its marketplace. Determining how much and what kind of customer service you need to provide requires that you take some time to define your reality.

The key factor within this process is determining whether you are selling a product, a service or some combination of the two. Once you've done this, you can market accordingly. Customer service flows from this—and is one of the defining elements of an effective marketing campaign.

In short, you need to be aware of the right level of customer service for what you do. This awareness—sprinkled with creativity and baked with perseverance—is a sure-fire recipe for long-term success.

CHAPTER FIVE: DEFINING THE COMPETITION AND MANAGING CUSTOMER EXPECTATION

> Competition is the keen cutting edge of business.
>
> —*Henry Ford*

When it comes to determining and evaluating our competition, most of us have a tendency toward tunnel vision. We immediately think of the geographically closest rival with the same service or product.

This may have been a functional approach in the simpler past, but it doesn't work today. Your competition is every business that touches your clients in any way, manner, shape or form. Geographic boundaries have fallen—and, more importantly, industry boundaries are falling. Banks sell insurance. Gasoline companies develop convenience store chains. Computer software companies publish magazines. Car companies build their own lease and finance companies. Movie studios start television networks.

You may own a bicycle store—but your competition can include the local baker, dry cleaner, hardware store or department store. Maybe even Walt Disney ... probably even Walt Disney. When it comes to identifying the competition, most companies need to expand their perspective.

Expectation— a moving target

Traditional Standards Fall

A traditional standard in the customer service field is that all companies aim to provide the Three S's—Sales, Service and Satisfaction. Companies that excelled in customer service provided these three things clearly and well.

Creating a client nexus requires more.

If you only rated yourself by sales, service and satisfaction, your local rival might indeed be your only competition. The problem with this scenario: In today's marketplace, the Three S's need to make room for the Big E—expectation. Creating a client nexus requires that you constantly meet increasing market expectations.

It's in this context that many businesses and business gurus talk about things like delighting customers or seeking continuous improvement. The situation can be explained more plainly than that.

Expectation isn't static. It's a moving target. It will, occasionally, move down—but it usually moves up. In most industries, customers will expect more goods or services on more cost-effective terms as time progresses—if only because they have become more sophisticated buyers.

Rising expectations also tend to have a leveling effect on industries and geographic regions. As customers expect more, they learn to look elsewhere for satisfaction. If one company doesn't meet their expectations, they'll try another. If one industry doesn't meet their expectations, they'll consider alternatives.

So, your Big E competition, unlike your Three S's competition, may not even be in your industry. This competition runs the gamut of human experience—from personal issues to strictly business.

To be successful over the long haul, you must meet or exceed your client's expectations. In this context, your customer service function needs to operate as an early-warning system. It needs to keep in touch with clients and stay on the lookout for changes in their expectations regarding what you do and how you do it.

Three Questions that Measure Performance

Every single contact with a client has the ability to impact future sales, regardless of whether the contact was initiated by you or your client.

Customer surveys, questionnaires and one-on-one discussions are all important tools—but a client need only answer three questions to help you measure your performance. In fact, these three questions should be asked during every single client contact, particularly if the contact was the result of a complaint.

1) Based on our performance, do you plan to continue doing business with us, or purchase additional products or services from us?

 If the answer is yes, you have met the minimum expectations of this customer and laid the groundwork for continuing contact and selling opportunities.

2) Do you know of anyone else who could benefit from our services?

 If your customer is willing to provide you with a referral, you then know that you have met the majority of this customer's expectations.

3) Would you be willing to endorse our product/service to others?

 If your customer is willing to personally endorse and support your company to others, pat yourself on the back—you have exceeded this customer's expectations and established a client nexus.

Note: Aside from helping you to determine your effectiveness in meeting and exceeding the expectations of your customers, I also can guarantee that you will immediately experience increased sales if you are steadfast in asking these three questions during the course of every customer contact. Referrals are the most effective source of prospecting, and the failure to ask for a referral is the most common mistake made in business.

A referral means you've met expectations

High-quality service is a serious commitment

Who's Responsible When Expectations Go Unmet?

For most companies, the initial reaction when a proposal is declined or an account lost is to lay the blame of unmet expectations at the feet of the sales force. After all, doesn't sales set the cornerstone of client expectations at the time of sale?

Before you answer that question, let's take a closer look at the issue of client expectation.

A good illustration of the effect of rising expectations is the process that begins the first time a child goes to Disneyland—and then steps back into the reality of daily life. For the next few hours or days, every person, place and thing will be compared—usually unfavorably—with the park, where every supercalifragilisticexpialadocious expectation was exceeded. The neighborhood park or pizza parlor, which a week before had been the kid's favorite place, doesn't have the same allure.

This isn't the fault of Disneyland's ad campaign (the equivalent of its sales force). It's also not the fault of the pizza parlor's sales force.

When expectations have started to rise, they're tough to stop. That's why high-quality service is such a serious commitment—and such an important part of sustained success. Once they've experienced quality service, your clients won't feel comfortable with anything less.

As consumers, most of us have come to demand considerable levels of service from the stores and shops we frequent. So, bakeries offer a baker's dozen when we buy pastries. The owner of the local hardware store guides us through a plumbing repair. An appliance store offers to refund the difference between its price and a lower one offered by a competitor.

Innovative companies can change consumer expectations for a whole industry. I've mentioned the effect that Disneyland and its sibling parks have had on children's amusement. More recently, much has been written and said about the effect that the Washington-based Nordstroms department store chain has had on retail sales. By increasing customers' expectation for service—including every-

thing from live piano music and sales assistance to return policies—Nordstroms has made people feel all department stores should treat them better. This has made some chains improve their service, and chased others out of the business.

Client satisfaction, built on professional sales efforts and effective service, is critical to loyalty, retention and profit. However, if we are truly to build a long-term relationship with our clients, we must assess all our efforts against expectations.

To compete in the arena of expectations, you compete with a consumer mind-set that has been nurtured from birth—goods and services are supposed to get better all the time.

(As we'll see in later chapters, the disappointment that often accompanies this expectation has made some younger demographic groups cynical about customer service and business in general.)

Satisfaction = Expected Product Quality + Expected Service

Because expectation isn't static, the ultimate burden of customer satisfaction is also ever-changing. You have two customer expectations to meet every time you make a sale: expected product quality and expected service.

This formula brings a new responsibility to the successful business: the management of client expectations, which impacts both sales and service.

Perhaps one of the greatest examples of mismanaging customer expectations was an advertising campaign used by Ford Motor Co. in the early 1980s. In an infamous ad, a ball bearing rolled along the edges of the trunk and hood of a Ford car to demonstrate a precision fit.

Reality wasn't quite that precise. Ford service departments around the country were visited by customers demanding that their hood, trunk and doors be aligned perfectly. The ad campaign had created a level of expectation that was unreasonable at the time.

(A few years later, Toyota's Lexus division tweaked Ford's experience by producing similar ads—and

Create open lines of communication

encouraging car buyers to do their own tests. The Lexus cars usually passed.)

Many businesses have a similar problem. Client expectations are generally higher than the reality. When that occurs and expectations are not met, your future with that client is in jeopardy—even when the expectations are unrealistic.

Earlier in this chapter, I pointed out that an important function of your customer service department is to gauge marketplace expectations. At this point, I'll add that customer service also should manage marketplace expectations. This is a critical part of the client nexus—using the interactions to direct client response.

A Communication Solution

Businesses must learn to manage client expectations, in order to exceed them consistently. This requires marketing that creates communication, not problems. It requires sales efforts that build ongoing relationships on firm foundations of product quality and service. It requires product delivery that educates the consumer about specific reality—and combats ill-informed assumptions.

Most of all, it requires a customer service operation that creates open lines of communication between you and your clients.

This kind of communication can cost some money to develop. It can include everything from buying a toll-free phone line for comments (on the inexpensive end) to offering money-back guarantees or organizing direct-mail follow-up (on the pricey end).

Whatever you spend, make sure you get your customer service money's worth. Formalize the questions that you ask customers who contact you to make complaints or comments. This qualifies their position to judge your product—and allows you to retrieve useful information from the interaction.

Managing Expectations upon Delivery

A key element in the process of managing expectations occurs at the time your product or service is delivered to your client. The days and weeks when a purchase is new offer the best opportunity to

gauge customer satisfaction—and expectation. The following tactics may help you take this opportunity systematically:

- **institute a delivery policy** that includes a questionnaire (or at least the delivery of a questionnaire) and reviews all relevant paperwork;

- **review and explain** exactly what has been purchased—if you offer guarantees or warranties, they should be explained in detail;

- if there is a customer service **procedure for communicating future problems**, make it known clearly—and encourage the customer to use it;

- if there are **ancillary or optional items** or services that the client might assume to be included with the purchase, clarify. (A classic illustration: Clerks in most electronics stores remind customers what batteries are needed in battery-operated items—this avoids frustration later and generates additional sales immediately.)

When Handling a Customer Complaint:

Since perfect customer service doesn't exist, periodic complaints always will arise. Although they can't always be prevented, they do not need to cost you a customer's business.

Listen to the complaint and determine what has happened. Then act quickly and take action to counteract the problem. View complaints as an opportunity to establish a better working relationship with your customer. Satisfying a customer's problem quickly will build goodwill and increase his or her desire to work with you again in the future.

Everybody can sell product. It's how well you handle a problem that makes the difference.

There's no such thing as a problem-free relationship. Problem resolution is probably the most critical competency in customer service.

There's an old saying in customer service circles: "A problem is a problem when the consumer feels it is a problem."

The customer's solution may be the easiest and least expensive

In today's increasingly competitive environment, consumers are becoming more discriminating in their purchases and making complaints about poor after-sales service, product quality and value-for-money.

Responding effectively and efficiently to consumer complaints is an important area for retailers to address in order to provide differentiation in the marketplace and maintain customer loyalty.

Consumer dissatisfaction often arises from poor business practices, and is an area retailers must address in their efforts to provide good customer service and encourage repeat sales.

Everyone wants to be heard, understood and respected when they have a complaint to make. Good customer service is simply that—hearing, understanding and respecting.

When a Customer Complains

1) Let them know you're **listening**—"I'm here to help. Please tell me about your concerns ..."

2) Acknowledge their **feelings**—"I can understand you are angry, frustrated, inconvenienced ..."

 Regardless of whether customers are right or wrong, you should acknowledge their feelings in the matter.

3) Reiterate the **facts**—"Now, as I understand it, this is what happened ..."

 Once the customer has vented and you've acknowledged his/her feelings, restate the complaint and probe to make sure that you fully understand the details. This lets the customer know that you've cared enough to listen and you want to resolve the situation.

4) Find out what the customer **expects**—"Let me ask you a question. What would you like to see us do to resolve this for you?"

 Often the customer doesn't want you to do anything. The simple act of having the complaint heard was enough. However, if ac-

tion is required, the customer's solution may be the easiest and least expensive. You won't know unless you ask.

5) Provide the **solution**—"We value your business and want to resolve this as quickly as possible. Here's what can be done ..."

Depending on company policy, a) you may be able to do exactly what the customer requested; b) you may offer a solution according to the policy of your company; or c) you may be empowered to create a solution.

6) Confirm the **resolution**—"Will that be satisfactory, or is there anything else you would like us to do?"

If you haven't resolved the complaint, now is the time to find out. If the solution is beyond your authority, bring in the proper management to make the necessary decisions.

7) Either in writing or by phone, **follow up** with a thank you to the customer for having brought the problem to your attention, and verify that the necessary actions were taken to resolve the problem.

Knowledgeable customers will appreciate the attention you pay when they take the time to contact you.

Turning Trouble into Triumph

In 1995, the magazine *U.S. News and World Report* published a survey that found nine out of 10 Americans think incivility is a serious problem. About 78 percent said the problem of rude and crude people had become worse in the previous 10 years.

This means your chances of coming across what the customer service trade euphemistically calls a "challenging customer" are greater than ever.

Good customer service is the best defense when you are confronted with a challenging customer. Always respond in a civil way—no matter how difficult the situation. Treat your challenge as you would like to be treated in the same situation.

Complaints from "challenging customers"

Here are some service skills that may lessen the chance of having a problem with a problem customer:

- Note the tone of voice and the body language.
- Use the customer's name.
- Remain calm and respectful.
- Don't interrupt.
- Show empathy with words, tone of voice and body language.
- Apologize.
- Acknowledge any anger.
- Follow through on all promises.
- Offer an alternative.

And here are several things to remember you shouldn't do:

- Don't ask why or say, "Why didn't you ...?"
- Don't debate the facts. What is reality to the customer is the reality that needs to be addressed.
- Don't jump to conclusions. Understand the entire situation.
- Don't evade responsibility or say, "That's not my job," "I'm not allowed to do that," or "But the computer says ..."

Minimizing Complaints through Adjustments

Solving customer complaints before you lose the customer seems simple enough, as long as you get customers to complain and set up a problem-solving process. But how do you minimize complaints? How do you make those constant adjustments necessary to keep customers satisfied so they don't complain? The easiest way is to survey your customers and find out how they feel about your company, products and service.

Armed with the knowledge of how existing customers feel, the customer-oriented company can make

adjustments to meet the expectations of its customers. Companies that are not customer-centered will continue to chase customers away and spend money trying to attract new customers—consumers who may have heard the word from disgruntled ex-customers and are likely to ignore even the most innovative advertising messages because they already have negative perceptions about the company.

Ignoring a minor complaint or problem can only be interpreted as negative feedback by customers. Instead, view these complaints as early warning signals that suggest something may be wrong. Addressing customer service problems positively can often turn the most bitter buyer into one of your most loyal customers.

When problems arise with the performance of your product, stand behind it. Product warranties are really only as good as the people who back them. Explain any limitations involved, and offer several alternatives to the problem at hand.

Always try to make sure the customer is satisfied with the remedy to the problem. All companies will have an occasional problem. It's how they deal with it that separates them from the competition.

A Firsthand Account of a Problem Customer

For years, tire manufacturers included road hazard warranties with the purchase of new tires. Those days are history. If you buy replacement tires for a vehicle today, the salesperson usually offers an optional road hazard warranty or a package program that includes it. You then can intelligently decide whether or not to include it with your purchase. That's good.

However, what about the tires on a new vehicle that you've just purchased? Do they have a road hazard warranty? Usually not. Does the dealer tell you that? Usually not. That's bad.

Does the dealer tell you that you can go down the road to buy a road hazard warranty from the local outlet for the company that manufactured the tires? Usually never.

I polled a number of car dealers in my area about

Concealing a problem is the worst thing to do

why the absence of a tire warranty isn't mentioned to customers. Among the replies:

"I don't want to tell them they need to spend more money."

"The tire manufacturer includes free tire rotation with the warranty package and I would lose that service business."

"The customer would just want me to throw it in the deal."

"The tire dealer might get their maintenance business."

That sort of expectation mismanagement backfires when the customer has a blowout—as I recently did. Knowing that the tires were warranted by the tire manufacturer, I went straight to a tire dealer.

"The tire needs to be replaced, Mr. Burke. And the bill will come to $178. Didn't your dealer tell you that you could purchase a road hazard warranty from us for $100—which would have covered this situation?"

The tire dealer may have been the messenger with the bad news, but my anger was directed at the dealer who sold me the car. I won't be going back there again.

On the other hand, the clerk at the tire shop was well trained in handling the situation:

"I'm sorry you didn't have the warranty, but maybe I can help you out. Under our adjustment policy, if you buy the policy now, I'll be able to sell you the tire at our cost and install and balance it for free. That will actually be less than purchasing the tire at normal retail."

Without going into a detailed financial analysis of that offer (it wasn't quite as good as the clerk made it sound), it was certainly the right thing for the tire shop to do. It was establishing a sophisticated level of service with an unhappy customer. Whether or not I took the deal, I thought the tire company was doing a better job of anticipating my needs.

Concealing a potential problem is probably the worst-case scenario of mismanaged expectations.

Some Final Thoughts

Managing expectations is a quantum step forward in client satisfaction. Focusing on the time of purchase is the best tactic for accomplishing this.

But managing expectations is only one of many steps on the ladder that builds the relationships that create loyalty and generate profits.

Build your marketing programs on honesty. Don't promise what you can't deliver. And don't be afraid to discuss problems in a straightforward manner.

When determining delivery dates, give yourself a little room. Clients are always irate when something is late, but excited when something is delivered earlier than promised.

Only when you surpass the expected do you truly impress (or delight or excite) a client. Whatever your industry, market position or geographic region, your competitors are looking for ways to manage and surpass customer expectation. This is one of the defining characteristics of business competition today.

If you're not defining and managing customer expectations in your market, you're falling behind the competition.

Chapter Six:
Integrating Sales and Customer Service So You Get Repeat Business

> Nothing can have value without being an object of utility.
>
> —*Karl Marx*

Despite turbulence in today's health field, HMOs have made dramatic inroads into our national concept of medicine. Twenty years ago, most people only visited a doctor for problem resolution, not prevention. Today, we are just as likely to visit a doctor for preventive medicine as we are to cure a specific illness. The doctors have become advisors, as well as healers.

Taking a cue from medicine, perhaps we need to ask ourselves if we are advisors, as well as marketers.

By putting itself in an advisory position, a company increases its value to the client. This, in turn, promotes client loyalty and retention—which increases profit. That is the nexus at work.

Repeat Business Is the Prime Measure of Customer Service

As a customer's relationship with a company lengthens, profits rise. At a 95 percent retention rate, the value of a customer more than triples compared with an 80 percent retention rate.

Encouraging repeat sales

When customers stay with you over a period of time, you reap several benefits. They become less price-sensitive, they give referrals that bring higher-quality customers, and they produce more volume over time as they get to know you better. They're also less costly to serve because they understand how to use your business system efficiently, and your employees get to know them and learn how to be more productive.

A 1996 Xerox Corp. survey reported that customers who rate themselves as "very satisfied" yield six times as much repeat business as those who rate themselves as "satisfied."

The latter group had their expectations met; the former group had their expectations exceeded.

Customer loyalty is estimated to be worth 10 times the price of a customer's first purchase.

Most customers who have problems with a product or service do not complain. They just take their business elsewhere. And, in the process, they tell several dozen friends, neighbors and relatives about how perturbed they are.

To keep customers coming back, customer-oriented organizations find out what customers expect, then work to meet or exceed those expectations. If they fail to keep the customer satisfied, they make it easy for customers to complain. That way, they can rectify problems, convert dissatisfied customers into satisfied ones, maintain customer loyalty (repeat sales) and prevent the spread of negative word-of-mouth comments.

Merchandisers and advertisers are primarily concerned with making the initial sale to new customers. Preparing for repeat sales at retail is often given less effort and thought. Yet, as much as 90 percent of a brand's profit comes from repeat purchases.

It costs six to 10 times as much to get a new customer as it does to retain a loyal one.

Depending on your type of business, there are various basic ways to encourage repeat business. Here are a few ideas:

- If you have a retail store, make a mailing to past customers, thanking them for their

business and enclosing a discount coupon good for the next 60 days.

- For more expensive items (or items that are delivered to the home, like pizza), consider delivering a 10 percent discount coupon with each item. These could be used individually or combined on the next purchase (so 10 coupons would equal a free pizza).

- If you have an item that sells for a few dollars or less, punch (or stamp) cards are a good idea (just be sure to secure a unique punch or stamp to keep customers honest).

- Schedule an annual customer appreciation day at your place of business, with food, door prizes and special discounts, but invite your regular customers before the published starting time.

- Consider having your customers complete questionnaires on their buying habits for your product or service. Not only can this help sales, but it also can help you tailor future incentive programs to your clientele.

- Don't ever have your business phone answered by a machine during working hours. If you do, you are eliminating the personal contact with incoming callers, and it is this initial contact that says you care about them.

- Consider installing a separate phone line exclusively for customer service calls, giving the number only to existing customers. When this phone rings, you know it's someone who needs help, so pick up the phone and say, "Customer service, how can I be of help?"

Keeping Track of Repeat Customers

Most customer service departments are oriented to respond to customers' inquiries rather than develop a database or aggressively pursue customers' favor and business. The foundation for successfully building a sales base depends on only two basic assumptions. The product must be consumable (for replace-

Do not eliminate personal contact

Hunt for untapped revenue opportunities

ment), and it requires a high level of customer satisfaction (for a willingness to repurchase).

The key to developing relations with your customers is, of course, developing a comprehensive list of your product's users. This will enable you to target them when implementing a new program or product offering. It also will enable you to gather information in order to define your objectives in alignment with your market. Without this comprehensive database, you are underutilizing your company's important assets.

There are a number of useful methods of developing customer databases. Product warranties, registrations, offers of information, sweepstakes and rebates can be used to obtain names of purchasers. The size of the list is less important than its productive use.

When managers recognize that opportunities have been lost by not developing meaningful customer databases, they realize that planned efforts should have been made earlier for their conversion into additional sales.

Marketing for Repeat Business

Developing loyal, repeat customers merits an integral part of the marketing plan. It must not be an afterthought. Regardless of how the initial sale is made, the plan should be prepared and executed to lay the foundation for future repeat sales from these customers.

If prepared and executed properly, direct response marketing has the advantage of laying the foundation for future sales at retail by building relationships with the customers.

Rather than focusing primarily on finding new customers, more companies will hunt for untapped revenue opportunities with the customers they already have.

There is a trend among firms toward building customer relationships that will lead to more repeat sales. Some companies are not only moving toward team selling, but also are pursuing other approaches geared toward empowering field sales staffs.

More firms are allowing salespeople to sign off on price breaks or make other final decisions during client negotiations. Also, companies are training their sales staffs to take a more consultative role—one in which they can advise clients on matters that go beyond selling or servicing products.

The general idea of bonding with customers, commonly known as relationship marketing, has been central to the quality-management movement that began taking hold in the late 1980s. In fact, what is occurring at many companies and will drive sales in the new millennium is being caused in part by increased customer expectations resulting from company quality endeavors. That—and increased competition—is making customized customer approaches an imperative.

Many companies, either with or without full sales staffs, are putting the polish on new approaches to getting closer to customers.

Here are some strategies that work:

1) Identify your best customers, and develop new incentives to get them to return repeatedly.

2) Build a company, from the ground up, around the idea of repeat sales.

3) Help your sales force spend more time thinking about your customer's big-picture needs.

4) View your effort to improve customer relationships as something that is constantly evolving.

Business-to-business customers are especially tough to keep. Businesses today have higher expectations for professional services and very little tolerance for service flaws. Customers have their own businesses to run; they can't afford to be in business, too.

Because companies are more selective than ever, they choose their business partners very carefully and only maintain partnerships with key players. To improve customer service and efficiency, they look for new ways to cut administration costs by leveraging technology, streamlining work flow and reducing redundancies between what they do and what you do.

How to get closer to customers

A customer service faux pas

In an intangible or intellectual property business, knowledge is a competitive advantage.

Balance Your Approach

There are, however, dangers inherent in naively focusing on customer retention. Such a focus can overlook how much of its total budget for your product or service that customer is spending with your company. You may be retaining customers over a long period, but they may be spending most of their budget elsewhere.

In one study of the retail industry, those customers retained the longest were the least profitable. These long-term customers had learned how to shop the stores for sales and bargains, picking the least profitable mix of merchandise.

In early 1996, Capital One—a Virginia-based bank with major credit-card operations—made a major customer service gaffe. In a letter mailed to a select group of customers, the company's marketing officer wrote:

> We have identified a group of cardholders making an unusually large number of calls to our Customer Service Department. Your account is among this group. While an occasional inquiry is to be expected, we ask that in the future you limit your phone calls to only those which are truly necessary.

The letter went on to list as truly necessary those calls relating to "billing errors, disputes, lost or stolen cards or communications that you've received from us."

So, if you just want to see if a charge cleared or find out your balance or get an explanation of the rates and fees associated with your card, the bank would prefer you didn't call.

One marketing guru complained: "It sort of sounds like the way many of us talk to our children, or, even worse, the way we remember our parents talking to us."

A spokeswoman said the bank had analyzed phone calls to its toll-free customer service lines and found that a small percentage of customers were making 35 percent of the calls. Capital One felt the need to

limit calls to customer service so it could keep its costs low and protect its reputation.

This didn't do much to encourage existing customers to stay with the company. But the company had decided that the targeted customers were costing more in customer service time than they were generating in interest payments and fees.

Dealing with Complaints Well Is a Plus

Some customers deal with you once and then they vanish, never to be seen again. Where did you go wrong? Why didn't they say something? You spend money on advertising—they still don't come back. While you are wondering, your repeat sales are going down.

A 1994 survey of consumer behavior and complaints by the Research Institute of America offered the following conclusions:

- On average, 96 percent of customers who receive rude treatment will not complain. So when you hear a few complaints, they are only the tip of the iceberg.

- Ninety percent of customers who feel dissatisfied will not come back or buy again from that establishment. And they don't tell you why. You don't even get a chance to fix the problem. Such is the modern-day consumer.

- Each of these dissatisfied customers will relate their horror story to at least nine others. Some of them (13 percent) will tell their story to 20 persons, not just nine. Thus 100 unhappy customers will spread bad publicity about you to 1,043 people.

- For every complaint reported to management, 24 others go unreported. And six of these are serious.

- Sixty-eight percent of customers who give up on a certain establishment do so because they think management is indifferent. They don't fault the staff. The feeling is: Management should have known better. If management really cared, none of the problems would have happened.

A survey of customer complaints

Pass on some tidbit of information

- It will take at least 12 positive incidents to erase the effect of just one bad experience.

- Between 54 and 70 percent of those who complain will shop again at the establishment if the complaint is resolved amicably. If the complaint is resolved quickly, 95 percent of complainants will come back.

A good suggestion: Deal with complaints in a speedy fashion. It impresses the customers.

Advice Is a Valuable Sales Tool

I remember working a convention a long time back. There was one superstar salesman in the booth who always amazed the rest of us with his ability to close a sale. Aside from a vivacious personality, I noticed that he always passed on interesting tidbits that would help his clients improve their businesses.

Late one afternoon, a business owner sheepishly walked into the booth, approached the superstar and said, "I shouldn't even come in here, you SOB! You always end up selling me things I don't need in quantities greater than I can use at prices I can't afford!"

The salesman laughed, slapped him on the back and said, "Then why did you?"

"My curiosity is too great, I've got to find out what sort of ideas you have for me this year to get more business."

Since that afternoon, I've made a concerted effort to pass on some tidbit of helpful information during every call or customer contact I make. It may be a new twist to an old idea, or a sales letter that worked in some other industry. As a result, I frequently get calls from clients who simply want to check on what new ideas I've heard lately.

Several years ago, my wife and I bought a sports car with a V-6 engine. The engine had been a last-minute decision—we had been planning on the V-8 version.

Upon calling our insurance company with the policy change information, the customer service rep said in a snotty tone, "It's a good thing you didn't buy the V-8. We don't insure that model!"

I didn't like the idea of an insurance company dictating the car I drive, so I started looking around for another company.

When I told my story to a new prospective agent, he placed himself in an advisory position:

> "Your current company might not insure whatever car you buy—but I'd like to offer a service which could save you a lot of money down the road. In the future, when you plan to buy a car, give me a call with the models that you have in mind. I'll let you know what their rating categories are. If one model has a better rating and lower insurance costs, that might influence your decision."

Now, what this agent was saying—ultimately—was not so different from what the customer service rep for the insurance company had said. But his style was supportive and advising. Since I started doing business with that agent, I've considered him an integral factor in every automotive purchase. He has increased his value to our household, and thus his odds of retaining our business. (He now handles all of my insurance—corporate and personal.)

Is your business positioning itself as a valuable resource for your clients, or simply taking orders?

Marketing by Association

Jawaharial Nehru, India's prime minister during the 1950s (and namesake of the popular style of sport coat in the 1960s), once said: "Obviously, the highest type of efficiency is that which can utilize existing material to the best advantage."

Nehru was talking about politics—but I think his comment applies in business.

In 1985, I was marketing a program to automobile dealers by having my staff knock on dealer's doors one by one—literally. The program, which built customer satisfaction by managing expectations, was well received and a very profitable endeavor. The marketing, however, was a gradual process requiring a lot of client education to make the sale.

A year later, we had solved the marketing dilemma by personalizing the program to individual car manufacturers, who in turn had their field staff

Retain business by increasing value to the customer

Identifying needs of association members

market the program on our behalf. The volume of our business increased a hundredfold.

The increased volume enabled us to lower prices without decreasing our profit levels, and our marketing costs were drastically lowered since we now marketed only to the manufacturers, who in turn handled the national marketing effort. It was a major win for my company and our clients. It was an example of working the client nexus.

Since that experience, marketing by association has become the first method I investigate when I'm considering any new product or program.

Although many industry associations are nonprofit, they still need to generate additional operating revenue—the much-mentioned non-dues income. Also, many associations have for-profit subsidiaries or affiliated operations.

Whatever the mechanism, the common theme in these arrangements is combining your desire to make sales with the association's desire to offer useful services to its members. If a program or product can benefit an association's members, you can develop a mutual marketing program.

Aside from the credibility factor resulting from the endorsement, costs quite often are diminished in such joint efforts. Since many associations, franchise operations or distribution networks have regular ongoing mailings, we can include sales literature and order forms with their mailings, eliminating the cost of postage.

Often, you can offer the association a commission on sales made through its channels to its members. Occasionally, a program will be so valuable to its members that the group will forgo commission to pass on the savings—which only serves to increase your volume.

Again, the key here is to identify the service needs of the association's members. You can do this easily, by generating a basic questionnaire or survey that the association distributes to its membership.

This type of joint marketing is accomplished most easily in business-to-business ventures, but the retail trade can also benefit from the numerous clubs and associations that cater to individual interests. Investigate it.

Direct Marketing with a Government Twist

President Kennedy started it with his challenge, "Ask not what your country can do for you ..."

President Reagan took a different approach, reaffirming that what's good for business is good for the country.

In the 1990s, President Clinton is asking business and government to join forces for the good of the country.

Government and business have become unusual bedfellows in a unique and exciting direct-mail marketing concept in Montana that could serve as a template for a whole new direction in targeted direct mail. Although this campaign involves the automotive industry, it can serve as a creative stimulus for many others.

The September 20, 1993, issue of *Automotive News* reported that the Montana Chevrolet Dealers Association won a bid to mail 680,000 renewal notices for Montana's motor vehicle registrations. The bid, awarded to the group's ad agency, Sage Advertising, was believed to be a marketing first.

The Chevy dealers felt that the campaign would remove the junk-mail stigma from their direct-mail advertising, yet each renewal notice would include an advertising message from the recipient's local Chevrolet dealer. (Note the local aspect of personalizing the message to marketing territories.)

Meanwhile, Montana government officials were ecstatic over saving more than $200,000 in taxpayers' money budgeted for mailing expenditures.

The contract called for an initial mailing of 94,000 renewals with advertisements. Keeping in line with the mutual-benefit concept, the state publicized the agreement so that vehicle owners wouldn't mistake their renewal for mere advertising. The mailing envelope was clearly identified: "State of Montana Vehicle Registration License Renewal Notice Inside."

Six advertising messages were designed for use by local dealers. One included a $500 discount coupon redeemable only at the dealership indicated in the notice. Other personalized messages allowed for customization depending on current inventory con-

A new direction in direct marketing

Opportunities to work with government agencies

cerns or TV advertising campaigns. Each message included the name and address of the local dealer and, taking advantage of the unique nature of the mailing, suggested that the notice was a good time to purchase a new vehicle—before spending money to renew registration on an old one.

Advance focus group studies by Sage Advertising concluded that Montana consumers liked the idea that the dealer ads would be saving the state money. What better basis for free public relations publicity?

The state of Iowa recently began selling advertising space in 15 state documents, including finance newsletters from the Department of Revenue and Finance and driver's license manuals. In a poll of the other 49 states by the Iowa Department of Economic Development, none of the 38 states responding offered any such program.

But, after receiving the Iowa survey, I'm guessing the bureaucratic wheels are turning.

There are various advantages to cooperative programs with participating agencies in individual states, counties and cities. Of course, they subsidize government services—but they also offer you the opportunity to do some significant background research for your own customer service.

Just think of all the city, county and regional government agencies that could be the basis of a mutually beneficial relationship: business regulatory agencies, local taxation districts, animal licensing, business license renewals, property tax statements, utility bills. There are numerous opportunities to work in concert with government agencies—plus the publicity can be even more effective on a local basis.

You might be concerned about coupling your ads with a bill or invoice. If that's the case, investigate the various informational mailings that are published by government.

In California, residents receive water conservation newsletters and tips from local water districts. Such mailings are extremely positive in nature, tending to be green on the requisite environmental issues. Piggybacking here actually would provide a double endorsement: saving tax money and expressing environmental concern.

By now, I think you're getting the gist of this message: There's a brand-new vehicle on the direct-mail horizon. Investigate the possibilities—but, above all, start looking into it as soon as possible.

Based on the Montana contract, Ford, Chrysler, Toyota and all the other automotive manufacturers and dealers were prohibited from using motor vehicle registration renewals in that state for at least three years. The Chevrolet dealers cornered a valuable sales/service market.

The Gateman

On the East Coast, there's one of the more unusual retail operations I've ever seen. Practically speaking, it's a car dealership. But it takes an approach to identifying and servicing customers (and potential customers) that sets it apart from most dealerships.

The difference is a belief system that says: No one enters the premises without a desire or need to buy a car. This may sound like a small distinction—but it has some very big repercussions.

The highest-paid salesperson doesn't greet a single customer as he or she arrives. This salesperson only greets them as they leave. In fact, he's affectionately known as Gateman.

As people pull up to the exit gate to leave the dealership, Gateman walks up to their vehicle and says, "Thanks for visiting us today. We really do appreciate your business. What model did you buy?"

Once this question's been asked, there's a fork in the sales/service road. If the customer says she bought a new Hupmobile, Gateman congratulates her, wishes her well—and opens the gate. But if she says she didn't buy anything, Gateman goes to work with a simple question: "Why not?"

After intently listening to any objections, Gateman begins a process of slowly overcoming whatever purchase obstacles the prospect encountered. Slowly but surely, Gateman gets the customer back into the dealership and—in most cases—sells the person a car.

This top salesman thrives solely on the customers who didn't buy! His tactic: putting service before

Call the ones that got away

the sale. If the traditional identify-qualify-close approach hasn't worked, Gateman turns the process around—starting with the kind of survey most car companies use after the sale, then backing up.

At weekly sales meetings in companies across the country, owners and managers review sales activity with their producers. Congratulations are offered for sales attained and assistance provided for sales being sought. Occasionally, a eulogy is rendered for sales that got away.

Gateman prevents the eulogies by closing the sales that would otherwise get away.

I would like to suggest that we all need a Gateman. Take some time each week to collect the list of sales that were not made and call them. A simple conversation like this just may add to your bottom line in a big way.

> "Hi, Mr. Jones. This is Bob Smith, manager of the ABC Co. I know that we've been working with you to meet your needs with our product or service. I see where you've decided to place your business elsewhere. As manager, I was hoping that you could take a moment to tell me why."

Then, like Gateman, listen to the objections and overcome them if possible. One of three things will happen:

1) You will save the sale.

2) You will keep the door open for another opportunity later.

3) You will find out what went wrong and learn from it.

Using Customer Service to Control Variables

Customers never cease to amaze me. Many times simply introducing a new voice or face can make the sale. And, of course, every prospect likes to feel important and have his/her ego massaged. A call from the owner or the manager does just that. The customer feels important—and feels that you recognize that.

What about the other type of follow-up? Going after the prospects who used to be your customers?

Texas-based USAA Property and Casualty Insurance conducts an extensive and costly marketing campaign aimed at the ultimate niche market: customers who left them. Called The Grass Isn't Always Greener, this marketing campaign sends letters and quotation request forms to former customers. The letter begins with the question: "Was the grass really greener?"

The copy then goes on to affirm the customer's decision to change as probably the best for them at the time—but it then details three unique aspects of USAA insurance and asks the former customer to call or return the quote card.

To relate the significance of this effort back to the client nexus, consider that USAA has one of the highest customer retention factors in the industry. According to Perry Stevens, vice president of marketing and new member sales, the company retains roughly 98 percent of its customers; and of the 2 percent loss factor, nearly 40 percent is due to death.

"We've actually expanded our *get 'em back efforts*," says Stevens, "by immediately sending them a letter from our chairman, Robert Harres, telling them that we'll keep a light on for them. Then just prior to renewal time, we send the *is the grass greener?* piece, which goes out under my signature."

Does all this effort work? "It's difficult to track [scientifically]. But we get a pretty good chunk of them back—about 30 or 40 percent," Stevens says. "And, I might add, we also send a questionnaire to every customer who leaves asking them why they left."

Consider the effort and the results of USAA against what is already an extremely enviable retention rate. Then take a look at what you do to get those lost customers back. USAA has found ore in the veins of the old mine. Have you?

Some Final Thoughts

Most of us concentrate on getting new customers and retaining the old customers. All too often, we simply write off the customers we lost. Yet one of

Getting former customers back

the most proven concepts in marketing is that we have a greater chance to sell someone who has bought before.

Pull a report of former customers from your database. I think you'll be surprised at how long that list will be. Then begin a direct marketing process of contacting these current prospects. I think you'll also be surprised at how profitable a market they can be for you.

Follow-up and perseverance are the ultimate keys to successful sales—even if the sale hasn't been closed yet. In this sense, you can turn the traditional pattern of sales-to-customer service around. Serve the customers before they are customers— then all you have to do is collect the money.

Chapter Seven: Battling the Malady of Sales Prevention

> Show me a thoroughly satisfied man and I will show you a failure.
>
> —*Thomas A. Edison*

Do you have a sales prevention department in your company?

That question was posed by the publisher of *Telemarketing*, Nadji Tehrani, in the magazine's February 1994 issue. That question served as a reminder of the many mistakes I've made over the years—excuse me, a reminder of my many learning experiences.

No one is likely to admit that he or she sabotages sales and marketing efforts by treating customers badly. Or by turning sales and customer service—business functions which should operate very closely—against each other.

These things seldom occur on a conscious level. But ignorance in these cases is not bliss. It's a recipe for business failure.

One of the most valuable results of cultivating a client nexus is that you're much less likely to do things that might prevent existing sales—or future ones. By treating sales, customer service and repeat sales as a seamless process, you instill disciplines that avoid problems.

That said, negative reinforcement can be as effective as positive reinforcement. Looking at common mistakes can be useful.

This chapter is going to talk about how not to serve customers. If you identify with the key categories within this chapter, you may have an opportunity for change on your hands.

The three kinds of salespeople

I hope to stimulate thought about your service/sales process by reviewing a number of typical mistakes that may be occurring in your operations. These mistakes usually have to do with the tensions that sometimes crop up between sales and customer service functions.

Another point: Many of these mistakes are what theologians call sins of omission (things you should be doing but aren't), as opposed to sins of commission (things you shouldn't be doing but are).

Sins of omission are harder to trace—but they can be every bit as devastating.

"Keep Their Noses to the Grindstone"

Many sales managers think they need to be constantly pushing their sales personnel to be doing more or doing better. In fact, it seems to be a part of their job description. Unless they're breathing down the staff's collective neck, they aren't doing their job.

As a result, many salespeople are managed with too heavy a hand. They're pressed to make calls, visit customers or leads, sell units. They aren't pressed to find out what the customers or leads want—and why.

I'm not saying that salespeople don't need a bit of a push at times. Subpar performers will sometimes use relationship building as an excuse for not closing. But many companies push too hard, too often and in the wrong direction—which can lead to a sales force that trips over dollars picking up dimes.

I generalize salespeople—and, to a lesser extent, customer service people—into three categories: Shooting Star, Steady Eddie and Super Pro.

The Shooting Star is a cyclone of activity that, like a giant storm, leaves a lot of wreckage behind. Most shooting stars resign within a year or two, unless they are used strictly for opening new business.

Steady Eddie, on the other hand, will never lead the pack in sales. However, you can always count on Steady Eddie for a specific amount of business month in and month out—never much more and never much less.

The Super Pro combines the selling ability of Shooting Star with the thoroughness of Steady Eddie.

Regardless of which category he or she occupies, every salesperson needs to use customer service as a tool for doing business. Each kind of salesperson can emphasize a different aspect of the client nexus.

Rather than pressuring the Shooting Star to become good at account servicing, acknowledge this individual's strength in getting new business. Like a reconnaissance specialist in an army unit, he or she will be good at identifying customer needs and marketplace issues.

Although a Shooting Star may have a short life span, you can shorten it by demanding what cannot be delivered. Properly managed, a Shooting Star can create a lot of revenue.

Likewise, don't continually pick on Steady Eddie to deliver more sales. Over time, this will depress Eddie's level of confidence, and the regular stream of production soon will decrease. Accept the fact that Eddie will deliver you only so much business per month, but you can always count on that business.

Steady Eddie is the best candidate to bridge the gap between sales and customer service. Allow him (or her) the latitude to spend time with existing accounts, because Eddie's loyalty quotient is usually quite high.

You may want to design a sales contest that incorporates client satisfaction and repeat business, thereby giving Eddie a chance to claim the honors occasionally.

Super Pro's problem is usually a bit different. You seldom need to push this person because everything is usually right on target. The result is that this person often feels neglected.

Nurture this employee on a well-rounded basis, because she (or he) often will be a candidate for promotion to management. Seek out opinions on product development and operations. Ask if there are any projects in which Super Pro would like to be involved.

Managing different sales personalities

Alleviating mid-career crises

This kind of employee is usually very task-oriented. Explain the client nexus and ask her (or him) to develop accounts along its arc.

"Don't Integrate Education"

This is an all-too-familiar mistake. Managers brought up in the regimented corporate world of the post-World War II era were often taught that salespeople should only go to sales, product and motivational seminars; service staff should only be sent to service-oriented sessions; etc.

Just as I suggested that the Super Pro salesperson may eventually turn toward management, I say that even the best customer service personnel may want to move away from the phones (or letters, or e-mail, or whatever).

The best managers accept the fact that their best employees have hopes of climbing the ladder into new positions. For a substantial number of people, a career first represents a challenge, then turns to comfort as the challenge is met—and finally turns to boredom and frustration over its increasingly repetitive nature. Many great sales and customer service people experience a mid-career crisis after seven to 10 years of a successful track record.

Integrating the educational experience can help alleviate some of these psychological, locked-in-a-box feelings. Send your sales staff to a class on management, send your service staff to a sales seminar, send your telephone operator to a sales class—and send them all to classes on motivation. For those who do want to progress into new areas, you are providing some of the basic training they'll eventually need. Others will come away from such experiences with a refreshed appreciation for their current job. Plus, everyone will feel more a part of the whole, and that always translates into better employee morale and client relations across the board.

"What We Do Is What You Get"

Today's business world is more dynamic than ever. Satisfaction with the status quo no longer keeps you even—you're actually going backward. Just because certain markets have done well for you in

the past does not guarantee their continued success as sources of revenue. Keep on top of client needs and new markets, as this is what will keep you on the cutting edge of the competition in today's economy.

Every business should have at least one or two new products or programs under development and testing at all times. Your existing clients are great sources for ideas. They'll be more than willing to elaborate on what they need from you. All you need to do is provide them an opportunity and listen attentively—this is another example of the sales and customer service functions coming together.

"You Get It When We've Got It"

A simple question: Do you work on your client's time frame, or your own?

Suppliers to the auto manufacturers found that if they could not meet the requirements of just-in-time delivery to help cut the manufacturers' inventory costs, they no longer could consider themselves vendors to the industry. Most have achieved this by using the customer service function as a kind of pulse monitor.

All too often we think we know what customers need from us.

But, if we haven't asked, we have absolutely no idea what they need. And this remains true, no matter how long we've been in the business or how many hits we've had.

Service reps dealing with customers are in a unique position to assess those customers' needs. Here are some questions that should be asked. (I've broken this into two lists: one for product-oriented businesses, one for service-oriented businesses. Modify them for your particular business.)

Product-Oriented Questions

1) How much inventory of our product do you maintain?

2) How would that break down into days' supply?

3) Does that level of inventory meet your operational goals?

Determining service needs

4) Is there anything we could work toward that would help you meet your goals (i.e., shorter lead times, easier ordering)?

5) Does our shipping method, product packaging, bulk packaging, etc., meet your delivery and stocking requirements?

6) Do you need assistance in inventory control?

7) When you need assistance, is our customer service department meeting your needs?

8) Does our invoicing integrate well with your accounts payable policies and procedures?

9) Any other comments you would like me to pass on to management, account executives or office staff?

Service-Oriented Questions

1) How frequently do you need our services?

2) Would you classify these as emergency needs?

3) Does our response time meet your requirements?

4) Is there anything we could work toward that would better serve your needs?

5) Is there a way to reduce your "emergency" calls?

6) When you call for assistance, are your concerns being addressed promptly?

7) Does our invoicing integrate well with your accounts payable policies and procedures?

8) Any other comments you would like me to pass on to management, account executives or office staff?

By keeping in regular contact with the customer, you gain critical insight into business cycles and trends—and how orders follow.

It's a go-go world out there, and if you can't keep up with the client's needs, you'll soon be gone-gone.

"Promise Them Anything"

Overpromising and underdelivering are two of the most common causes of client departure. This is one of the most common clashes between sales departments and customer service departments. Typically, customer service will be frustrated because salespeople promise specific levels of service that are difficult—or impossible—to meet.

When was the last time you held a total staff meeting to discuss the expectations of the clients and the capabilities of your company? To help make this kind of meeting productive, use a flow-chart model that tracks the customer service needs of important accounts across their life spans.

After receiving tracking reports from customer service personnel, management should then compute the findings:

Customer _____

Sales rep _____

Month/Year _____

Estimated monthly customer
 service expense $ _____

Sales revenue for the month $_____

Service expense to revenue _____%

Divide customer service expense by sales revenue:

Standard customer service allocation _____%

This is the percentage built into your pricing.

Ratio of projected expense to actual _____

Divide service expense to revenue percentage by allocated percentage.

If this is more than 1.00, then expenses are exceeding budget. If it is less than 1.00, expenses are coming in under budget.

Analysis

Based on your ratio of projected expense to actual, is there any action necessary to reduce expense, increase service or adjust your budget factors?

Know what service can be delivered

The key to successful sales management

Does the customer service demand within the month correlate to the monthly sales revenue?

Do you need to take into account any unique factors, such as unusually low or high sales?

Based on this summary, do you need to take any actions? If so, identify them.

Once this type of tracking system has been implemented, management can track the customer service needs of each identified customer on a life-cycle basis. Using a standard connect-the-dots graph, use a separate line to chart service expense and corresponding revenue. Watch out for jumps in service expense without correlating jumps in sales—or the reverse—as indicative of the need for further investigation.

Hold salespeople accountable for promising service that can be delivered—and customer service people for delivering it. As my daddy used to say, "If we know what they want and what we can do, the promise can be truthful!"

"My Job Is Managing"

Too many sales managers no longer understand the market from which the sales are derived.

Recently, I saw the résumé cover letter of a very successful advertising sales professional who was vying for a sales management position. The first sentence of how he would manage was "to set producer goals and manage their achievement."

When I asked him how he would accomplish this, he began a litany of call reports, sales meetings, etc.

If I were to rewrite that letter, the first sentence might go something like this: "As a sales manager, I would spend a minimum of one day per month in joint sales calls with each producer."

Sales management requires up-to-the-minute knowledge of the markets and the clients. You can't get this sitting behind a desk and reading reports.

Despite the fact that nearly everyone agrees that a desk jockey isn't the most effective manager, too many managers are loath to go out into the field—

or to hit the phones themselves. Their experiential advice and direction is often years out of date.

A good economy can disguise their ineffectiveness through the phenomenon known as accumulated order taking. But, in a tough market that requires persistent salesmanship, the camouflage usually fails. Once the damage is done, repairs can take years.

The Infamous "Survey of One"

Have you ever been really excited about a new marketing concept? I mean really, really excited! When you thought about it, did visions of a financially secure retirement bubble into your consciousness? And, upon implementation, did it crash to the ground, smashing those visions into smithereens? If you're anything like me, a lot of money probably went down the drain—not to mention the loss of the anticipated revenue.

Statistics prove that new is most likely to fail. Just look at new business start-ups. Nearly 90 percent end in closure or bankruptcy. Yet every budding entrepreneur starts his or her business with dreams of success.

True, some of these failures have to do with mismanagement. But it is my opinion that most fail due to a lack of thorough market research.

One of my greatest mentors was the owner of a national manufacturing company. As the manager of eastern sales operations, I frequently approached him with ideas for new products that I was convinced would cause sales to skyrocket. The first time I approached him with the youthful zest of a new idea, he asked me about the reaction of our customers to this idea. Having talked with a couple of my "top" customers about it, I quickly replied that they all loved the idea and couldn't wait for it.

He said, "If you're sure it's a winner, go ahead."

Several months later, as we discussed the reasons behind the failure, he told me that I had learned the lesson of the Survey of One. Running a new idea up the flagpole with a few friends or clients doesn't constitute effective, thorough research. (And this doesn't just apply to new product ideas—it

Conduct thorough research

Managing revenue per employee

applies to any major change in the way you manage products, make sales or service customers.)

A good rule of thumb is to seek the reaction of at least the top 10 percent of your clients, the bottom 10 percent of your clients and each of your employees who would be involved.

Whenever possible, arrange that the replies be written and anonymous. This dramatically increases the odds of getting honest, objective feedback. Too often, we seek the opinions of friends and associates who may give us faulty feedback—they don't want to hurt us with the truth.

I would love to say that my Survey of One lesson was learned well—and that I never repeated that initial mistake. But I can't. More times than I would like to remember, excitement has overpowered judgment and I've plowed forward into failure on the basis of a Survey of One.

"The More the Merrier"

Is revenue a little down this year? No problem! Hire another salesperson, or two or three. Retail businesses refer to this as *flooding the floor*. I won't mention what I call it (wouldn't pass the censors).

Management gurus talk until they're hoarse about the importance of managing revenue per employee. Before adding to your sales department, examine the current revenue per salesperson. It's probably too low. Hiring more people, who will probably produce less than desired revenue, will only serve to exacerbate the problem and increase the overhead.

The answer here is to search out the causes of the low production and fix them. Many owners lack the objectivity and brutal honesty required to find and fix the problems. You may wish to consider having an outside consultant perform an evaluation and recommend solutions. But before you throw good money after bad, make a commitment to follow through on the necessary changes that the consultant will bring to the table.

Staffing Analysis

Most companies fly by the seat of their pants when it comes to adding sales and service staff. This navi-

gational system can put a company out of business sooner than any other.

When you consider how long it takes to recover your investment in the training of a new sales employee, hiring thoughtlessly seems like a foolish indulgence. Some industries claim that it can take up to five years before they start making a profit from revenue generated by a new salesperson.

Many experts suggest complicated formulas for determining when to add sales and service staff based on revenue and expenses per employee. I'd like to offer a simplified checklist that can help management determine when to add sales or service staff.

- At the end of any given week, leads that have been supplied to the sales department have not yet been contacted. *Sales*

- Management is receiving phone calls from prospects wanting to know when a salesperson will finally contact them. *Sales*

- Existing clients are complaining that they never see anyone from your company. *Sales/Service*

- Clients complain that they never get through to your customer service department; the lines are always busy. *Service*

- Orders are slow in being processed. *Sales/Service*

- Your telephone receptionist informs you that calls to sales or service departments are flashing on hold for lengthy periods of time. *Sales/Service*

- You have unused production capacity. *Sales*

Each of these items can indicate that additional personnel are needed in either sales or service. However, please rate the performance of your existing employees first, since these points also can indicate a performance, rather than a staffing, problem. If existing personnel are not performing, adding more staff will only complicate, rather than resolve, the problem.

A checklist for determining when to add staff

Solve performance problems first

John Jaques, a noted consultant to the insurance industry, uses his Mack truck theory. It's tough, but it goes like this: "I look at each staff member, envision them leaving the office and being hit by a Mack truck, and then ask myself if I need to replace them."

Chris McVicker, the owner of a successful insurance agency in New York, uses a slightly different analogy. "Each month I envision myself on a sinking ship with all of my sales producers—let's say there's 10, plus myself. However, the lifeboat only holds nine. Which nine people are welcome aboard, and which two aren't worth saving?"

These are both brutal evaluation criteria, but each has proven successful in determining whether or not the staff is performing up to the management's expectations. Remember, adding staff is not a solution for poor performance. Solve the performance problems first, then see if you still need more staff.

One Light at the End of the Tunnel

When it comes to building a client nexus, Opal Singleton is a legend in the making. In the late 1980s, Opal was the western regional sales manager for what was then one of the nation's largest inbound and outbound telemarketing/teleservicing centers, Cincinnati Bell's NICE Corp. in Ogden, Utah. Prior to her departure, Opal had become head of the corporate division that served such major clients as Proctor & Gamble and Microsoft.

Always searching for a challenge, Opal went on to design and set up the telemarketing program for Hughes' DirecTV Group, which brought the 18-inch satellite dish to the public and now bills more than $45 million just in telemarketing. Following that start-up, Opal went on to bring that same concept to the international marketplace.

"After a million and a half frequent flyer miles, I quit to pursue the entrepreneurial spirit, and headed up the international direct response product distribution for Santa Monica–based Williams Worldwide Television, a $100 million company owned by Katie Williams. Basically, my operation takes products that have sold on television in the United States and markets them into 55 other coun-

tries." Asked about the receptiveness of the international market to direct response, compared to the United States, Opal replied, "The only limitation is your own energy. It's like feeding a hungry lion. It's a tremendously fast-growing market that affords a huge, huge opportunity."

Talking to Opal is like opening an encyclopedia of marketing, and I could devote an entire book to her exploits with DirecTV and adventures in the international marketplace. However, what I really wanted to find out from her is what sells and what doesn't. Although personally responsible for selling hundreds of millions of dollars' worth of product via television, Opal is quick to admit that not every project is always successful, regardless of the due diligence beforehand.

"Over the years," says Opal, "numerous products of real value to the consumer fail to sell. I'm talking about personal protective devices for women, like warning sirens, mace, pepper spray and stun guns. Same thing with child kidnapping devices and the radon detector for inside your home. These are the things that are predicated on fear-based selling. Well, most people really don't want to know about radon, thank you; most women don't want to envision themselves as being in a position to need mace; and nobody wants to imagine someone kidnapping their child."

Are there any rules of success to direct response marketing? "More and more," Opal told me, "as I look at potential product to feed our network, I am absolutely convinced that the number one criteria is that people do not buy product, they buy how they see themselves. If you can play to an innate desire of theirs, they will have their credit card out of their wallet and be spending their money before you know what happened—even though the product might only become another dust collector. But if you can identify and trigger one of these innate desires, so that they are able to see themselves in that innate desire, you've got a sale."

Opal went on to identify what she considers some of the specific innate desires: "I'm going to be thin, I'm going to exercise, I'm going to diet, I'm going to get organized, I'm going to get out of debt, I'm going to get control of my life, I'm going to quit smoking,

People buy how they see themselves

Evaluate your inventory

I want to get away, I want to get in touch with myself. The key is not the product—the key is to trigger and satisfy the innate desire." Opal giggles as she adds, "The product tends to end up under the bed or in the closet." Apparently, it's one thing to envision yourself using the product when you purchase it, but the actual implementation of that vision is another story.

Some Final Thoughts

These are a few of the common mistakes that can cost us sales. Many of them are simply human nature.

Turning it around, success in sales requires nothing more than common sense. At least twice per year, take time to evaluate the basics of your sales and marketing efforts. Brainstorm new ideas and review the old ones. Seek out constructive criticism from your clients and don't be afraid of their comments—a good dose of reality from a client can put you back on the track to success.

Depending on the nature of your business, the concept of inventory may be quite common or a little bit strange. Yet we all know that most successful retail and wholesale businesses rely on their annual inventory.

It's time to see what sold and what didn't, what spoiled and what remained fresh. The results enable companies to make the tough decisions of dropping a line, reducing stock levels or simply throwing out the bad. Likewise, they also are able to improve profits through the addition of new items, increased stock levels of fast-selling items and decreased carrying costs.

In the service industries, your sales and marketing evaluations are your inventories. Build on what works, discard what doesn't and test out the new. It works. It really does.

CHAPTER EIGHT: INTEGRATING PUBLIC RELATIONS AND CUSTOMER SERVICE

> I don't care what they call me as long as they mention my name.
>
> —*George M. Cohan*

Webster defines *public* as "of, concerning or affecting the community or the people." *Relations* is defined as "business or diplomatic connections or associations."

Unfortunately, too many companies define public relations as sending out a story on employee promotions with a photograph attached. Even more don't even do that!

There are hundreds of articles on the how-to's and the 1-2-3's of public relations, but very few take the time to actually examine what the concept of public relations really is and the role of your company within that context. In this chapter, we'll consider how to build publicity for your company—and follow up with a customer service effort that can make sense of the expenditures.

First, let's divide PR into three very distinct categories: the trade public (your peers), the general public (the overall marketplace) and the business public (your specific market). You need to consider all three when you're trying to integrate PR into your client nexus.

The Trade Public

Many will ask, "Why worry about relations within my industry?" There are any number of reasons, a few of which might be:

Solid trade relations increase your value

1) **Perceived Value**. Every day we are seeing businesses bought, sold and merged. We also are seeing businesses not being bought, not being sold and not merging. Public relations within your industry can make the difference in your company's perceived value. If a competitor is continually hearing about "your company," there develops a psychologically enhanced value—which can translate into added dollars if you sell, added advantage if you are trying to buy or added leverage for a merger.

2) **Improved Employee Morale**. Everyone likes to be associated with a winner, and there is an inherent value to your operation when employees read and hear about their own agency within the trade publications.

3) **The Leadership Factor**. Most successful businesses are pro-active, rather than re-active. Solid public relations within your trade can position you as a leader to be emulated, rather than the weakling that is always reacting to someone else's idea or action. This positioning as a leader within your industry is an invaluable sales tool when prospecting for new clientele. Just like employees in item two, your customers want to be associated with a leader.

Building Industry Relations

Trade publications are the primary vehicle for public relations within any industry. Ranging from four-page newsletters to glossy magazines, nearly every industry is filled with trade publications. But how many of you have a list of all pertinent publications, their addresses, phone and fax numbers, and names of editors and key reporters? If not, go through that pile of magazines in the corner of your office and begin entering all that information into a computer database. Once you've completed that task, don't give yourself too many pats on the back—because there's more to do.

Call each publication and talk with the publisher or editor. In many of the smaller publications, the publisher is the editor and often the writer. In larger

publications, the publisher may be somewhat removed from input on specific articles or columns, and the chief editor is a better contact.

Just like a cold sales call, try to find some common ground. Introduce yourself and perhaps mention a recent article and how it may have been of help to you. Tell them a little bit about your company, your products or services, and your unique differences. Explain that you are available if they ever need any assistance on an article, and that you would like to occasionally submit information for publication. Start to develop a relationship.

You can give yourself a couple more pats on the back at this point—but don't get carried away, because most people falter before the next critical point.

After concluding the initial conversation, calendar three more calls over the next 12 months. Only by following through with continued calls will you make an impression that can help your public relations efforts. Treat each publisher/editor/writer to the same persistence that you would apply to a potential client. It only takes a few minutes here and there during the course of a year, but it makes a vital difference in whether you manage to get any articles or information into print.

As far as what to submit to trade publications, considerations might be:

1) **Information related to your employees**—promotions, classes being attended, new hires, awards, signing of major deals, major milestones in tenure, etc. These items are usually placed in columns about people in the industry, and most publications appreciate a photo accompaniment.

2) **Information related to your products or services**—major awards, new marketing programs, success stories. Often this can be a cooperative release with your product suppliers, franchisers or companies you represent. Their PR department may even handle the story writing and the releases. However, don't take a wait-and-see attitude. Ask them if they are going to do a release and when. If they aren't planning one, do it yourself.

Submitting information to trade publications

3) **Association activities**—I hope you belong to at least one trade association within your industry. Put out press releases about your company's involvement. This can include participation in special panels or programs, election to office, etc.

4) **Commentaries**—ranging from letters to the editor to "op-ed" articles (many publications accept in-depth commentaries on timely topics, which are generally positioned opposite the editorial page), this type of writing reflects your professional opinion on topics of interest, and positions you as an expert.

5) **Firsthand reports**—sometimes a crisis can impact your industry, and you can offer firsthand observations and information-gathering to the various publications. This is much appreciated by the writers, and can be valuable in helping you place later articles in their publications.

My suggestion on association activities stresses the importance of involvement. Don't just be a member. Be a participant. Take part in the elected or appointed offices. Volunteer for various panels and commissions. All this activity helps to further the relations of your agency within your industry. You become known as a leader and a doer.

The General Public

A little more involved than relations within your industry, but well worth the effort, is relations with the general public. This is oriented toward the entire community or region where you do business. As such, it often goes beyond your specifically targeted market, but is invaluable in building the public perception of your firm.

Much of what is released to the trades also can be simultaneously released for the general public, although it is less likely to be printed due to the industry-intensive nature of trade releases. Still, you never know when an editor or a newscaster needs to fill some space and your release just happens to be handy.

The best approach to the general public is to supply items of general interest within your community. Every business has areas in which it can be helpful. Insurance agencies could talk about home safety or insuring the teenage driver. Auto dealerships can release tips on safe travel. Medical offices can put out articles on wellness, accounting firms on tax tips, etc.

The big trick is to get it printed! And that takes us back to the basics.

1) Start to database the address, phone, fax, editor and writer listing for all news media in your community. Start with your daily newspapers, expanding to local radio and television stations (and don't forget cable TV operators). Then expand the list to include weekly newspapers, local or regional magazines, even newsletters put out by area merchants (e.g., many real estate companies publish monthly newsletters of general interest). Be sure to categorize this list separately from your trade media listings.

2) Just like the trade media, contact each of these sources to begin developing a relationship and positioning yourself as an expert to whom they can look for help. Again, calendar yourself for a year's worth of follow-up calls and at least one personal visit. A side benefit is that each of these contacts also might be a potential customer.

The smaller the town, the easier this is to accomplish. Many smaller markets have only one newspaper, one radio station and maybe one TV station. The larger the population base, the more difficult the task of getting to all the various news media and developing relationships—but it is not an impossible task. Start small with the ones that specifically address your market area.

For instance, in Los Angeles, the *Los Angeles Times* covers all of Southern California, and developing a relationship with an editor is nigh unto impossible. However, this particular newspaper has satellite offices strategically located in regional areas, and it is fairly simple to make contact at one of these smaller offices. Plus, competitive newspapers seem to center in specific areas.

Developing mainstream media connections

Alternatives to traditional public relations

If, for example, you have a business in the San Fernando Valley, cultivating a relationship with the Los Angeles *Daily News* would probably be more beneficial than with the *Times*, because the smaller paper is known for its coverage of the suburban Valley area.

In major markets, it's also a good idea to try to identify specific columnists or reporters who concentrate on business news, as well as the lifestyle writers. You'll generally find a much warmer reception here than with the hard-news reporters.

News directors of radio stations are a really good bet—particularly if you let them know that you are available for interviews if needed to augment a story. Good radio reporters know that a sound byte from an expert makes the story much more interesting. A good time to send releases to radio and television stations is toward the weekend. They generally run a skeleton staff on weekends and often need filler material for their newscasts.

Television stations should be treated much the same way as radio. Keep in mind that they, too, are eager to build their list of experts who are willing to go on camera when major stories break. For instance, let's say a story has broken that somehow relates to your industry. Most news directors will immediately look to their Rolodex of available experts for comment. Are you on their list?

Most mid-size to larger cities also have one or more magazines dedicated to life in their city. These are ideal for many of the longer, special-interest articles that you could submit, since magazines are more feature-oriented, with less emphasis on hard news.

Breaking away from traditional PR press releases, here are some other alternatives in managing your general public relations:

- **Civic Memberships**. Most business owners look at their membership in the Rotary, Optimists or Kiwanis clubs (to name a few organizations) as networking or community marketing. Although such memberships are good marketing and networking, try to think of them more in terms of public relations. Just as with trade associations, such memberships are only as good as your level

of participation. Seek out elected offices, serve as a spokesperson, take on special-interest committee work. Among the personal benefits you may experience, other members will think of you as a mover and shaker, becoming reliant upon your guidance. Not a bad image for any business person. Plus, the more active you are, the greater the chances of you being seen as a spokesperson for your group when local media covers your activities.

- **Charity Work**. Nearly all the above-mentioned items under civic memberships apply to charity work. One distinct advantage is that you don't even have to look for a charity to join—you can start your own. Just pick a local shelter, hospice or any other nonprofit organization that benefits your community, and build your own fundraising program for them.

Although the list of how you can build your image by managing your public relations is endless, most business owners make one major mistake—participation in various activities is frequently limited to how much the owner or executive management can do. They forget about the impact they could have on a community if every employee was urged to participate in at least one group or program. Offer to pay their membership fees and add civic-mindedness to their annual reviews.

In this scenario, everyone wins. The employees feel good about themselves, the business maintains high visibility, and the community in which you live and work is all the better for it.

The Business Public

A lot of your efforts with the general public and the trade public already begin to pay off here. The general public also happens to include your clients, and trade stories definitely can be used to enhance your sales presentations.

However, even allowing for all that, it's time to roll up your sleeves and go to work on your business-oriented public relations efforts.

Urge employee participation

Conventions provide a valuable market

As before, add a third category to your media database that includes all the aforementioned information for local business newspapers, business editors of regular newspapers and all the trade publications that cater to niche markets you serve. For example, if you do business with dentists, make sure that all their publications are on your press release mailing list. You may already know many of the publications, but it is a good idea to check with several clients within each category to find out what periodicals they tend to read.

Large markets also may have a radio station or two that cater strictly to business and financial news, and don't forget the cable companies. Build your relationships with each of these free publicity sources in the same manner we've discussed in the other sections.

Unlike the other two categories, you must rely more heavily on press releases, since there usually aren't organizations or associations that you can join, although some of the associations catering to specific markets may have auxiliary memberships available for vendors/suppliers. It's worth investigating and possibly joining, but don't expect the involvement and exposure found in the other areas. Most such memberships are primarily designed to market exhibitor space at their annual conventions.

Speaking of their conventions, there's gold to be mined if you can get scheduled as a speaker at these annual events. Not only will you have a captive audience, but you also might get picked up by the reporters covering such conventions for their trade papers. Whenever you have a speaking engagement (this applies to the other categories, as well), send a press release indicating that you were a speaker at such and such a group, then add a brief synopsis of your topic material. A good way to open the release is with a quote attributed to yourself, and always include a picture. (Note: Although I am editorially using *you*, this applies to everyone on your staff.)

Another great method of building your business public relations is with value-added seminars. Every year there seem to be several hot topics within just about any industry that apply to your clients. Arrange a seminar for clients and prospects to en-

lighten them on these topics and how your company can help. Your own trade association can usually assist you in finding speakers or material for such presentations.

But don't stop with just the seminar. Put out a press release and invite the media to attend. They may or may not attend. They may or may not print the release—but, then again, they just might do both. In either case, you never know unless you expend the effort. Plus, if you have a relationship with editors and reporters, you can follow up with a personal call.

A Case Study: Hikari Products

One of the foremost proponents of—and experts in—integrating public relations with customer service is Robert Reed, who was president of Hikari Products Inc. from 1985 through 1994.

Not a household name, Hikari is known primarily within the beauty salon industry as the Rolls-Royce of scissors and other cutting tools. Hikari scissors often would cost a stylist up to a full week's worth of earnings.

Hikari originally had been the distributor of Japanese-manufactured scissors. Eventually, it developed its own product line and manufactured in the United States.

Reed learned the secrets of selling to the beauty industry from some of the top names in the field. As a young radio advertising salesman in Los Angeles during the early 1970s, he walked into a fashionable hair salon that served wine from a water cooler and played rock and roll music in the background.

"This is the industry for me," Reed recalls thinking to himself. Starting as a consultant and trade show emcee, he went on to work for Jheri Redding, the legendary founder of Jhirmack and Vidal Sassoon.

During our first meeting, one comment Reed made about Hikari left an indelible impression on me: "We don't spend a penny in advertising. Everything is done through public relations."

He went on to explain that, "Our story is too complicated for a simple advertisement. Feature sto-

Continually getting free press

ries better position us as experts in the field and allow the space for our story to be told. So, the only mediums available were public relations and trade shows."

The complicated Hikari story had to be heard by two groups: individual stylists and the companies that sold hardware to the beauty industry.

"Our competition wasn't the other scissors manufacturers' our competition was the 1,200 other items that were being sold by the independent rep organizations who represented our products," Reed liked to say.

To accomplish the task of continually getting free print, Hikari hired Esche & Alexander, a professional public relations firm in Oceanside, California. Each year, Hikari would set up a list of PR objectives—messages that needed to be delivered to stylists, sales reps and prospective distributors.

Esche & Alexander brought editorial contacts and relationships to the table—but those, by themselves, were not enough. Hikari's approach had to become issue-oriented.

Working with Reed and his people, the PR firm found out that if they addressed industry issues, rather than self-promoting technical details, the market would respond.

Issues could be artistic, such as endorsements by major styling artists; or educational, such as explanations of state board guidelines that impact the salons.

"In fact, editors and writers actually get inquisitive about the issues, and contact us for even more information—which translates into more print space, more exposure, more promotion," said Reed.

One of Hikari's most successful issues—and a personal interest of Reed's—was repetitive stress injuries and carpal tunnel syndrome. These work-related disabilities affect many hair stylists.

"One thing that I regularly began to notice at trade shows and salon visits was the high number of stylists that were wearing various types of wrist constraints," Reed said. He began researching hand movement theory with an orthopedic surgeon.

Through that, Hikari developed an injury prevention video training program and a rehabilitative training program. Both were introduced with extensive public relations—press releases, personal appearances and lectures. The publicity resulted in a major insurance company calling Hikari in as a consultant to help a national chain of beauty salons develop a customized injury prevention program.

The overall public relations process involved a weekly conversation between Reed and Esche & Alexander to track performance against the annual goals. Hikari used a simple order tracking system that allowed it to get a general idea of how many inquiries were generated by PR.

Reed's approach to public relations is simple, but requires a commitment to consistent effort. He's taken that commitment to his new company—a marketing and customer service consulting firm for companies in the hair care and cosmetics industries.

"Public relations is a way to connect with the customer in a way that is not sales-oriented, but allows you to achieve your sales goals. It connects at a whole different level—one where the customer asks you questions, rather than you pitching your product," Reed says. "It's a far more interactive approach to selling. Advertising is where you tell your story. Public relations is where someone else tells your story for you.

But always remember this one rule: Every press release must include the means by which the reader can contact you. When that contact is made, selling is far easier because the customer has already developed a trust in your expertise."

Where Customer Service Comes In

The most common—and, in many cases, most legitimate—criticism of public relations efforts is that results are difficult to quantify. It's tough to track exactly how many sales your publicity efforts actually generate. This is where a well-run customer service operation can come into play.

In many cases, successful publicity efforts will turn into what customer service pros call no-code con-

An interactive approach to selling

How to track inquiries generated by PR

tacts. Customers or prospective customers will call you to inquire about something—or even buy a product—but they won't have a direct mail piece or other traceable marketing tool that referred them. They'll probably say they read about you in the paper or heard about you on the radio.

If you haven't prepped your customer service staff, these nonspecific answers may be lost in the reporting process.

If you're going to commit to doing publicity, commit your customer service staff to doing the minor additional work of tracking nonspecific referrals. Create a special questionnaire or menu that allows a customer service rep to ask a few pointed questions about how the client heard about your company or product. If the contact can't remember where he saw it, try to establish when he did. If neither, try to establish what the coverage said.

You may not be able to keep all publicity referrals from falling into the no-code void, but a good publicity person will be ecstatic about getting even a limited response from your front-line customer service staff—it's more than many companies provide.

I have one major recommendation to make: Share your publicity clippings with the customer service department. It never ceases to amaze me how many companies will work hard at getting media coverage of their goods or services, and then not let their customer service people know what to expect. That's just as wasteful as dropping a direct-mail piece and not saying anything about it to your reps.

Here are a few simple suggestions for script entries that will help your customer service people track the origin of sales, referrals and inquiry calls.

- We appreciate your interest. Do you happen to remember where you first heard about our company/product/service? (If the contact can say at this point, there's no need to go further.)

- It's great that you read about us. Do you recall whether it was a newspaper or a magazine article?

- It's hard to remember what magazine (newspaper/radio/TV show)—but it really

helps us to know. There have been some recent articles about us in *Good Housekeeping, Ladies Home Journal* (or shows on USA or Lifetime—this is why your customer service team should be kept abreast of what's happening). Do any of these ring a bell?

Of course, you need to include these script entries on your order form or processing system near the no-code entry.

But the main point is still keeping the reps informed of what to expect. Regardless of how extensive you make a questionnaire, if the customer service people have no idea of what publicity is out there, they won't be able to track origin.

I think you've got the idea that in order to minimize no-codes, the customer service personnel need to take a few minutes to generate the information. It's a funnel approach that starts with broad, general questions and keeps narrowing it down with additional, more specific questions. It's a little extra effort, but it definitely can pay off by helping your public relations team to align its efforts more closely with your demographics—one more step toward nexus with your clients.

A Publicity-Generating Guarantee

Hallmark Greeting Cards developed a simple customer service policy that generated a lot of publicity for its company-owned Gold Crown stores. The Hallmark Right Card Guarantee says that if the store can't help you find just the right card, you may choose a free card on your next visit to any Hallmark Gold Crown store nationwide.

"The Right Card Guarantee puts the customer first. Hallmark Gold Crown retailers want to not only meet, but also exceed the consumer's expectations for outstanding service," said Wayne Strickland, director of planning and marketing for the Hallmark Gold Crown store network.

"Also, the guarantee lets consumers discover how wide the card selection is at Hallmark Gold Crown stores and, finally, the program will give Hallmark valuable feedback about what consumers want when they shop in Hallmark Gold Crown stores."

If a Hallmark Gold Crown retailer cannot help a customer find just the right greeting card, the shopper is given a short questionnaire attached to a certificate for a free card of choice.

The questionnaire portion asks what kind of card the shopper was unable to find, and how the store might have better met his or her need. The research part of the card is left with the store, and the guarantee certificate is given to the consumer to take to any Hallmark Gold Crown store in the United States within 30 days to choose a free card.

The guarantee reflects the trend toward very personal card messages, according to Strickland. Hallmark wants any shopper to find a card specifically for him or her in a Gold Crown store.

Hallmark offers more than 10,000 different greeting card designs, right for thousands of specific sending situations. For example, Hallmark offers cards in Braille and in large print, as well as cards for African-American, Hispanic and Jewish consumers. Greeting cards for the workplace, for people in recovery and for people going through stressful times meet today's needs. Hallmark continually receives feedback from consumers through focus groups, consumer diaries, formal research and analysis of point-of-sale information.

"Today's consumer is looking for superior products, wide variety and outstanding service," Strickland says, "and the Right Card Guarantee lets people know they'll find what they're looking for at a Hallmark Gold Crown store."

Some Final Thoughts

Almost any issue can be built into a public relations hook.

Is your company a franchise? Do you represent services of other companies? Do you offer specific product lines? Most every company you represent has a public relations department or, at the very least, an assigned individual within the marketing department. How many of you can name these people?

Just like the news media, call the designated PR person for each of your companies. Introduce your-

self and explain that you want to build ongoing PR programs within each of our three categories.

Ask if they would copy you on pertinent press releases they are issuing. You can personalize them to your firm and re-release them to your media database.

Ask them if there is any way you can be of assistance to them. Maybe you can become the topic of one of their press releases.

Ask them to provide you with copies of various brochures or flyers that they have written on topics of interest within your industry. These again can be rewritten into a press release format from your company.

Hertz, the car rental leader, gets millions of dollars of free publicity every year when it issues its annual Cost of Car Ownership Study. Although this benefits every Hertz location, corporate or franchised, the smart operators contact the local media and offer statements that enable the media to personalize the story with a local slant.

You could be doing that with every release issued by each of your companies. A national release from a company stands a pretty good chance of making the papers and, by offering the local element, you can come along for the ride.

Here's a sampling of possible press release subjects:

- Accident Prevention
- Anniversaries (Business)
- Anything Unusual (Hobbies, Human Interest, Office Events, Trips)
- Automation Advancements
- Community Service
- Convention Attendance
- Foreign Trainees
- Franchise Appointments
- Handicapped Workers
- Honors
- Legal Issues

- Local Disasters
- Mergers
- New Anything (Address, Employees, Officers, Offices, Products, Techniques)
- Pricing Changes
- Promotions
- Public Service Work
- Remodeling
- Resignations
- Retirements
- Scholarships
- School Work
- Social Events
- Sports Sponsorships
- Trade Press Articles or Awards
- Training Courses Taken
- Unusual Customer Stories

Let loose your imagination on how you can begin, or improve, your public relations efforts. The best part is that PR is—relatively—cheap.

CHAPTER NINE: ENCOURAGING EXCELLENCE IN YOUR ELECTRONIC LOBBY

> Intelligence and courtesy are not always combined.
>
> —*William Wadsworth Longfellow*

Despite quantum advances in computer automation, the telephone remains the single most essential technology for effective customer service. From fax to modem to voice, it is your lifeline. If you have any doubt about that, just think back to the last time there was a phone failure.

This being the case, I often wonder why so many businesses place so little importance on the person who operates the phone.

Salespeople who call upon businesses have a saying: The owner is usually the one who is outside picking up the cigarette butts! Why? Because the owner knows that a clean, attractive entrance is crucial to getting a prospective customer inside the store.

Today, for most businesses, the first contact comes over the telephone.

The telephone is your electronic lobby—it's the source of the vital first impression many prospects receive. In some cases, it's the only impression.

That's why it's strange that the same business owner who is out front picking up the butts may not even interview the applicants for the position of telephone receptionist.

Voice mail is no substitute for a receptionist

Your Front Line

The core of my business is consulting with companies on marketing and customer service issues. But I've often ended up working with clients on their receptionists and telephone systems—because this is a place where smart people who know their business well are often at a loss. Hiring a good receptionist seems as if it would be easy, but it's not.

One memorable time, I called a medium-size firm and had a terrible time getting through. The receptionist sounded confused, irritable and none too bright. It took three calls before the receptionist could identify the person I was calling—and I dreaded calling back each time I was shuffled off to the wrong extension. I couldn't avoid the impression that the company was underfinanced, badly organized and amateurishly managed.

The person I was trying to call: the company's owner and CEO.

Your telephone receptionist is your opening gambit in the customer service game. This person—not your sales department, customer service reps or product people—sets the tone for how customers think of your company.

A side note: This is one area where technological advances have failed businesses. During the 1980s, most companies rushed to buy and implement computer-controlled automated telephone or so-called voice mail systems. These things are horrible ways to treat business leads that have taken the trouble to contact you.

In an interview with the *Dallas Morning News*, voice mail inventor Gordon Matthews said, "The biggest mistake is using voice mail as a company's receptionist, forcing callers to work their way through a maze of menus instead of having a human direct the initial calls."

(Such systems also may be in violation of the Americans with Disabilities Act, since they may not be compatible with telephone devices for the deaf.)

A business should use automated systems only to provide specific service in an efficient manner. It's not so bad to call an automated system to check your bank account balance or activate a credit card.

It's terrible to call an automated system when you've got a salesperson you're trying to reach, a complaint to make or a question about a product.

If your company has a specific high-call-volume function—like a bank or stock brokerage that gets lots of account inquiries—go ahead and set up a separate number with an automated service to handle those calls. On the other hand, you should use a real human being to channel incoming calls of a general nature. Even if that real person simply directs the caller to an answering machine or automated system, the caller will be less frustrated than if he or she had to navigate through a computerized maze from the beginning.

If your receptionist is calm, efficient and professional, you'll do well. If your receptionist is endearingly wacky or eccentric, you might be all right—depending on your business. If your receptionist is abrasive or dense (or other-than-endearingly wacky), you're losing business.

A comparison that illustrates this importance: Restaurants pay particular attention to hiring their hostesses. A hostess's smile, personality, friendliness and ability to function under stress are important assets that predispose the customer toward a satisfactory experience.

The telephone receptionist is your hostess, your greeter. A well-trained, personable receptionist can make or break the sale before the customer ever gets to the point of buying.

Another suggestion: Include the receptionist as part of your customer service staff—not as an administrative hire, as many companies do. In fact, some companies don't even use a single, permanent receptionist; they rotate customer service reps through the front desk. Even if this doesn't work for your operation, it's important to make the receptionist feel he or she fulfills a customer service function.

John Peterson is the dealer principal at Cormier Chevrolet, a successful, high-volume dealership in greater Los Angeles. "I don't know if there's a more important position within our dealership than the telephone receptionist," he said. And when John finds a good one? Well, Joanne Lench has filled that

A receptionist can make or break the sale

Tracking systems reduce waiting time

position for about 17 years now. John, who admits to paying nearly double the going wage for the position, added, "I don't know if anyone can really teach someone how to be a good telephone receptionist. It's sort of intrinsic to their personality. Aside from being professional, they have to care about the business and the customers. They also need to have a great memory. Joanne can identify voices that belong to people who might only call us once or twice a year."

John further commented that another important customer contact position within a business is that of cashier. John's cashier is proving that the art of nurturing customer nexus may be genetic. Jessica Clark is Joanne's daughter.

The Horror of Waiting on Hold

Trendy talk of things like customer delight runs head on into another management trend: down-sizing. The two impulses are essentially contradictions, and their conflict leads directly to a customer service issue.

Staffs get cut back to the point that a customer with a problem has to wait on hold for more than an hour—interrupted every 20 seconds by a recording that bleats, "Your call is very important to us. Please hold on the line. A customer service rep will ..."

After the long wait, a harried customer service rep often talks to a fuming customer. It's not a great starting point for delight.

Of all the burdens on their time, people most resent waiting in line, according to a 1995 poll reported in the *Wall Street Journal*. Forty-one percent of those surveyed said they resent waiting in line more than any other drain on their time. Doing household chores placed a distant second, at 21 percent of those surveyed.

One tool that high-tech companies have used to reduce customer service waiting time: computer-based call tracking systems.

For example, once a customer calls in to a technical support department, the initial call handler starts a record of the incident, including customer name, company, product and so on. It's crucial that

the record include a complete, detailed description of the problem at hand. When a caller is handed off to the appropriate technician, this record, or trouble ticket, should follow the caller, so the new technician knows the entire history of the caller and the problem.

These systems provide two fundamental benefits.

First, it's easier on the customer. Callers won't have to repeat the same information each time they are transferred to a new technician, or as they move up the tier. This process is especially helpful when a solution doesn't work out and the caller must contact technical support again, or if the caller needs to perform some follow-up.

Second, companies can realize an internal benefit by using this caller database to build a knowledge base of incidents and successful solutions. Companies can collect data on the types of problems experienced with certain products. Based on this data, they can decide what needs fixing and what new features they should add to the product's next release.

The ultimate results are shorter calls (as problems can be identified quickly and matched with appropriate tried-and-true solutions) and a potential reduction in the volume of calls a company receives as products improve based on past shortcomings.

What an Exceptional Receptionist Does

Over the years, I've seen a lot of incompetent telephone receptionists and many good ones—but only a handful that I would classify as exceptional.

Exceptional receptionists use words and vocal personality to make the customer feel immediately welcome and comfortable. In a nutshell, "They cared about the caller!"

You know the ones I'm talking about; you enjoy talking with them. They keep you posted on the status of your call—you're not left on hold for two minutes wondering whether you're going to get to talk to anyone. And they take good messages if need be.

Try this little test. Inconspicuously watch your telephone receptionist. Do you sense a rush to process

Train the receptionist

the calls—or does each caller receive a good level of attention and concern? Is the receptionist smiling?

It may sound supercilious, but a physical smile comes through as warmth in the voice.

Are others hanging around and talking with the receptionist? If so, discourage the practice. Your customer's call may come second to intra-office conversation. Is the receptionist juggling a personal call with the incoming calls? Same problem: the customer comes in second.

Many businesses take pride in their dedication to employee education and training—but few train their telephone receptionists. The process doesn't have to cost a fortune, and it can return the investment many times over.

The first level of training should be about the business itself. The telephone receptionist needs a solid understanding of the nature of your business, the types of calls you receive and routing of callers to the correct department or personnel.

Invite your receptionist to attend occasional outside meetings, as well as internal training classes for the various departments. This provides an opportunity for both clients and employees to meet the person who answers the phones and vice versa. It's a relationship builder. Plus, your receptionist feels like a part of the team.

However you accomplish it, your goal should be to avoid a customer service nightmare: the receptionist who sits down with a company directory, but not even the most rudimentary knowledge of your outfit or what it does.

Many companies don't stop there.

Knowing your business and your clients is only the first step in a long-term customer service process. Send your telephone receptionist to specific educational sessions on telephone etiquette and personality development. Contact your local telephone company and ask about any educational programs it offers (most do). Interpersonal skills classes (the Dale Carnegie program is a well-known example) are an excellent investment for most receptionists.

These programs will provide your person with the tools for being an effective receptionist.

If you haven't noticed by now, I've refrained from using the term *operator*. I feel strongly that the word automatically instills a condescending tone. A good receptionist does more than process calls. He or she is the host of your electronic lobby.

Build importance into this position and it will pay you back in untold dividends. Give the position its due.

Case Study: National Corset Corp.

Here's an example of one company that was able to effectively mix the benefits of a high-tech phone system with the needs of its clients. Tucked away in an industrial corner of metropolitan Los Angeles, National Corset Corp. (NCC) manufactures lingerie under a number of brand names that are distributed through more than 3,000 retailers around the world.

One of the ways that this company differentiates itself from the competition is by maintaining inventory in a manner that enables the retailers to order and receive their stock on a very timely basis. Since most of these retailers phone in their orders, telephone management is critical.

In the early 1990s, with business booming, the company started having some problems. According to NCC president Roy Schlobohm: "With 15 flashing lines stacked up on hold, our operator would have difficulty in getting the right calls to the right party in the order received. We were losing customers. The phone was ringing, we weren't getting to it, and [customers] were getting frustrated on hold and hanging up. Several years earlier, we had bought some time by contracting for a customized message program that would play while they were on hold, but even that wasn't preventing the frustration."

Realizing that the company was losing business, CFO John Schlobohm (Roy's brother) and Director of Customer Service Eric Schlobohm (Roy's nephew) began to research automated phone systems.

"I realized that we had to make the change," says Roy, "but I didn't want to lose the personal touch upon which we had built our business. After all, the relationship with your customer is everything

An automated phone system made a difference

in business. So I had a couple stipulations: 1) whatever system we chose, a real live operator had to answer the phone—I didn't want a computer running our business; and 2) there had to be an escape hatch for the customers if they wanted to get out of the computer system."

After meeting with a number of salespeople and reviewing lots of systems, everyone settled on a system from Milford, Connecticut–based Executone. According to John Schlobohm, who negotiated the price, "It was a substantial investment—about $50,000—which we set up on a lease/purchase program. But we were also impressed with the company representatives. They worked with us to understand our needs and recommend a system that would work for us. Plus, they were here for a week to install the system, fine-tune it and train us on how to best use it."

During regular business hours, the operator answers every call. If the caller is requesting a specific individual, the operator connects the caller. If the phone rings five times without being picked up, the call will be processed to the voice mail system. Or, if the operator knows that a person is not available, she will ask the caller if they wish to leave a voice mail message.

"Even the voice mail system is personalized," says Eric. "We record our own messages, and we can do it as frequently as we want. It's a nice touch for the caller to actually hear the voice of the person they are calling."

The bulk of the daily calls are orders. Once the operator determines that the call is for the sales department, the call is directed into a customer service pool. This is a queue system that processes the calls in the order received. However, the customer retains control. At periodic intervals—both 30- and 60-second durations—the caller can choose to continue holding, return to the operator or leave a voice mail message.

Eric describes the major advantage of the system: "Where customers had been lost on hold for up to 10 minutes, we're now able to limit the holds to about two minutes maximum—even at peak times—with most calls being picked up within 30 to 60 seconds."

"We also have a lot of Spanish-speaking customers," said Roy, "and during the day the operator, who is bilingual, can direct such calls to bilingual service reps. But we needed to address that issue on our night lines. This system allows after-hours callers to choose either an English voice mail menu or a Spanish one. We never want to lose a sale due to a lack of communication on our part."

Roy goes on, "Before we implemented the system, I mentioned that we had contracted with a message-on-hold company. Over the years, our customers have told us how much they enjoy hearing about special values (many of which are otherwise unpublished). So we kept that service as part of the new system."

Each month, NCC works with the message-on-hold production company to prepare a new script. It enables the company to keep the customers apprised of recent sale items and discount packages. It also reminds customers about various point-of-purchase and training programs that NCC offers.

"It reinforces the direct mail communications, as well as what our customer service personnel are telling them," says Eric. "So, whenever they are waiting on hold, they're also being given vital and timely information about us."

The transition wasn't accomplished overnight. It took several months for customers and employees to get used to the system. The Schlobohms say that customers were a little afraid of getting lost in the computer queue, until they used the system several times. But—with careful management of the wait times—the system actually works a lot better than what NCC had in place before. So, the initial concerns (which are very common with voice mail or automated call response systems) gradually turned into enthusiastic support.

"It also has helped us with our customers in a way that we really hadn't expected," says Eric. "Before, we would take the call and they would explain what they needed. If it required research, we would have to get back to them, which meant a minimum of two calls. Now they leave us the message and we can take the time to research the answer and have all the information ready when we call them back. That cuts the phone time in at least half."

Even on hold, customers receive vital and timely information

Equipment makes a difference

Technology and Equipment

These days, many telephone receptionists and customer services reps use headsets. In most cases, this is a good idea. Headsets are comfortable and convenient—they free up a person's hands to do paperwork, make notes, etc. They also prevent the person from having to bend and twist his or her neck into awkward positions—which means users are less likely to have backaches or other problems.

But you should pay some attention to how these tools work. Take a few minutes to check the voice transmission quality from a telephone headset. Is it tinny? Does it have an echo effect? Is the voice thin and hard to understand?

A good customer service person can be crippled—either physically or productively—by inferior equipment.

Your current headset may have been purchased on price only, without any regard to quality and value. It's also possible that no one ever checked for voice quality before making the purchase. Maybe it was the best headset at the time of purchase several years ago.

Whatever influenced your company's buying decisions, you should periodically check your equipment. In the communications hardware business—as in the computer hardware business—there are dramatic strides in product development every few years. It may be time to update your equipment.

The Quality of a Voice

Regardless of the equipment, the most rudimentary tool of customer service and communication is still the human voice.

All tools, including vocal quality and technique, need to be maintained in order to do their jobs effectively. Voice is one of the key tools in business—whether it's on the phone, in person or during a media presentation.

Many of us merely accept our voice as an unchanging constant in our lives. Yet with a little understanding and some practice, we can sharpen the vocal skills of our company and dramatically impact the force of our communications.

Nearly 20 years ago, as manager of a growing automotive leasing company, I was researching specialty bus manufacturers to represent. It had finally come down to two manufacturers, either one of which would meet the service and pricing needs of my clients in the hotel and car rental industries. One was headquartered in my home state, the other was 2,500 miles away—in California.

Based on a telephone voice, I chose the California manufacturer. The sales department secretary had a soft, soothing voice and a tremendous telephone personality. Plus, she was a great storyteller. If you asked about her weekend, she could rhapsodize about the crisp evening air and star-filled skies encountered on a camping trip to the mountains. Whatever the story, it was always captivating. I invariably looked forward to our telephone chats.

Why did this voice make the final difference in my decision? This woman was also the company's primary customer service rep. Complaints would come to her before being processed to the proper department. Since all clients experience problems at some time or another, I knew that any problem calls would receive a warm, welcoming attitude, and that her telephonic talents could disarm the most hostile client.

Do your clients and prospects communicate with dull voices when they call your office—or effective telephone personalities? Do they hear someone rattling off words like a computer printout, or do they experience the subtle nuances of pleasant conversation?

This may seem like a soft issue—but it's not. Many people who rely on your customer service function will never meet your staff face to face. They will influence decisions about doing more business with you, based on telephone conversations. Ignore your staff's telephone skills at your peril! (Of course, a pleasant conversational voice is a tremendous asset in personal meetings, too.)

To steal an old line from sales: How you say something is often more important than what you say.

Phrasing, changes in pitch, inflection, pauses and pacing dramatically impact the force and the feeling of the words. If you need proof, compare your

A soothing voice is a tremendous asset

Delivery tools that improve effectiveness

own reading of Shakespeare with a reading by someone who participates in a local theater group. Same words, different impact.

Or—if you're more adventurous—try the old goodbye gimmick next time you're at a party. When you're leaving, give the hosts a smile, a hug or a kiss, and say happily, "Thanks for having us. We had a really terrible time."

Most people will never hear the word *terrible*.

Experience and Practice

In most cases, vocal improvement can be achieved with practice and experience.

An inexpensive method of vocal telephone training merely requires a tape recorder and a bit of role playing. Set aside a specific training session, during which several employees act as customers while one plays the customer service rep.

Keep the role-players in separate rooms and record the exchanges from the rep's phone. Have each of the several callers present a different kind of response—a loyal customer, an angry one, a confused one, etc.

After the conversations, conduct a constructive group critique. It's okay that the employees know they were role playing. For this exercise, the content of the rep's response is less important than the vocal intonations and voice traits a person exhibits. These things are tough to tailor—even for a training exercise.

In the review, concentrate on simple delivery tools that can improve an employee's effectiveness on the telephone. These tools can become second nature if you take the time to learn them through consistent and repetitive practice.

- **Vary your speaking speed**. No one likes a single-speed voice, also known as a monotone. Don't use a vocal cruise control.

- **Let humor shine through**. A chuckle goes a long way in establishing rapport with the other party on the line.

- **Put some inflection into your voice**. Begin sentences on an upbeat note. Ask ques-

tions with a rising inflection at the end. Normal sentences should end with a decisively lowered inflection.

- **Use your lower ranges**. The lower the tone of your voice, the more sincere and confidential.

- **Acknowledge interest in the caller**. As you listen, sprinkle supportive comments through the other person's narration. When appropriate, you can build concern and sincerity with such simple phrases as "I see," "I understand" or "I agree."

- **Develop a sense of timing**. Pace your words for maximum effectiveness, slowing down when making a crucial point. A pause, for instance, can indicate reflection. A pregnant pause can even answer a question.

Held quarterly—or more frequently, if necessary—these self-help sessions will result in dramatic improvement of individual telephone technique.

The video camera in your closet also can be put to use as a continuing education tool for improving the communication and presentation skills of your customer service personnel.

Unlike other training, that utilizes role playing—including the telephone exercises—the camera catches everything about a person's responses.

Watch the body language for confidence and comfort. In the evaluations that follow, ask the following questions:

- How is the pitch of the voice?

- Are there any distracting mannerisms in either speech or appearance?

- Is the presentation coherent and intelligible?

- How is the pronunciation of words?

- Is the facial expression happy and excited, showing genuine interest in the client?

- Does the service rep or salesperson stop to listen?

The camera catches everything

Overcoming telephone anxiety

- Are objections overcome effectively, and is the sale made?

Often the camera will point out mannerisms or speech patterns that can hinder closing the sale. Most people are not even aware of the mannerism. So awareness is the first step in correcting the situation.

Unaware, a camera caught me in a habit of covering my mouth with my hand when pausing to think of a reply. It also showed that I still covered my mouth when I would begin to reply. This unconscious habit muddled my words and diminished the credibility of my answers to client questions.

Without the benefit of a video review, I'd still be doing it.

Are You a Phone-a-Phobic?

You're having a great morning. You're on time ... no traffic ... good weather. What could possibly go wrong?

Move the clock ahead a couple hours.

You're sitting at your desk, looking at a list of calls to make and an innocuous device known as the telephone. Your hands get clammy. You feel a headache coming. Your heart's beating a little bit faster. There's a ball of dread building in the pit of your stomach. Concentration seems utterly impossible.

Welcome to the world of phone fear. Most commonly found in the sales department (particularly when prospecting calls need to be made), phone fear can strike anyone in any department.

The first step in overcoming this anxiety is to know you are not alone. Not only have I felt it at times, but some of the best sales professionals I've known have admitted this problem to me.

Like stage fright, even veterans of telephone work experience performance anxiety at some time or another. Some people experience more than others.

The difference between a pro and a rank amateur is that the pro learns to work through the hard patches.

Here are a few simple tips that can help:

- You're more likely to become anxious if you're hungry, overly tired or simply have had too much coffee. **Prepare** for your scheduled phone times by making sure you're well rested, have had a good breakfast and have kept the coffee to the essential minimum of your addiction.

- **If you're angry, reschedule** the phone calls for another time. First, you're more likely to be fearful. Second, even if you're not fearful, the anger will come through the telephone. Not a good time for calling.

- If you're making sales calls, **know your pitch**. Rehearsal counts and keeps the jitters away. There's nothing more anxiety-provoking than not knowing what you're going to say. As the Boy Scouts say, "Be prepared." If you are not involved in sales, preparedness still counts. Take time, in advance, to familiarize yourself with the topics to be discussed, and I guarantee that you'll feel more relaxed and confident.

- Take a moment before each call to **clear your mind** by taking a couple of deep breaths. This will help to keep you relaxed.

- Every so often, get up from the desk and **walk around** the office for a couple of minutes. It gets the blood flowing again and keeps you on track.

- **Use isometric exercises** to reduce the anxiety. Simply pressing your hands together for 15 seconds does wonders.

Above all, pick up that phone and make the first call—no matter what! Paraphrasing the words of a great leader: Fear the fear, not the phone.

Some Final Thoughts

As I've pointed out through this chapter, it's dangerous to dismiss developing the telephone skills of your customer service staff—including your receptionist—as a waste of time or money. It's not. Just as you invest resources in training managers or product people, you need to develop service reps.

Know your pitch

Basic telephone rules

The good news is that you can do a lot of this development in your office, using your existing phone system and during off-peak hours. The role-playing and group critique exercises outlined in this chapter will do a lot to improve performance.

Beyond that, there are a few basic telephone rules that are worth repeating:

1) **Smile**. By simply smiling as you talk, your voice automatically becomes warmer, more cheerful. Unlike talking in person, the telephone eliminates normal communication tools, such as body language, gestures and facial expression. All you have is your voice—and a smile for warmth.

2) **Be cheerful**. Every phone call is an opportunity to be of service, to help someone fill a need. Let your enthusiasm at this opportunity carry over in your voice.

3) **Set your mind to your task**. Your voice, like your eyes, can be a window to your soul. Therefore, cultivate a positive mental attitude before picking up the phone. Remember, it is an opportunity to help someone. Listening to a motivational tape on the way to work will help set your mind for the day.

4) **Be easy on yourself**. Take time during the day to recoup. If you've just handled a stressful call, take a moment to refresh your attitude before proceeding on to the next call.

5) **Be helpful**. Reach out and touch the other person with your ability to help them solve a problem or fill a need. They are seeking your expertise. Use it to provide solutions, not roadblocks.

6) **Be courteous**. Good manners are not an option. Treat your telephone contact as you would like to be treated yourself. Avoid using slang.

7) **Your mouth is for talking**. The telephone picks up a lot of sounds other than just your voice. Gum chewing, sipping coffee,

smoking, yawning and other such non-vocal uses of the mouth usually come through the phone loud, clear—and annoying.

8) **Be clear**. Successful communication requires clear input of information. Keep your sentences simple and to the point.

9) **Listen**. Communication is a two-way process. Allow time for the other party to state their business and to interact with your comments.

10) **Be yourself**. Allow your own unique personality to shine through the telephone. Be personable by being yourself.

Chapter Ten:
Responding to
Electronic Media in
a Television Age

Sanely applied advertising could remake the world.

—Stuart Chase

Most businesses have to advertise in order to generate customers. Any business that needs to generate leads and prospects should take a look at both radio and television advertising. But just because you spend the money for media advertising doesn't mean that it is going to work. The best plan is to integrate media plays with customer service plans.

In Chapter Six, I made the argument that customer service must be integrated with sales for both to reach maximum potential. My suggestions in this chapter expand on that belief. Some companies might concentrate on integrating advertising and sales—and that is, indeed, always important. But I continue to argue that customer service—at its best—can qualify sales prospects.

In this context, you can pass along leads generated by an advertising campaign through customer service to the sales department.

This chapter will take a look at coordinating your company's customer service operations with advertising in the electronic media.

In my experience, business people often want to know the how-tos of radio and TV promotions. They're as mesmerized as anyone by the mass media. We'll consider the mechanics—choosing stations, creating commercials or campaigns, purchasing time, etc. But the real key to using these outlets well is making sure you've set up the internal mechanisms for tracking and servicing response.

Radio—a constant companion

Regardless of the type of advertising that you might place, there are two critical issues to keep in mind:

1) **Repetition creates results**. The world doesn't necessarily beat a path to your door after the first commercial (or any other type of ad). This is nice when it happens—but it doesn't happen very often. Most successful campaigns are built on consistency and repetition.

2) **Don't advertise beyond your customer service capabilities**. You want your advertising to be effective—but what will happen if the results are beyond your capacity? There is nothing worse than being deluged with prospects that you can't process.

It takes careful management to balance advertising and your ability to service response. Of course, in order to balance these things, you have to be able to measure both. That measurement is what this chapter is about.

A Look at Radio

Radio is everywhere. We wake up to it. We drive to work with it. We hear it in the background at work. It entertains us. It makes us think. It gets us mad. It soothes us. It keeps us informed on late-breaking news. It helps us beat the traffic. But, above all, it compels us to buy, buy, buy!

In fact, radio is such a constant companion that the messages almost become subliminal at times.

Between 1970 and 1992, radio sets in use in the United States increased from 320.7 million to 576.5 million. And these numbers don't take into account the 142.8 million car radios and 43.7 million truck radios playing on the nation's highways. In fact, 97 percent of the vehicles used to commute to work have radios, reaching 86 percent of commuting workers every week.

Put another way, every weekday, 95 percent of Americans listen to the radio on an average of 3 hours and 20 minutes. Based on standard programming policy, that amount of time generally will carry an average of 50 minutes of commercials.

As for keeping up with the world, more college graduates get their news from radio than from television or newspapers.

I think you're getting the idea by now. Radio is a good way to get your message out to a significant number of people. But radio ads can flop—while soaking up lots of your advertising budget.

For most small to mid-size companies, the solution to using radio well is twofold:

1) **Make your ads as direct as possible**. Include a phone number or outlet location—and encourage listeners to use them. (This is yet another good use of an 800 number.)

2) **Allocate customer service resources** for maximum capacity during the several hours after ads or programs appear.

The problem with electronic media promotions—much like the problem with public relations—is that it's easy to lose track of how many people are responding to the placement.

One company with which I've worked had an executive go on a radio show for a series of non-advertising appearances. The problem: The shows were on in the evening, after the last shift of customer service reps had gone home. Calls came in from the appearances—but went into the company's general customer service voice mail system.

It wasn't until several appearances had taken place, when the executive asked whether customer service was seeing any increase in telephone inquiries, that the customer service manager said, "That must be what all those messages are from."

The company adjusted by having one phone rep stay late on the nights when the radio shows aired.

This example may sound absurdly simplistic—but it's a good distillation of the difficulties that most companies have with electronic media.

If you're thinking of buying mass-market advertising, radio is a good place to start. A series of ads on a local station usually will cost a little more than a series of display ads in a local newspaper. Start by buying off-peak time (usually anything other than morning and afternoon rush hours) in a single show

Be ready for responses

Sample questions for callers

for a set period of time. Then make sure you have customer service reps available to take calls and qualify them as having been referred by the ads.

(You can use the same kind of script we discussed in Chapter Eight for sourcing public relations leads.)

Choosing a radio station is relatively easy in small markets. There may be only one. In such instances, although many may listen to distant stations from major cities, ratings histories indicate that people will listen to the local station more often than to others.

An example: Buy ads twice a day for a week. Designate one or two people as the prime reps for radio ads, and make sure they're available during the program and for a few hours afterward. After they have explained your products, answered questions and—let's hope—made some sales, have them ask a few unobtrusive questions about the customer's demographics.

Profiling the Response

After fielding questions, sales and requests for information generated by radio (or TV) advertising, here is a sample questionnaire that will help you further define your market demographics. Remember, the better you define your market, the better you'll understand your clientele and the closer you'll move toward nexus with your clients.

1) **Ask their consent**: We really appreciate the opportunity to serve your needs (or thank you for your business), and so that we can continue to improve our services to you, would you mind answering a few questions about yourself?

 Note: Most callers will be agreeable; however, if they're in a rush, or uncomfortable with the process, respect their feelings.

2) **What was the trigger**: Was there something in particular about our ad, product or company that caught your interest? Do you normally respond to this type of advertising?

3) **Get specific**: If you don't mind a few personal questions—how old are you? Are you

married? Do you have children? Do you own your own home? And other questions that you feel are pertinent to your market needs.

4) **Thank them**.

Once you've established that radio ads generate cost-effective response—and you can schedule customer service support to take calls—expanding your ad schedule is a matter of logistics. In the advertising industry, this kind of expansion is called rolling out a campaign.

A Look at Television

Within most of our lifetimes, it was the lucky household that owned its own television set. Today, the boxes have proliferated into nearly every room of the house—including the kitchen and bathrooms. We've got mobile TVs for watching in cars, miniature sets to watch distant sports events while attending a local game, large screens, surround sound and so-called home theaters.

Television programming penetrates more than 98 percent of all U.S. households. Multi-set households average nearly three sets per home. Cable has penetrated more than 60 percent of households, while nearly three-fourths of households now have VCRs.

From an advertising perspective, television is important because it dominates the process. In 1991, television (including cable) generated more than $27 billion of advertising revenue—nearly one-fourth of the total advertising expenditure in the United States.

Like it or not, television is a focal point of our lives. Our children are educated by a motley assortment of TV puppets long before their first day of school. In courts of law, criminal defenses blame TV for violent behavior. Home shopping channels offer 24-hour commercials that compete with local merchants. Religious groups pillory TV programming, while using TV to spread The Word and raise money.

Consider some highlights from a study done by Bruskin Associates for the Television Bureau of Advertising in 1990:

TV generates more response

1) Eighty-nine percent of the adults interviewed watched television the prior day.

2) Television's reach encompasses every major demographic group, including upper income, higher educated, professional, managerial and working women.

3) Fifty-seven percent of the adults interviewed felt that television was the most authoritative medium for advertising.

4) Seventy-six percent felt that television advertising was more exciting than advertising in other media.

5) Eighty-one percent indicated that they were most influenced by television advertising compared with advertising in other media.

As bright as those statistics look, there are some shortfalls. For instance, television viewing decreases in direct proportion to rising income and education levels. (However, this decrease may be offset by the high ratings TV gets for being authoritative, exciting and influential.)

Savvy merchants understand this urgency and exploit it. Some, like Los Angeles–area Ford dealer Cal Worthington, have even become TV stars in their own right. One of my daughters, like a classic movie fan, watches commercials while reciting the memorized dialogue.

Of course, the same strategies for using radio ads apply to using TV ads. The main difference is that TV costs a lot more (between 10 and 50 times the price of comparable radio ads, in most local markets). For many businesses, though, it also generates a lot more response. So, your customer service capacity would have to be even larger.

Selecting a television station is a bit more complicated than choosing a radio station. In TV, viewers are more program-oriented, as opposed to radio's station orientation.

Begin your research by asking an account executive from your local television station(s) to stop by your office with a media kit. When they arrive, spend some time with each representative to review the contents of their media kits. Ask them to explain

the ratings, the pricing and the other requirements in terms you can understand. This also will give you an opportunity to assess the qualifications of the rep with whom you eventually will be dealing.

Cable television systems—which offer viewers dozens and even hundreds of channels to watch—are a cheaper alternative to broadcast TV stations.

Some cable companies have a channel dedicated to printed material, with commercials and programming schedules scrolling across the screen. They sell advertising on this channel at cut-rate prices—but how many people watch it?

On the other hand, some cable stations have local access channels filled with interesting, locally produced programs—many dealing with financial or environmental matters. They usually maintain a significant niche audience. These channels offer attractive rates, and there might be a particular audience that you want to reach.

Finally, national specialty channels (USA, Lifetime, CNN, ESPN, etc.) provide local cable companies two minutes per hour in which they can insert local advertising. This is an excellent way to be associated with national programming at minimal cost.

Media-Related Nexus

At this point, you might be asking: "Why is so much attention being given to radio and television advertising in a book about customer service?"

The answer is simple. If service is to be inculcated into every facet of a business in order to develop client nexus, then the advertising media also must correlate to the ongoing development of that nexus.

As I mentioned earlier, radio and television have become intrinsic to our personal lifestyles. They have gone beyond useful tools in our lives; they are part of our lives. We identify with them and through them.

Radio first reacted to this concept as stations began to offer music to specific markets: rock, country western, classical, middle-of-the-road. Today, their markets are defined to such a degree that there are a couple dozen niches within each of those original markets. Rock, for instance, could be soft old-

ies, oldies from the '60s, '70s and '80s—or even the '90s. Then there's alternative, rap, heavy metal, new wave and further subcategories for each subcategory.

The same thing is happening—even more dramatically—in television. From three very similar networks, cable has enabled television to gear toward market niches much like radio: lifestyle (for women), sci-fi (for science fiction buffs), history, movie channels, sports, etc.

When you advertise through the electronic media, you are being offered the chance to become a part of your market's lifestyle. When your commercial airs on a station with which your market already identifies, you are one giant step closer to the eventual achievement of nexus. It is almost like a personal endorsement. The subconscious message goes something like this, "I identify myself with this particular station. This company is advertising on my station. Therefore, this company must understand my needs, wants and desires. If the station makes me happy, this company/product/service will make me happy."

Overcoming Reticence with Some Ground Rules

Many companies shrug off the idea of advertising on radio or television without even researching the possibilities. They think it will cost too much ... or that producing a commercial is too much work ... or that never having done it before makes it impossible.

That's unfortunate, because using the electronic media to promote your company and your products can be very cost-effective. Aside from the two primary guidelines I've already mentioned, there are a number of smaller tactics you can use to make a good choice.

- Price should not be the primary factor in picking a media outlet on which to advertise. A good rule to follow: the lower the rate, the lower the audience.

- Ask about production services. Does the outlet provide assistance in writing the copy

of your ad? Does it provide studio time or equipment to make the commercial? Are there any costs involved—or are these things provided for free with the purchase of advertising? And, if the outlet produces your commercial, can you use it on other stations?

- Mass-media advertising is a least-common-denominator process. You reach the greatest number of listeners or viewers by using the most general approach. Note: A good rule of thumb is to choose the station that provides the best coverage of local news—the music is usually middle-of-the-road pop, adult contemporary, country and western or oldies.

- Don't necessarily choose your own favorite outlet. Conduct a postcard survey of your best clients, asking them the media stations they use. Demographically similar people tend to use similar media. (Also, advertising on the stations listened to by your top clients will serve as continual reinforcement of their decision to entrust their business to you.)

This last point—finding prospects like your existing client base—is an important piece of common sense. Doing this certainly will make it easier for your customer service people to qualify leads.

Once you have gathered information from the local media outlets in your area, review their audience demographics, ratings and prices to make a preliminary decision on the station you are most likely to choose.

A good measure to use: Divide the number of households watching that station in the time period you've selected by the rate card cost per spot. This will give you the cost per household, and provide a good basis for comparison between stations.

Negotiating the Cost

In advertising, as in most business, everything is negotiable. Media outlets have ad space that they need to fill with revenue-producing commercials. If they don't fill it, they get nothing. If they fill it for a

Small companies benefit from direct response

price lower than suggested retail, they're still ahead of the game.

The least expensive rate on either radio or TV is generally run of schedule (called ROS in industry jargon). This means the outlet can place your ads whenever and wherever it wishes during the broadcast day. This doesn't usually make sense for smaller companies—because you can't allocate your customer service and support staff to be on call for contacts.

Media outlets know that it's important for smaller companies to use ads that generate direct response. In most areas, stations will work to accommodate this need with special direct response (called DR) rates and times. Both of these are less expensive than standard advertising. Many outlets will allow longer ads in these periods, which suits some small companies. And, because the ads are scheduled, you can allocate your staff to track calls.

A caveat: DR rates often come with limitations. For instance, they may be pre-emptible, which means they can be bumped off the schedule if a higher-paying commercial comes along.

I've personally had very good luck with many stations on pre-emptible, direct response schedules. For instance, a recent ad campaign I worked on targeted six cities with a two-minute commercial. Over a two-week test period, the commercial aired more than 240 times. The market audience for the six cities totaled nearly 3 million households. Because these were late-night spots (after 11 in the evening), we were able to keep the cost for the entire campaign to $9,800. That's less than $41 per two-minute commercial.

Even if only 5 percent of the households were watching, that's 150,000 potential impressions for $41. Putting it another way, each penny reached 36 potential customers—and that was on regular broadcast stations.

Producing the Commercial

You've decided to advertise on radio or television. You've picked the station, determined the time slots and negotiated the price. Now comes the hardest part—producing the commercial.

Careers—and companies—have been made and broken on single commercials. I can't pretend to offer a solution to this specific challenge. But, keeping in mind that you want an ad that you can track easily with customer support, there are a few things that you need to accomplish:

1) **Get their attention**. Your commercial has to cut through the clutter and gain their attention.

2) **Be memorable**. Most of us remember only a few commercials among the thousands we see or hear.

3) **Create an identity** for your company.

4) **Prompt the audience to action**.

5) Make **contact information**—a phone number or address—a clear part of the message.

That last point is the most important—it's why so many ads beseech you to act now or warn that operators are standing by. Of course, in your case, the operators really will be standing by—so you need to do everything you can to get the audience to pick up the phone immediately.

This also creates the main customer service issue related to electronic media: You have to have people on the phones ready to answer calls that follow. Unlike PR, paid advertising on radio or TV can be tracked pretty surely—as long as you have someone on the receiving end to process the response.

When it comes to actually making the ad, you'll usually have a number of options—including buying generic ads from an agency, hiring an agency to do a custom job or hiring the station to do it. But I recommend at least considering another option: producing it yourself.

Before you call out the men with the white jackets, let me tell you about a friend with a mid-size retail store chain in southern Missouri. He wanted to produce both a commercial and a marketing video suitable for broadcast as a cable television infomercial. The local station wouldn't go beyond producing a commercial, and his advertising agency wanted a $20,000 budget to do it.

Building image with advertising is not enough

This friend went to the local library and borrowed several books on television production. Learning some of the basics, he laid out a general outline of both a marketing video and a 60-second commercial. He took Polaroid snapshots of the features of his business that he wanted to stress. He then laid the pictures out on a large posterboard in the order of how he envisioned the programs would look. Having done all this, he then visited with his ad agency and arranged for its copywriter to write the script at a cost of $300.

Script in hand, he paid a visit to the broadcast journalism professor at a local college. The production became a class project using the students, cameras and editing equipment of the school. Total cost: a $500 donation to the school.

Now comes the surprise: Several creative students rearranged the script for the marketing video in order to accomplish both the commercial production and the marketing video simultaneously. The commercial is actually a 60-second segment of the longer video.

My friend spent several days in the editing bay at the university to watch over the assembly process: But, not counting for his own time (which was a substantial investment), he ended up with a first-rate commercial and a 15-minute marketing video for less than $1,000 in total cost.

There are caveats to this, of course. The main one: Check your ego.

Years ago, when I was working at a radio station on the East Coast, a local business owner who advertised on the station insisted that he do the voice-over for his own commercials. This man's speaking voice was terrible. It was so terrible that the commercial always got your attention—but for the wrong reason.

His commercials became a joke and he nearly lost his business. The man was in the financial services industry. The commercial results were diametrically opposed to the image of someone with whom you'd trust your money.

Some Final Thoughts

It's not enough just to build image with advertising. It's always better to view advertising on a direct response basis. You want the audience to stop by, call, write or take some action based on your commercial.

The challenge here is to manage your advertising and customer service in such a way that they work in sync. It's as much a logistical challenge on the customer service end as it is a financial and creative challenge on the advertising end.

On a parting note, let's briefly discuss a psychological factor that may come into play—particularly for first-time advertisers. Your first commercial may run and ... nothing might happen.

Don't sink into depression, thinking about how much money you just wasted. Give the commercial a chance to do its work. Like many other types of advertising, the audience must be exposed to it several times before it begins to take hold. Then, it takes a couple more times before it actually stimulates action.

Patience is the watchword here. Be prepared to spend some time and money in process, before you get started.

CHAPTER ELEVEN: RESPONDING TO PRINT MEDIA BY FOCUSING ON MAGAZINES AND YELLOW PAGES

> The business that considers itself immune to the necessity for advertising, sooner or later finds itself immune to business.
>
> —*Derby Brown*

I have mixed feelings regarding newspaper advertising, which is the mainstay of print advertising. Just as in the case of radio or TV, you have to support print ads with customer service staff ready to qualify responses. This is tough to do, because newspaper ads are not specifically focused—either by content or schedule.

Although newspaper advertising remains important for certain portions of the retail trade, it has very little usefulness to the wholesale or business-to-business trade. Plus, the impact and readership of newspapers overall is diminishing. At the same time, the smaller the community, the greater the importance of the local paper in most cases.

Metro newspapers generally will have less impact for most companies due to:

1) the **widespread geographic coverage** which may extend well beyond your marketing area;

2) the sheer **size and volume of ads**, which makes it very difficult to compete with the big advertisers; and

3) the **astronomical rates** of the larger newspapers, which unlike radio and TV are seldom negotiable.

Trade magazines are the safest place to begin

Certain businesses—such as real estate, automobile sales, employment agencies, grocery and department stores—still rely heavily on newspapers. But, for companies in most other industries, the only print advertising I recommend is in magazines.

The late 1980s and early 1990s were a tough period for magazines, but they remain a good bet for integrating customer service support and promotion. Magazines offer the kind of specialization that radio and TV do. They have a more focused appeal than newspapers—although their schedule is usually even less predictable.

Still, magazines—especially trade magazines—are often the safest place to begin advertising.

Print advertising, in my opinion, must elicit a direct response in order to make budgetary sense for most firms. There should be a benefit and feature offer that stimulates the reader to some type of action. This is not the place for pure image advertising.

Like the other media we've already discussed, it pays to have an expert develop the ad for you. If that is not economically feasible, the graphic department of the periodical often can lend assistance for free or at a reduced cost.

I do strongly suggest that you follow several guidelines:

1) All print ads should be built around your **overall marketing image** in order to build upon and enhance all of your other efforts.

2) Although the copy may change, the overall design of the ad should remain the same to **build continuity** and reader identification.

3) **Give the ad time** to work. One-time shots are wasted money. You'd have better odds of making a profit by going to Las Vegas and placing your ad budget on a roll of the roulette wheel.

The first two suggestions work together.

As director of car sales for Hertz Corp., I developed a framework design—or format—for all car sales advertisements throughout North America. The heavy black border with rounded edges and incor-

poration of our Hertz Buy-A-Car logo framed all of our display ads everywhere.

Over time, the ad format became recognizable to consumers and easily found by those looking for our ads. As a result, a smaller ad would get as much play as a larger-size ad, at less cost. Plus, the straightforward clarity separated us from the more common styles of car sale ads.

Another benefit was derived from the mobile nature of today's society. Wherever our clients moved, our ads had the same look, the same identity that helped to retain their repeat business.

National franchise operations are further proof that conformity of image helps to build identity. See a pair of golden arches and you don't even need a name to identify them.

Local businesses can receive the same benefits. Years ago, an East Coast car dealer designed a used car ad that duplicated the classified section appearance of a newspaper. Over time, consumers identified with the ad, and it built the image that whatever you might want in a used vehicle, this dealership would have it. Upon arrival at the dealership, this image was set in concrete because its unique difference was the tremendous inventory on hand. Everything came together.

There are times when breaking from the traditional design concept can add to the impact of a special offering. But this should be done only after careful study and upon determining that the feature, benefit or price will justify breaking from tradition for added impact.

The final point is true for every facet of a marketing/advertising program. Don't expect a one-time ad to do wonders—or even serve as a test. Every advertising maven in the world teaches the repetitive factor in advertising.

Repetition Is Key

In most cases, consumers must see an ad several times to become aware of its presence, a couple more times for it to gain their attention and yet another time or two to stimulate them to action. I know that there are exceptions to the rule, but those

Develop a recognizable format

Track your source and determine your return

one-ad success stories are just that: exceptions—not the rule.

Most newspaper representatives will reinforce this fact for you. They aren't necessarily trying to pump up the value of the sale. Rather, they want your campaign to be successful, and they know that repetition is necessary. Try placing a one-day-only ad in the classifieds. Most papers won't even take it.

Magazines—especially monthlies—are a different story. The same rule on repetition applies, but many will gladly take a one-time placement. (Note that one-timers pay a considerably higher price than even a three-time rate.)

Again, if you're going to try one ad, save your money and spend it elsewhere.

I usually think of magazines for business-to-business advertising, rather than regular retail, unless you're Procter & Gamble. Yet many localities have local magazines with good readership and excellent results for advertisers. Since they are more expensive than newspaper ads, here's a little trick to build repetitive identity. If your budget is tight, run the ad for two months, skip the third, run the fourth, skip the fifth and run the sixth. At the end of six months, most regular readers will assume that you're advertising every month, and you've cut your costs by a third.

Wrapping up the printed word, there are a couple footnotes for consideration. In the yellow pages—or any other advertising for that matter—it's vital to track your source and determine your return on investment. Test your ads on your better clients, before spending money to place them. It's cheaper to design a new ad than to run a bad one.

Try placing the ads in different sections of the paper. In business to business, I've always preferred placement in the business or financial section. Some retail products or services work well in sports; others are better in the lifestyle section. I try to avoid the general news sections. I find that too many people are so caught up in reading the news, they don't even see the advertisements.

Although I've stated that print rates are more solid than radio and television, try to negotiate the costs.

The worst case is that you pay what the rate card says; the best case is you cut costs.

Check out the chances of cooperative assistance from your suppliers and vendors. They might pick up a portion of the placement costs, and they might already have proven ads available that will save you on production costs, too.

In that vein, investigate joint-venture, split-cost advertising with other businesses in your area. This will help generate direct response. If you are located in a small strip mall or even a block of stores, perhaps the mall as a group can take a large ad with individual merchants each taking a segment of it. Maybe your products tie in well with a complementary item or service offered by another firm, and you can jointly place the ad.

Print It in Yellow

Commercial telephone directories—what you would more commonly call the yellow pages—make up the fourth largest advertising medium in the U.S., with more than $9 billion in revenue. That's less than newspapers, television and direct mail—but more than radio, magazine or billboard advertising. It's a very effective direct response medium.

Here are some relevant numbers:

- Fifty-five percent of adults refer to the yellow pages every week. That equals 45 million references per day, 16.4 billion per year.

- Fifty percent of the users are shopping with no name in mind. That's a major prospecting opportunity.

Companies that specialize in the placement of yellow page advertising, as well as the yellow page directory itself, can provide a wealth of information on the many, many technological advances in telephone advertising methods and strategies. Computers enable you to track calls, identify the source of calls and match your client demographics with phone book distribution. The list goes on and on.

Some of these are applicable for smaller business, but most are designed for and limited to the large regional, multi-state and national companies.

Yellow pages—an effective medium

Coordinate with your other advertisements

Creating the Ad

In the yellow pages, as with any other advertising medium, regardless of whether you are a small or large advertiser, the ad is critical. Make sure that it provides a message with meaning and benefit. When people turn to the yellow pages, they have already determined that they have a need. You need to give them a reason for calling you, as opposed to the other listings. For a plumber, 24-hour service might be the most important message to prompt a call. For a pharmacy, home delivery could be the unique difference. Be informative and specific in terms of what you can offer. Plus, make your services benefit-oriented. How will you help the consumer? How will you help them save money? How will you make doing business with your firm convenient and pleasant?

Since a yellow page ad is going to run for a year, there are no quick fixes for a bad ad—you simply have to live with it. For this fact, and this fact alone, I heartily recommend that you consider using a professional ad agency for assistance in designing the ad. That cost is generally far less than the cost of a bad ad.

The Style

Seldom am I impressed by the ads in the yellow pages. Year in and year out they always seem to look the same. Take an objective look at your current ad. Does it convey your image? Is it professional? Does it hit the hot buttons of a shopper?

Remember: You're trying to generate a specific response.

Again, use your advertising agency or graphic artist to design a memorable, well laid-out advertisement. If money is slim, perhaps a college art class can be commissioned to develop an attractive ad. If you allow yourself enough time, test several designs among your clients and friends for feedback before placement.

As reinforced throughout this book, your yellow page ad should coordinate with all of your other marketing and advertising campaigns, especially those in print. When the yellow pages echo your

corporate identity and image, the payoff is much greater. Other features that can help bring it all together are inclusion of your logo, affiliations, even endorsements.

Don't Overspend

Yellow page ads are not inexpensive. Specialists in yellow page advertising often find that advertisers are overspending by as much as 50 percent. Don't buy the sales line that bigger is always better and paying a premium for red ink is key. Studies have shown that both statements are subject to question. Review your section of the yellow pages. What size do you need to effectively compete within your category? For some, a 1-inch box can give you the edge and cost considerably less than a quarter page. As for the red ink premium, it seems to have a huckster quality. Better to run a professionally designed, one-color ad that tastefully positions your company to the shopper.

Larger firms can participate in extensive testing and tracking, but for most, a simple monitoring process can be beneficial. Have a notepad that categorizes the basic sources of your business, including the yellow pages. Have your operator, or secretary, or other call-processing person ask this simple question: "Where did you find out about us?" Then note the answer with a hash mark under the appropriate column.

Even such rudimentary monitoring of prospect sourcing will help you to determine the return on investment for your yellow page advertising, as well as your other lead-generation methods. Simply tally the calls for the specific category, determine the average number of calls that it takes to make a sale and the average profit per sale made. By doing this, you will know whether or not the ad is generating a positive revenue.

For instance, let's say the yellow pages generate five calls per day and, of those, two make sales. If each sale is worth $10 of profit, you're generating $20 of profit per day. Based on 22 working days per month, you realize $440 of profit from the yellow pages per month. If your ad costs $175 per month, you have a 251 percent net profit return on your investment.

Tracking the return on your ads

Advertising before a product is distributed

Maintaining careful records of this nature will enable you, over time, to test the results of various size or design advertisements. It's an easy calculation, but I am always surprised at how many companies fail to track the return on their advertising budget.

Yellow pages can even offer an opportunity to service customers before you have a product or distribution network. In the late 1980s, Nissan was preparing to bring a new luxury car, Infiniti, to the market. Infiniti was going to have a separate dealer network—which would need a distinct market presence.

Robert Kadar was a national account executive with TMP West, a yellow page advertising agency ranked the fourth largest among direct response agencies in the United States TMP West was involved in the early stages of Infiniti's introduction.

"Infiniti wanted to begin advertising in the yellow pages before the car was out in the market. In fact, in most cities, Nissan had not yet appointed a dealership—but they wanted to start servicing potential customers by enabling them to receive information. We designed an advertisement built around an 800 number," says Kadar. "The copy told the reader to call this number for more information about Infiniti. Operators were trained to field questions and gain the caller's name, address and telephone number. Infiniti was not only servicing the immediate needs of potential customers, they were building a database of leads for the initial dealers to begin prospecting. Infiniti was building interest, callers were getting the information they wanted, and dealers were getting solid leads. It was a win-win-win combination."

Expanding on this concept, yellow page ads can direct callers to the right department before they even call your business. All you have to do is identify specific extensions in your ad: Sales, extension 101; Customer Service, extension 202. The better you meet your customer's needs, and the easier you make it to do business with you, the closer you move toward nexus.

Companies that are located in major metropolitan areas that require more than one yellow pages directory should also try to match the distribution of

their ad to their geographic marketing base. Computerized client databases make this a simple exercise, but even the non-automated can look through their invoices to chart which zip codes bring in the most clients. Once you know the zip codes that produce the majority of your business, then talk with your directory sales representative about restricting your ad to those books that cover your customer areas.

If your company is regional or national in scope, you should have an 800 number for your customers and prospects. The distribution base for the national 800 directory is increasing dramatically every year. Investigate the viability of incorporating this unique advertising opportunity. Our company has been advertising in this directory for a number of years, and it is our best lead-generation tool, without exception.

Most of us live or die by the phone. Yet we'll put a lot of effort into a newspaper ad and almost ignore our yellow page ad. It's your best bet for the money spent. Take time to review it closely.

Some Final Thoughts

Having been brought up in a two-paper household, I sometimes find myself a bit uncomfortable—and maybe even guilty—in acknowledging the declining importance of newspapers in building a client nexus. But, speaking pragmatically, Baby Boomers are probably the last generation with loyalty to the printed word. Those who have been born since the 1960s were weaned on television, computers and video games. This is the onset of a cultural shift from paper to electronic media.

As far as building your business goes, the two best bets in the print media are focus magazines and the yellow pages.

The main characteristic that these channels share is the ability to craft direct customer response. This response will be less intense—and more spread out, time-wise—than the response you'll generate from electronic media. For many smaller companies just starting to use advertising, this is a big plus. It certainly lightens the logistical load of keeping customer service staff on stand-by. This steadiness may make sense for you.

A shift from paper to electronics

CHAPTER TWELVE: SUPPORTING DIRECT MARKETING OR OUTSOURCING THE EFFORT

> The best mental effort in the game of business is concentrated on the major problem of securing the consumer's dollar before the other fellow gets it.
>
> —*Stuart Chase*

Over the years, many business people have spoken the language of pro-active marketing, while implementing strategies that are best defined as reactive. They speak of the necessity to keep change as a constant, yet fear the reality of change. They talk in terms of keeping ahead, but are often just keeping up.

My motto has always been: Don't worry about the competition. Let them worry about you!

Mention direct marketing and people envision direct mail. A few may even expand that vision to include telemarketing. To me, it's all just a play on words. If *direct mail* is response-driven printed material, what is *indirect mail*? If direct marketing means advertising, promotion or positioning directly aimed at the consumer with expectations of a direct result, why use the word direct? Isn't that what marketing, communication, advertising and promotion are all about in the first place?

In deference to the greater populace, this chapter will segregate direct mail and telemarketing under the umbrella of direct marketing—although direct marketing, as in direct advertising and direct response, really encompasses every method we've been discussing.

Making lists that generate response

Again, my interest is in how you allocate your customer service resources to best support the direct marketing effort. As I've said before and will say again, this logistical challenge is what separates good campaigns from mediocre ones.

The Mechanics of Direct Marketing

Different experts provide different percentages for the importance of the various factors in successful direct marketing. Some say the mailing or phone list is 40 percent of the formula, others say 25 percent, and some say 50 percent. Ditto the offer that you are making and ditto the copy or script.

Baloney!

One hundred percent of the value of a successful direct marketing program is based on your list of prospects.

One hundred percent of the value of a successful direct marketing program is based on the offer that you are making.

One hundred percent of the value of a successful direct marketing program is based on the ad, the copy or the script that you develop.

Successful direct marketing is like a successful relationship. If one partner gives 20 percent and the other gives 80 percent, you may have totaled 100 percent—in some tortured sense of the number—but you don't have a successful relationship. Each partner must make a 100 percent effort for success.

Likewise with your balance between direct marketing and customer service.

The List

When it comes to buying mailing lists, you need to do some investigation. There are some good companies that sell mailing lists—and lots of bad ones. Before choosing one, ask the following questions:

- Do they just supply yellow page compilations?
- How often do they verify the lists by phone for address changes, names of key person-

nel, fax numbers? (I know of one that makes more than 5,000 calls per day just to verify and improve the content of its listings.)

- What sort of guarantees do they offer?
- Can you try a test run?
- Does the company offer list download by modem or disk?
- Can you get preprinted labels?
- What about follow-up cards for names and phone numbers?

You also should ask to talk to several customers. Ask these people:

- What percentage of the list mail was returned as undeliverable?
- How many entries had bad phone numbers or outdated personnel names?
- How did the company respond when failure rates were high? Did it do things like offer make-good lists?

Another alternative to all of this checking would be to hire a company to coordinate your direct marketing campaign—be it mail, phone or fax. Many specialize within specific industries. Although the front cost may be a little higher, you generally save in the long run with lower postage costs and better returns. You still have to investigate the potential suppliers and determine which will best help you accomplish your goal, though.

The Pros and Cons of Outsourcing

Before moving on, I think this is as good a place as any to talk about outsourcing. You'll see a lot of this in direct marketing circles. Specialty companies are more than happy to do just about everything—including the broad definition of customer service I use in this book—for you.

"We think in the '90s we're going to see outsourcing of sales and customer service—things people once thought were their core competency," says Mike Callaghan, vice president of marketing for Matrixx Marketing, a $226 million division of Cincinnati Bell that provides revenue enhancement, customer ser-

Outsourced customer service

vice and full account management via telephone and database.

"Companies are realizing that yes, you can outsource portions of your business that are specific to your goals but that are not a core competency," says Callahan. "We think outsourcing is going to move to areas where people previously thought it could not be done."

Matrixx, a $5 million company in 1989, has virtually doubled in size in each of the past five years. Matrixx is integrating the telephone into the marketing process for an expanding, more sophisticated base of clients—such as DirecTV, which, with 1,200 dedicated agents, might be the largest outsourced customer service operation in the country.

"The sales process is changing for many companies," says Jim McAllister, president of Matrixx's business division. "They're reevaluating the traditional way to work with customers, and trying alternatives that they no longer feel are inappropriate."

Willie Loman is a ghost of the past, McAllister continues. "Before, there was only one way to do it—you had to have a face-to-face, belly-to-belly salesperson," he says. "But as companies change the rules and people don't spend 30 years climbing the corporate ladder, the whole way of doing business is changing. The pace is accelerating. Companies are trying things they wouldn't have ordinarily tried and they're finding out they work."

A survey sponsored by Matrixx Marketing uncovered the following trends in customer service outsourcing:

Types of Customer Service Likely to Be Outsourced

Product information	62%
Sales/order taking	44%
Sample fulfillment	39%
Complaint handling	37%
Appointment scheduling	15%
Billing information	13%

Types of Outbound Telephone Sales Likely to Be Outsourced

Campaign coverage (all clients need to be contacted)	35%
Small accounts (not served by a field sales force)	25%
Other accounts (not served by a field sales force)	20%

Here's a prime example of outsourcing: First Data Investor Services Group, a unit of New Jersey–based First Data Corp., started a major makeover in 1995 as it attempted to piggyback on the nation's love affair with mutual fund investing.

As mutual fund assets have increased into the trillions of dollars during the last decade, companies such as First Data have stepped in to service those assets by providing record-keeping and other services for mutual fund companies and their shareholders.

According to First Data Investor Services Group president Jack Kutner, almost all but the very largest mutual fund companies farm out at least a portion of their record-keeping and other customer service activities.

Besides dealing with a fund's customers directly, First Data provides mutual fund customers with fund accounting and marketing services, tax planning and preparation, proxy solicitations and assistance with all the other details associated with operating a mutual fund.

"Basically, we do just about everything except manage the money," said Kutner. "Our approach has been to equip ourselves with the ability to provide any and all of the service products that a fund complex would buy."

Using Temporary Services Companies

As the need for skilled labor of all sorts increases, many employers are turning to temporary services companies to augment their staff. And as employ-

A network of independent customer service representatives

ers' needs have grown, so have the types of temporary employees available. Temporary services companies provide industrial, technical, professional, health care and marketing employees, in addition to the traditional office and clerical staff.

An example: Even before the 1996 crash near Miami, Florida, that caused it to suspend operations, the cut-rate airline ValuJet had begun outsourcing its reservations functions. As it prepared to emerge from the suspension, it planned to job out even more. Company executives had discussions with Florida-based Willow Customer Service Network.

Willow spokeswoman Gail Nichols described the company as a virtual call center linking independent customer service representatives (ICSRs) to clients of the network.

ICSRs are agents who work out of their homes and pay a fee to belong to the network. Actually, they are employed by clients of the network. Companies that employ ICSRs also pay a fee to Willow.

Willow is not itself a call center, but acts as the medium for ICSRs to interface with large call centers and service bureaus. Agents work on an as-needed basis to offset normal peaks, unpredictable spikes, emergencies and disaster periods.

"Airlines have very unpredictable busy situations. Traditionally, they lose those calls, and that's lost revenues and unhappy customers. And they've done everything to minimize the fallout. They've put in special technology to predict when [a spike] might happen," Nichols told one airline industry journal. "But if the people aren't there when the calls come in, you're dead."

That's where companies like Willow fit in. When the airlines have unpredictable spikes, they can overflow instantly into the Willow network. The network knows which agents have been trained to take that airline's calls.

What this means to companies like ValuJet is that they have access to a qualified, dependable, reliable, flexible work force that is there when they need it and not when they don't.

Is this a good idea? Maybe. However, the main reason I recommend thinking of customer service in

its broadest sense is to build extra value in the client nexus. This can be tough to do when someone else is talking to your customers.

I recommend that most companies follow the model used by airlines: Keep enough customer service staff in-house to handle between 80 and 100 percent of your average customer service call volume. Then, make arrangements with an outsource company to take excess volume.

This can be done seamlessly to the caller—and it's better than losing clients from a waiting queue.

What's in an Offer?

Back to direct mail.

What is the purpose of your campaign? Do you want to generate leads for one-on-one sales calls and closings? Do you want to sell a specific product at a given price? Are you building floor traffic for a store? Will a promotional giveaway build that traffic?

Be precise in your goal, and do not have more than one!

I've watched thousands of businesses, including mine, try to be all things to all people in one mailing or one phone call. It never works!

The first and foremost rule in direct marketing is: Keep it simple.

A few years ago, I ran a television campaign for my mail-order lingerie company. The goal was to build our database list on a cost-recovery basis. To do this, we would offer a garment and the gross profit would cover the cost of the spot placements and inclusion of our catalog in the shipping of the garment.

I kept telling myself, "Keep it simple ... keep it simple." I concentrated on one single garment in one single color and one size that fit all. How much more simple can you get?

The product offer was simple—but I had developed a tunnel vision in which garment and simple went hand in hand. The message that went out with the mailing was anything but. The promotional material sold the garment—but also highlighted the wonderful catalog customers would receive (show-

Be honest and avoid gimmicks

ing pictures of models in other garments) and $100 worth of discount coupons that would accompany the catalog and garment.

You can probably guess the rest. The company handling the inbound calls and order fulfillment got all sorts of calls.

> "I don't want the sleepshirt. Can I just get the catalog?"

> "I'm really small ... will it fit a size 5?"

> "I saw other garments in red ... can I get that color instead of black?"

> "How much is the catalog without the discount coupons?"

Many friends extended their condolences over what they thought was a disaster.

"No, it's a success," I insisted. "This was a test that only ran in six markets, and the test showed us that we had made some mistakes. The test was successful!"

If I had run that commercial spot on a national basis, rather than testing it first, then we would have had a disaster on our hands. Understanding that the product line catalog was what the consumers really wanted, we revised the offer to selling a video catalog on a cost-recovery basis. We wanted the price to be irresistible, and by getting the product information into the hands of potential buyers at a break-even—we win!

Offer. Message. Product. Service. Keep it simple. Keep it all simple.

Today's consumers are anything but naive. In fact, they're jaded. They've seen it all and heard it all—and whether you're calling them or they're calling you, they don't want to hear it anymore.

What works is straight talk. Be forthright, be honest, and state your case. Key in on a pre-established need, explain what you are offering to fill that need, and give them a justification to make a decision now.

Avoid gimmicks, unless they will tastefully get their attention. Let's say you are promoting a Hawaiian vacation. If you're doing direct mail solicitation

based on the sensual pleasures of an island vacation, try including a half-ounce package with one or two macadamia nuts. If you are promoting a price package, include a penny or some shredded money to make your point and get their attention.

Once you've got their attention, state your case.

Integrated Direct Marketing

As I mentioned earlier, all marketing should be direct marketing, interrelated and coordinated. Direct marketing is truly a multimedia event, ranging the gamut of every known method of communication. And, whatever the method, the goal of direct marketing is to achieve a desired response.

Think of it in terms of travel. The goal is the destination, and the medium utilized is the vehicle. And each destination can be reached by a vast array of transportation vehicles, or a combination thereof. For instance, on a recent trip from Los Angeles to San Francisco: I drove to the airport, walked to the terminal, flew to another airport and took a motorized walkway to a bus stop for a ride to a train station.

Then, I took a train to the city, a cab to the building and an elevator to the office.

Yet on other trips, I've been known to bypass all of that and just drive from point to point.

Like that trip, direct marketing can use a combination of media or a single method. So don't lock into a single-method mindset. Allow yourself the freedom to be innovative and creative in direct marketing.

The key is to keep tight control of the cycle between mailing your material and marshaling your customer service troops to take the responding calls. This is easier than the logistics of electronic media or print media—because you're in control of the market focus and the schedule. You can test mailing lists and material. And, when you find a combination that works, you can roll it out slowly or aggressively.

Don't lock into a single medium

Matching the staff to response

Staffing to the Demand

As you begin testing direct marketing, you'll find that the only thing more frustrating than lack of response is more response than you can handle.

If you plan on handling the response internally, here's a basic worksheet that can help you match staffing to response.

Test Results

1) Number of mailings (or ad placements): ___

2) Number of responses: ___

3) Average telephone time per response: ___

4) Average clerical time per response: ___

5) Total manpower time: ___

> Divide your manpower hours by your test mailing and you have a manpower factor. Multiply any mailing by this factor and you have determined your manpower needs.

> Example: Company A sent out 100 mailers and received five responses. Each response took 10 minutes of telephone time and 15 minutes of clerical time. Allowing a five-minute margin, this means that every 100 mailers will require 150 minutes of manpower (5 responses x 30 minutes). Divide 150 by the 100 mailers and you have a 1.5 manpower factor in minutes. A mailing of 5,000 pieces will require 7,500 minutes (5,000 x 1.5) of manpower, or 125 hours.

Once you've identified your manpower factor, spend some time in determining the proper scheduling.

Remember that clerical functions can be accomplished throughout the workday, while telephones have to be answered when they ring. Since we know that clerical requires a bit more time than the telephone in our example, let's allocate 65 of the 125 hours to clerical.

Over one week, this effort will require 1.5 staff positions on a 40-hour basis.

However, let's say that the bulk of your phone calls occur between 9 a.m. and noon. That would require four people working those three hours on a

five-day-week basis. Massaging those numbers, I would schedule two staff members for a 40-hour week, and three extra to work from 9 a.m. to noon.

It would be nice if there were a chart that could accomplish this final bit of scheduling for you, but this decision needs to be evaluated and made on a case-by-case basis.

If your campaign is a short-term, high-volume promotion that only runs once in a while, or you are uncomfortable with bringing on additional staff right away, investigate outsourcing the handling of incoming calls to a good telemarketing company that provides such inbound services.

Using Gimmicks and Humor

In recent years, a growing number of companies have experimented with lightening direct marketing material with gimmicks and humor. This generally runs against the prime directive of direct marketing. Comedy isn't pretty—and it also isn't simple.

This is true in more than just direct marketing. You need to watch closely how your customer service people use humor. Many times, even the best reps will start getting arch or sarcastic after a long day ... or week.

Humor is one way of dealing with stress. But is it helping you to develop more prospects, close more sales and support the team spirit within your agency? Or is it the cause of turned-off prospects, lost sales and disintegrating morale?

According to humor expert and president of Sarcastics Anonymous Virginia Tooper, the demon of sarcasm could be destroying the effective value of your humor. It may work well if you plan to understudy the career of Don Rickles, but it can be a corrosive element in external and internal business relationships.

Sarcasm may have its place in a unified deriding of your competition during a stress-relieving session of office camaraderie and gossip, but the opposite is generally true when sarcasm surfaces between employees, during sales presentations and during competitive analysis with a client.

Perhaps a look at the Greek origins of the word will

Sarcasm can backfire

make the point. *Sarcasm* can be traced to the Greek *sarkazein*, which is loosely translated as to tear flesh. Unless your clients and co-workers lean to the masochistic side of the street, tearing their flesh doesn't seem to be the best way to promote harmony and loyalty in a relationship.

Oops, my sarcasm is showing!

Perhaps the best rule to follow in the use of humor is the golden one: Empathetically put yourself into the recipient's shoes before you strategically put your foot into your mouth.

This rule holds true in the development of humorous marketing campaigns. Review and thoroughly test the humor in advance to assure that it is not offensive to the audience, thereby costing you business in the long run.

A sarcastic pot-shot at the competition could backfire.

This rule also holds true in any interpersonal relationship. Client, prospect or co-worker—it's all the same. No one enjoys being the object of a put-down or ridicule. Plus, many will consider such remarks— even when directed at a third party—crude and hurtful.

Subliminally or overtly, this judgment can then carry over to the person who made the comment. How many prospects will choose to place their business with the source of such sarcasm? And how many co-workers will feel a kindred team spirit with such a person?

According to Tooper, there are three media where the potential of danger is greatest in the use of humor within business: letters, telephone and in person. Utilizing humor in any of these areas requires some early analysis and preparation.

Letters can be dangerous because the printed word does not offer the advantages of vocal intonation, facial expression or body language. Telephone communications are a little better in that the vocal intonation is present, but facial and body expressions are still lacking. The least dangerous of the three is when humor is used in person, one on one. However, humor that is inappropriate or badly executed still can backfire.

The best use of humor is situational, not personal. Focus your irony on circumstances, not people. And—as always—it's safest to make yourself the butt of the joke.

Regardless of where humor is used in business—among employees or clients—it is important that there be a joking relationship. This establishes a mutual approval of the use of jokes, even sarcasm, as part of the relationship that has been built.

The bottom line when considering the use of humor in any marketing, communication or vocal interchange is first to consider how you would react. Always remember that true humor is defined by the audience.

Legitimate humor allows one to diffuse difficult situations, develop a more relaxed and resilient attitude and become more productive and creative in the resolution of problems.

The first goal of direct mail is to get it opened—not to be the wittiest thing since Oscar Wilde's last bender. Stick to the earnest basics.

Commonly accepted rules are that imprinted envelopes are better than address stickers. Personalization is better than occupant. Stamps are better than metered mail. Some experts even break it down to the color of the envelope and the ink. *Reader's Digest*, and others, suggest that enticements be printed on the envelope to encourage opening it.

If you are running television or radio ads, mark the envelope As Seen on TV or As Heard on Radio. Likewise, tie the piece to any timely newspaper or magazine ads. Aligning a direct mail package with other advertising can dramatically increase effectiveness.

Finally, make sure that the people taking the phone calls that the mail piece generates have a script that's substantially similar to the language in the mailer. They also should have a hard copy of the piece, so that they can refer to the real thing if a prospect or customer has questions.

Humor is defined by the audience

Have a dress rehearsal

Checklist for Inbound Customer Service Calls

- Provide the customer service team with copies of the mailer, printed ad or script of the television/radio commercial.

- Review the advertising material with the customer service team so that they fully understand it.

- Provide customer service with a highlight list of key points.

- Provide and review order forms.

 Note: For inbound orders, I like to use a large, well-spaced 8½ x 11-inch form for telemarketers. Even if a company has standard or computerized order forms, these often are not suitable for taking telephone orders quickly.

- Provide and review questionnaires and scripts for additional demographic data that you are trying to capture.

- Have a dress rehearsal. I don't particularly care for the term *role play,* as it often has negative connotations in the minds of some employees. Think of a practice session as a dress rehearsal. Make an event out of it so that everyone has an enjoyable time preparing for your marketing campaign.

Telemarketing: Out or In?

In a general sense, I've been talking about telemarketing throughout the whole book. I feel strongly that customer service reps need to perform most of the functions of general marketing. But, for clarity's sake, let me make a few specific points about telemarketing as a distinct function.

I am against automated telemarketing. I am against cold telemarketing, in most cases. These efforts are simply too impersonal to generate much business.

I am for follow-up telemarketing. I am for cold telemarketing to highly selective prospect lists. Most of all, I am for what industry insiders call client contact telemarketing.

This is just another way of describing the client nexus.

Telemarketing is one of the greatest examples of the phrase. The only constant is change. Just 10 years ago, telemarketing sales centers were being championed as the greatest prospecting tool since doorbells. Slowly, the concept began to take hold, as more businesses reported successes. By 1990, it seemed that everyone was engaged in telemarketing for prospecting.

Beset by a daily onslaught of prospecting calls, business people grew afraid to pick up their phones, and citizens began turning on their answering machines during dinner hour in self-defense. Now, many companies are disbanding their telemarketing departments in the belief that such marketing has become ineffective.

Rather than discarding a proven marketing tool, perhaps it's merely time to experiment with some changes. Telemarketing experts refer to outbound marketing versus inbound marketing. Most companies have concentrated primarily on outbound calling to generate sales.

Let's look at the other side of the telemarketing coin: inbound. Here, a sales center can continue to be a valuable tool in processing responses that are generated from other forms of direct marketing, such as television, radio, newspapers, magazines, billboards, mail, etc.

Typical marketing designed for inbound callers might be: Just call 1-800-234-5678 for a free gift ... or survey ... or more information. A trained sales center can quickly turn those responses into leads.

One very strong caution: Develop several telemarketing scripts. If you don't have the expertise available, hire an expert. Then have your telemarketing people practice, practice and practice the scripts until they become second nature. Off-the-cuff telemarketing is a waste of money.

Fax for Profit

So far in this chapter, we've considered mail and phones. How about the combination of both: fax.

Develop several telemarketing scripts

Using faxes and follow up calls

We've all come to rely heavily on the time-saving convenience of the fax. But how many of us are using it for direct marketing? And how many of us realize the potential savings of direct marketing by fax?

Computer programs now allow your computer to do what's called broadcast faxing. This is simply an automated delivery system—no one needs to stand and feed paper into the machine. That means less labor. Plus, such computer programs allow you to run the fax through the night. That means lower phone line charges. Plus, in most cases, a fax is immediately delivered to the recipient, as opposed to being lost in a stack of daily mail.

One caveat to using broadcast faxes: You have to follow up quickly with telemarketing. Otherwise, your message may be ignored as a junk fax.

The Compliance Publishing Division of Sound Marketing began using a combination of fax and telemarketing with a surprising degree of success. The project was to market a compliance manual for the Americans with Disabilities Act. After identifying our target market and purchasing a list with fax numbers, we sent 50 faxes a night between midnight and five in the morning. The following day, our telemarketers would call to solicit orders for the manual.

Some interesting conclusions:

- Less than 1 percent of the contacts said they had not seen the fax (in prior mail campaigns, up to 40 percent of the contacts hadn't seen the package).

- Earlier telemarketing attempts without first sending a fax had been failures—because too much information had to be given over the phone. By using the fax, the prospect already had much of the necessary information.

- Tests of using the fax without telemarketing follow-up also provided minimal results. Individually, telemarketing and/or fax resulted in less than 1 percent sales; but in combination, we averaged more than 3 percent in sales.

By the way, if a prospect said he or she hadn't seen the fax, it could be retransmitted within minutes—and another call made shortly thereafter.

Another caveat: Federal, state and local governments are regulating the use of fax advertising to stem the tide of junk fax. So be sure that there is value to your message. Include information that your prospect will need and appreciate.

Your fax message should indicate that you will accept their response by fax, phone (for immediacy) or mail. Remember that the quicker the response, the greater the sale.

Some Final Thoughts

Direct mail can be as simple as a letter of introduction, or as intricate as a newsletter. It can be pure image enhancement. Or it can solicit a response. It can include a return postcard. Or it can promote response with an 800 number. It can include a gimmick, a gift, an audio or a videotape.

Or it cannot.

Here are a few valuable mail tips based on personal experience:

- Use a **first-class postage** stamp. Meters are convenient and bulk rates are cheaper, but mail with a stamp usually gets opened.

- Make the piece look like **an invitation**. Most mailers use a standard No. 10 envelope. Be different. The smaller, more personal style stands out and gets opened.

- Don't use **address-o-graph type stickers**. The name and address should be typed or computer printed directly onto the envelope.

- **Personalize** the envelope. Dear Owner, Occupant, Manager, Executive or whatever doesn't cut it. People like to see their name on their mail. Generic addresses get tossed all too often.

- **Limit your mailing**. I've seen small companies send out thousands of pieces in one fell swoop, only to be deluged by more calls than they are capable of handling. Test your

mail in lots of 100 or so, until you can determine your rate of return. Then adjust your daily mailing to match your ability to handle that rate of return.

- **Test, test, test!** After "keep it simple," this is the second major rule. You may have some higher printing costs by running smaller numbers in order to test—but that expense is minuscule compared with the cost of mailing a poor-performing piece to your entire list.

- **Follow up**. You can double the results of any direct mailing with phone follow-up. This doesn't apply to every type of mailing, but it does apply to most—particularly business-to-business. Don't just sit and wait for the phones to ring or the mail to arrive. Call them up, refer to the mailing and ask for their business.

A combination of mail, phone and fax can be the most cost-efficient method of developing leads and closing sales, if you are willing to change and open to creative ideas. This flexible and determined approach will keep you moving pro-actively along the client nexus. Your competitors will be left trying to keep up with you.

CHAPTER THIRTEEN: INFOMERCIALS AS A CUSTOMER SERVICE TOOL? INTEGRATING WITH ALTERNATIVE MEDIA

"I have to do something to make s**t happen."

—*Anthony Robbins*

Before tackling infomercials, let's start with a little quiz to find out how much you know about them.

1) Infomercials are a relatively new advertising phenomenon.

 [] Yes [] No [] Who cares?

2) *Infomercial* is a term that relates to television.

 [] Yes [] No [] Who cares?

3) Infomercials are the advertising method used by hucksters; major corporations would never enter the infomercial arena.

 [] Yes [] No [] Who cares?

4) Infomercials are a very expensive way to advertise.

 [] Yes [] No [] Who cares?

5) Infomercials are merely a trend that will soon pass away.

 [] Yes [] No [] Who cares?

The original infomercials "sold" religion

If you answered Yes to any of the questions, you have a lot to learn about infomercials. If you answered Who cares? your competitors may be getting ready to reap the benefits. If you answered No to all of the above questions, congratulations! You should be expecting a call from Guthey-Renker Productions any minute.

On a serious note, infomercials are an important means of communicating with prospects and customers. They are one of the purest and strongest forms of direct response marketing—and they are very easy to integrate with a good customer service operation.

As you might suspect, having gotten this far into this book, I'm for the integrated use of infomercials—whatever the medium.

A New Version of an Old Trick

Many people tend to credit the origin of infomercials to the old, late-night slicer/dicer and pocket fisherman commercials. There have been some tacky infomercials that used the slicer/dicer format, but the original infomercials began on a higher ground: religion.

At this point, it's probably a good idea to define *infomercial*. An infomercial is an advertisement for a product or service that has been expanded with information, entertainment or both, in order to retain the attention of the audience.

In days of old, itinerant preachers would pass the basket after preaching a message that was interspersed with the singing of hymns. As radio, and later television, arrived on the scene, religious leaders began purchasing half-hour or larger blocks of airtime to carry their message to a larger audience, merely replacing the traditional basket with an address to which people could mail donations.

Profitable? You bet! Many such ministries built tremendous cathedrals, multimedia production centers and even their own television stations from the revenues generated by religious infomercials. In the meantime, marketers of product and service just sort of rambled along with the purchase of 30- and 60-second time slots to air their commercial messages.

For a long time, this worked well and everyone seemed to be happy. There were only three networks spread among the limited number of television stations (four networks for radio), which meant that there was only so much advertising time available. Expensive spot commercials held sway during prime hours, and the religious broadcasters helped to fill the late-night and Sunday morning voids.

Catalysts of Change: FM and Cable

For decades, these limitations remained unchanged. Cable was futuristic, and radios capable of receiving FM stations were limited. Then, almost simultaneously, FM became the king of radio and cable catapulted television into a new age.

The popularization of FM radio more than doubled available commercial broadcast frequencies, and cable brought a twentyfold increase for TV. All this meant a quantum increase in available time for commercials, and broadcast stations scurried to find sources of revenue. This abundance of airtime also resulted in bargain basement pricing. Many cable TV stations charged less for a spot than the local radio station did.

In 1984, the final obstacle for infomercials was overcome when the Federal Trade Commission handed down a decision allowing stations to sell lengthy blocks of advertising time. Existing and budding entrepreneurs were quick to take advantage of the situation by purchasing blocks of time for expanded commercial messages. As this trend began to mature, the content and production values of these commercial messages improved dramatically. Today, it is not unusual for a national infomercial to have a production budget ranging from $500,000 to $2 million. Infomercials now even have their own awards, equivalent to the Emmy, and commercial spokespersons are assuming star status.

From the initial pitches to get rich quick and lose weight fast, the industry has grown to encompass lengthy advertising from major Fortune 500 corporations and legitimate local businesses. More than 90 percent of television stations now run infomercials—some even during prime time. It has been

Production budgets can reach $2 million

Call surges require adaptability

estimated that more than $1 billion in product sales was generated in 1993, triple the 1988 level. The Home Shopping Network and its competitor, QVC, are constant fodder for the economic mills of the *Wall Street Journal* and the business sections of newspapers throughout the world.

Case Study: QVC

If you want a dynamic example of customer service at its best and broadest, you have to look no further than QVC Networks Inc.

In many ways, QVC points to the future of customer service—and the creation of a client nexus. Thousands of people call the network every day to buy everything from household goods to sports collectibles. At the other end of the line, the television home-shopping retailer has integrated computers and telephone systems to master details of callers' buying habits, its own inventory, product information and other databases.

Overall sales at QVC have grown steadily, reaching $1.6 billion in 1995 after 10 years in business. The company has 55 million viewers each year, about 9 percent of whom are regular customers.

Its customer reps can handle nearly 50,000 orders an hour. Its distribution centers can ship more than 400,000 packages a day. In addition to its headquarters and broadcasting facility in West Chester, Pennsylvania, QVC has two separate customer service and distribution centers. The company stocks and ships all of the products it sells.

Unlike catalog merchants, which can predict call volume surges after an ad campaign or catalog shipment, QVC's load may spike in intervals of minutes, not hours, requiring great adaptability. For example, after a product demonstration on-air, call volumes can increase six- or eightfold within a matter of seconds.

Weekends and evenings are the most popular calling times. The average order is placed and recorded in less than two minutes—often with a computer-generated suggestion for an up-sell to a related product.

Returns—the bane of any retail marketing business—run 20 percent. (That's about average for its

sector, but large when compared with the less-than-5 percent rate normal for traditional retailers.)

Much of QVC's efforts center on getting product to the market and in the hands of its customers faster, but not necessarily cheaper. The company does not position itself as a discounter.

"One of the best things we do is fulfill," says QVC senior vice president of marketing Fred Siegel. "When you call us, the customer service representative will answer the phone within a ring and a half, the transaction takes seconds and, chances are, it will be shipped out within hours—not days."

QVC customers are serviced by three major call centers, based in Virginia, Pennsylvania and Texas—with a total of nearly 1,300 workstations among them.

The company has two key automated service applications that it has developed for callers: order taking and customer service. The automated ordering application is the one that has delivered the greater commercial benefits. (The customer service application deals with the most routine and frequently asked questions, such as "Has my order been sent?" "Where do I send my check?")

Each of the three call centers has a main automated caller directory system, which places callers in a queue waiting for the appropriate agent. While the callers wait, a series of voice processing platforms offer to take orders automatically. These systems offer the equivalent of more than 1,800 extra representatives ready to take orders—that's the capacity of another call center, without the expense of having to build one.

The customer is offered automated ordering as an alternative way of placing an order when all representatives have calls waiting for them—hence its name: QEater.

The QEater option works by giving customers on hold a message, which informs them of the option to use QVC's automated service. Once in the QEater application, callers then use their telephone keypads to navigate the system and place their orders.

Customers who do not want to run the risk of an item selling out while they are holding for a repre-

Two key automated service applications

Retaining good call center employees

sentative voluntarily go into the system and place the order themselves, thereby reducing the length of the call waiting time.

At its launch, QEater was so successful that a number of customers could not understand why the service wasn't available all the time. So, QVC established a separate 800 number that puts callers straight into it.

"It's fairly seamless, and about 80 percent science, 20 percent art," says John Hunter, QVC's senior vice president of customer service. "About 30 percent of all calls have the option to use QEater. We opened that in 1992, and people said, 'Hey this isn't bad.' "

But good customer service reps remain the strength of QVC's franchise. In a series of TV commercials touting the network, customer service reps played key roles. In one spot, a rep assures consumers that the company doesn't "rent or sell our customer lists"; in another, a quality assurance representative tells viewers about the high standards QVC upholds in its product testing.

Retaining good call center employees means marking out a clear path to the top. Most call center managers began their careers on the bottom, talking to customers.

When a rep logs in a customer's name or credit card number, QVC's computer system brings up that person's recent buying history. When a product number is entered, the system brings up related products that the customer may want.

At many companies, call center jobs are intense. Employees are graded on how fast they handle each call, how closely they follow computerized scripts and how much they shut off their phones to talk to their supervisor or run to the bathroom.

"You were supposed to keep [time off the phones] under one hour a day," one former employee of a Texas call center told a local newspaper. If she exceeded that limit, she had to write out an explanation.

QVC tries to create a less stressful environment. At its call center in San Antonio, managers decorate its giant phone rooms with crepe paper, balloons

and festive party hats to commemorate the city's festivals. Employees can read or study while they're waiting for calls. The facility's general manager greets every employee he sees by first name.

The upbeat atmosphere, coupled with a company store that sells returned merchandise at deep discounts, keeps the morale up.

Monitoring—better known as "quality control"—is a way of life at QVC call centers. Managers sit in the back room and listen in on calls. They've got a form to check off whether each employee verified the customer's address, totaled up the order and suggested related products.

This can be tedious work, but QVC does what it can to make its reps content and productive. The efforts have paid dividends. Rival TV sales company Home Shopping Network (HSN) concentrated on price at the expense of quality and customer loyalty, acquiring an image of cheap, inferior merchandise and lousy customer service.

HSN reaches 67 million households, but its sales have stagnated for the last five years at roughly $1 billion. QVC, which reaches fewer homes, boasts significantly higher sales. A staggering 17 million people have ordered one time only from HSN, hence the new emphasis on customer satisfaction.

"It's painfully obvious we have to change," Gerry Hogan, HSN's chief executive, admitted to a trade publication. "We maintained a focus on price at the expense of customer service, quality and value. That is a dead-end strategy."

What About You?

Don't let their historical development, particularly at the national level, scare you away from infomercials. They can be a viable way to expand your revenue base by attracting new clients. Depending on your product or service, you might want to contemplate the direct response Juice Man style of infomercials, or concentrate on a more educational/informational aspect of delivering your message.

In fact, the vintage half-hour radio and TV sermons of Bishop Fulton J. Sheen might be a good example

A viable way to attract prospects

Investigate the local cable companies

of a simple, educational infomercial. During a 30-minute time frame, Sheen would utilize a chalkboard and persuasive voice to bring his message to millions of Americans in a straightforward manner.

Many small to medium-size companies are already using an infomercial concept, without even being aware of it. Some service firms put on topical seminars to solidify their client relationships and attract new ones. They book a conference room and present information that is valuable to the audience in order to gain more business.

For example, a financial planning company sponsors a seminar on retirement planning in order to attract customers. Or a chiropractic clinic conducts a wellness workshop in order to promote its health services. These seminars are nothing more than live infomercials with a limited audience. If a camera crew was present to videotape the seminar, it could be edited for television viewing. Or an audio technician could adapt the voice recording for radio.

As for radio, aggressive small businesses in a number of markets have been airing educational shows for years. In some cases, they've purchased the time slot and broadcast live or prerecorded shows on a weekly or monthly basis. Some just talk about their area of expertise; others actually accept calls from the listeners. In some markets, they don't even buy the time. The station feels that the topic is a viable program and hires the person as the on-air broadcaster.

Newcomers to infomercials on television should first investigate their local cable companies for two reasons:

1) The cable companies are required to provide a local access channel for their community. Time segments usually are available at very low cost, sometimes free if the program will be in the public interest.

2) Many local cable companies provide production facilities, personnel and/or equipment to produce your program. (Some may require that you undertake a training course in the operation of the equipment first.)

For these obvious economic reasons, this is the perfect start for a company interested in pursuing television infomercials. If it proves successful for you, you can expand your horizons and your budget. Even if it is not successful, it will be a valuable educational experience and a low-cost testing ground.

Although normally a bit more expensive, regular small-market television stations also may be willing to work with you on the development of an infomercial—particularly if it can be designed in the public interest. Perhaps your products or services can provide the basis for a program on home or workplace safety, health or financial planning, all the while promoting your business and/or your personnel.

Depending on your resources and the expertise of the station or cable company, the program can be as simple as you (or a spokesperson) talking to the audience. Or a more elaborate program could be staged with a live audience or several people talking to the camera. Unless you are videotaping a live seminar or presentation, this will take quite a bit more work and a larger budget.

Alternative Media

Although not normally thought of as infomercials, audio and/or video programs produced to promote your company or services are really infomercials. The only differences are the method of distribution and a more limited audience. You may have already produced such a promotional program.

Many companies produce marketing videos or audiotapes to sell their services and expertise to potential clients. Such productions also can be defined as infomercials—it's merely a different method of distribution.

Although not aired on TV or radio, you may mail it to selected prospects or play it during sales presentations. You may even make it available to local organizations for use in their meetings. True, the audience is minimal and very targeted—but it's no different than an infomercial. In fact, some firms contract to air these programs on local cable or radio stations.

The extended time slot enhances your image

The duality of use—broadcast and non-broadcast—is seldom evident to the company. The reality is that a broadcast infomercial can be duplicated and used on an individual basis to close the sale. Conversely, such promotional productions also can be used as broadcast infomercials. They may need some minor editing and adaptation, but the cost is minimal compared with full production services.

Other media that could be viewed as infomercials include newsletters, which provide an expanded format to inform and sell. Weekly or monthly columns in your local newspapers—even a company brochure—are sort of a printed infomercial.

Some Final Thoughts

The broadcast industry has indicated that some of the most promising markets for infomercials are:

1) **Products or services of a complex nature**, like insurance, financial planning, environmental products, mutual funds, real estate, etc. These categories are difficult to advertise in a 30- or 60-second time frame. It simply takes longer to explain all the pertinent details that are necessary to the purchase of such items or services. A half-hour program provides the time to fully explain the need, benefits and values that can generate solid leads. Plus, since the prospect has already been given some of the basic information, in-person sales presentations and closing of the sale generally consume less time. Result? More leads + quicker closes = more sales and greater profits.

2) **Image enhancement**. The extended time of an infomercial allows you to tell the full story of your business. Viewers can actually get to know you and your staff. They can learn about the education and experience that your firm brings to the table in order to better help them meet their needs. You can inform viewers about awards and community involvement. Take them behind the scenes to meet the behind-the-scenes people. Introduce them to current clients. You benefit from the endorsement, and your client benefits from the free publicity from the program.

3) **Joint-venture packages**. This is wide-open territory for exploration. Each business in every community has the ability to develop mutually beneficial relationships with other businesses that can be expanded to infomercials.

4) **Co-op advertising**. You've been through the fires of gaining approval for co-op assistance on advertising from your suppliers. You worry that their requirements will take away from the time for promoting your business. Infomercials smooth the way for everybody to have enough time to make their required points. A half-hour show can really sell your firm and the suppliers of your product.

We've been seeing the signposts for a long time. The future is communications. Infomercials are an ideal way to communicate your story to prospective clients. Ten years from now, they may be one of the primary methods of generating sales. Do you want to get the jump on the competition? Or do you want to wait until everyone's doing it?

The decision is yours.

Chapter Fourteen: Demographic Issues and the Client Nexus

> America has believed that in differentiation, not in uniformity, lies the path of progress.
>
> —*Louis D. Brandeis*

Niche marketing. Target marketing. Guerrilla marketing. The names may change, but such narrowly focused marketing generally takes aim at a definite market with a definite product. Or perhaps you choose to define your market by affluence, age, gender or any other factor you want. Just call a list company or database management firm and it will provide the names, addresses and phone numbers for your indicated target.

There are lots of pros and cons in the arena of marketing as to which is better—a well-aimed shot with a .22-caliber rifle or a broad sweep of buckshot from a shotgun.

Well, I don't intend to argue the arsenal. Instead, I am taking a middle position that will allow you to target all of your products to significantly large, but defined, markets: e.g., ethnic minorities, women and Generation X.

Because building a client nexus is an intensely personal way to do business, you have to understand individual perspectives in order to make it work. All too often, minorities are forgotten or ignored in marketing and customer service campaigns.

Like the misbegotten impression of alcoholics as bums in flash coats who live under bridges, erroneous assumptions about demographic groups abound. These faulty preconceptions can be costing us serious bottom-line profits.

The reality is that most minorities today, like the Irish, Italians or Greeks (to name a few) of years

Faulty preconceptions can cost

gone by, are hardworking, industrious individuals with needs of all kinds—and the means to purchase your product.

My former next-door neighbors were a good example. Fleeing from Iran during the Islamic Revolution of the late 1970s, this husband and wife—with two children—arrived in the United States and prepared to begin new lives. Under the Shah's regime, he had been a colonel serving as a mayoral equivalent for a large city. She was an educated housewife. Literally penniless, he began driving a taxi, since he couldn't find executive-level employment. Also unable to find work, she took computer training for database entry.

Today, he owns a dry cleaning establishment in an upscale suburb of Los Angeles, and she works as a middle-level manager for a major credit card processing company. One daughter is married and has moved out of state; the other lives at home and works in the loan department of a bank. The family now owns the dry cleaning establishment, a new suburban home, their former condominium (which is rented out with a positive cash flow), three nearly new vehicles and two dogs. It doesn't take an accountant to tally up their purchasing power.

You'll find examples like this throughout North America. Budding minority entrepreneurs open small businesses. Education has opened corporate doors for many second- and third-generation minorities. In other cases, foreign nationals sent here under corporate assignments for multinational firms are choosing to stay, and many wealthy citizens of the Far East are migrating here as they purchase homes and businesses with hard cash.

And yet corporate tunnel vision toward racial, ethic and other demographic minorities often precludes any marketing efforts to gain their business.

The Exceptions Have Become the Rule

According to *Time* magazine:

> Ethnic-minority shoppers, predominantly Afro-Americans, Hispanics and Asians, spent $600 billion on everything from toothpaste to shoes to cars last year (1992), up 18 percent since 1990. By the year 2000, minori-

ties may account for 30 percent of the economy.

In Los Angeles, the radio industry was jolted awake in early 1993 as a Spanish-speaking station took first place in the ratings. Although many considered it to be a fluke, that same station has remained in the No. 1 slot for more than two years.

Also in Los Angeles, the second-generation owner of a Chevrolet dealership in a Pasadena suburb watched his sales plummet as the demographics of his community changed to predominantly Asian. He had failed to learn the negotiation and buying habits of this group, let alone figure out how to reach them with advertising. On a daily basis, he watched his white, Anglo-Saxon sales staff idle away the hours without a single customer. And when an entire family (we're talking three generations) would arrive, usually with a translator, the sales staff would seldom close a sale. They did not know how to handle a group negotiation.

As a final effort before selling the dealership or filing for bankruptcy, he hired a new general manager who was experienced in trading within the Asian community. The new manager (non-Asian) began a multifaceted campaign that started with an analysis of the community. It turned out that there were about five or six dialects in the Asian community, and about 25 percent of the population was Hispanic.

Advertising in the major papers was canceled, and ads now run in about a dozen small local papers that cater to specific languages. A new sales staff was hired, with language being one of the major job requirements. Among the sales personnel, each of the major Asian dialects is covered, four speak Spanish, and everyone must also speak English. Traditional closing offices were torn down to create an open atmosphere in the showroom. Remaining desks have plenty of extra seating available, and three picnic tables have been installed for dealing with the larger family groups. No physical changes were implemented in the service or parts departments, but new personnel were hired to cover the major language barriers. The sales staff helps out when some of the less-used dialects surface.

Analyze the community

Guidelines for ethnic marketing

The dealership has regained profitability. Solutions are still being sought for major problems in areas of factory-mailed satisfaction surveys (most are tossed out by the customers, who don't understand them), and the dealership has not resolved how to handle ongoing written correspondence with its customer base. Most communications are handled by the sales personnel over the telephone.

Determining Your Demographic Market

If the geographic boundaries of your business include some ethnic minority population, you may want to consider the corporate advertising approach. Minority marketing was virtually non-existent in 1980. Most major corporations today have some type of marketing aimed at various ethnic groups. Such advertising totaled more than half a billion dollars in 1992 and is expected to reach $1 billion by 2000. Proctor & Gamble allots 5 percent of its total advertising budget for minority marketing, which may be a good rule of thumb for certain areas.

Here are some basic guidelines for ethnic marketing:

1) **Check the most recent census** for your geographic area and determine the ethnic mix. Major U.S. categories were 30 million Afro-Americans, 22.4 million Hispanics and 7.3 million Asian-Americans.

 Note: Prosperity among these groups has been increasing dramatically. Blacks earn twice the gross national product of Mexico, nearly $262 billion (more than $8,700 for every man, woman and child) and Hispanics earn $172 billion (nearly $7,800 per person). Asians, meanwhile, have a higher average family income than whites: $36,100 versus $30,400 in 1989.

2) Once you've determined the major ethnic categories within your area, **look at the mix within the categories**. Don't make the mistake of lumping all blacks or all Asians together into a single group. Haitian-Americans have little in common with American-born blacks. Likewise, major differences ex-

ist within the culturally diverse Asian community.

3) **Prioritize** the ethnic minority marketing you wish to target. This could be by population ranking, income levels, home ownership, educational level or business ownership.

4) Hire, or retain as a consultant, **someone who can speak the language**—and remember to be aware of the dialect situation with Asian-Americans.

5) Create **specific advertising**. Whether you are using direct mail, radio, television, print or telephone, your message needs to address the cultural realities of the particular group you are trying to reach. For instance, Hispanics react strongly to family security and will be more apt to notice an ad with a family setting. Asians, however, will be strongly motivated by a sense of accomplishment or achievement. With the black community, avoid placing white values within a black advertisement.

6) Investigate the **potential media**. Many of us are not even aware of the various publications and media that cater to the communication needs of ethnic communities. Search them out and discuss your plans and needs with their representatives. Many such conversations can open up a wealth of new ideas for you to contemplate, and most companies will provide translation services for free.

Note: Be sure to investigate foreign-language yellow pages. Ethnic marketeers swear by the results for such listings.

7) **Involve your new customers**. As you begin to add ethnic clients to your book of business, invite them to share new ideas with you as to how you can best service their marketplace.

8) **Become involved** within the ethnic communities you are targeting. Look into community clubs, groups and charities. If

you've hired an ethnic producer, support such activities. Most such communities place a high value on word-of-mouth endorsement, referrals and basically doing business with someone they know and trust.

Note: Don't forget sponsoring children's sport teams, holidays, festivals and church advertisements.

9) Conduct ethnic **sensitivity training** for your employees. You may create the most effective ethnic marketing campaign ever, only to sabotage it with inadvertent comments from employees that unknowingly offend.

If you're adding ethnic staffing as part of your efforts, this type of training gains in importance. Check with leaders within the specific community for available resources.

10) **Give it time**. In ethnic marketing, you're the new kid on the street, and they have to get to know and trust you before they buy.

A particular note of interest from the Direct Marketing Club of Southern California relates to the Hispanic community. While the average American household receives up to 300 pieces of direct mail per year (or more), the average Hispanic household receives only 13 pieces of direct mail. The impact of direct mail to these households is estimated to be extremely high, and Hispanic households are estimated to undergo a 48 percent increase by the end of the century. One direct marketing test of Hispanic response in New York drew a response rate nearly six times greater than that for average Anglo-American marketing.

On a final note—recalling the critical value of repeat business for long-term growth and profits—most analysts agree that the minority consumer has a far higher propensity toward loyalty than the average Anglo customer.

X Marks the Future

Are you finally getting a handle on the needs of the senior citizen market? Did you find a niche to target the Baby Boomers? Well, don't get too comfort-

able. There's a brand-new market upon us! It's the post–Baby Boomer, currently aged 18 to 29 and affectionately called Generation X.

Like every market segment that has ever been found, the X Generation is a whole new ballgame, and its needs are not yet being met. According to Karen Ritchie of McCann-Erickson Worldwide in Troy, Michigan, part of the problem in reaching this market is that many of the corporate decision-makers—Baby Boomer people—still think of themselves as the youthful generation.

This point was dramatically (and somewhat painfully) brought home to me recently by the 24-year-old daughter of a valued client and friend. This friend and I recently established a new company for direct marketing of a retail product through television commercials. The product is designed for females aged 18 to 49. We had begun scripting for the TV commercials when his daughter, who handles the marketing for his firm, commented, "You're probably right on target for 35 and up, but you better let me handle the approach for the younger buyers. Your way won't get their attention."

She was absolutely right!

Those under 30 have grown up in a visually intensive media world that didn't exist 10 or 15 years earlier. As a result, it takes a much stronger visual impression to catch their attention. With some hindsight, I now realize that I have seen this phenomenon frequently at home with our teenage daughters. My wife and I might see a commercial that we think was really good, maybe even causing a chuckle. But the only reaction from our daughters is a raised eyebrow and a look that questions our sanity.

The reality is that we Baby Boomers who comprise much of the business management world are facing middle age. Therefore, if we are sincere about wanting to reach the youthful market, we need to discover the needs and wants of Generation X and then determine how to reach them with our marketing.

The first rule to learn is not to make any judgment based on your own experience or lifestyle. Generation X, aside from its tremendous media awareness,

Ford uses college students as market advisors

is a much more serious and cynical group than Baby Boomers. They've watched the economy spiral downward, causing readjustment of family lifestyles, and they've been bombarded with dire news about their environment. They also tend to be cynical about the establishment, which is a symbol of the dismal economic and environmental news.

Despite Xers' familiarity with the media, conventional media does not appear to be the right way to reach this market either. With the notable exceptions of MTV, Comedy Central and certain magazines that have catered to them, most Xers feel that conventional media has made little, if any, attempt to look at issues from their perspective. However, that is sure to change as the Xers move into media management in the next 10 years.

Ford Motor Co. is currently taking its sporty, youth-oriented vehicles to local high schools, offering ride-and-drive programs for teenagers. The driving sessions highlight accident avoidance techniques, skid control and proper braking and steering. The vehicles used for the sessions are those that might be of interest to the students. The program was rolled out nationally as Ford Motor Co.'s Safe Driving School with Bob Bondurant.

Serious about the youth market, Ford also has established a National Youth Council of 14 college students, who serve as market advisors. At the council's prompting, Ford began a hard rock ad campaign this past March, and displayed vehicles on Florida and Texas beaches during spring break.

It is important to note one point that was made by Ritchie, "The X Generation is very worried about the future. Baby Boomers, as did their parents, trusted the system to take care of them. Xers believe that they will have to take care of themselves." Marketing to this psychology can be difficult, but very profitable if done properly.

The profitable nature of marketing to the Xers was made clear in a recent survey by the American Stock Exchange. The surprising results were directly correlated to the Xers' lack of faith in the long-term viability of Social Security. Their cynical nature has caused them to become a serious group of investors. Affirming the assumption that they cannot rely

on the government for retirement, 79 percent indicated that they already are saving for a long-term goal, such as retirement, emergencies, major purchases or "just for the thrill of it." In contrast to the 25 percent of the general public that owns mutual funds, 52 percent of the Xers surveyed own mutual funds. In other investments, 32 percent of the Xers replied that they own individual stocks and 24 percent own bonds. This compares with about 20 percent of the general public's ownership, according to the Amex survey.

Start by talking with your younger clients, as well as the children of your older clients. Take time to get to know them. Ask questions about their concerns. Think of it as a chance to be adventurous and to take a look at things from a 25-year-old's point of view.

Once you get a feel for their hot buttons, think of direct marketing and customer service as the primary vehicles to reach them. Target the message and target the recipient of the message.

As the father of three teenage drivers at one time, my insurance agent had a tremendous opportunity to build and grow relationships with these three drivers who are currently insured by his agency. During their teenage driving years, he never made an effort to protect his future by developing a relationship with them. He could have sent them personal letters on the importance of insurance or explanatory material about the services provided by the industry, or simply made a call to talk with them about the responsibilities of driving. Are you cultivating the futures that already exist within your current clients?

A recent full-page advertisement for MTV appeared in *Automotive News,* which makes the X Generation point clearly and succinctly.

Better than half the page was devoted to the picture of a 24-year-old fellow slouched in a somewhat tattered easy chair. His hair was long and a bit unkempt; the jeans torn at the knee. A leather vest covers his faded T-shirt, and his boots were of the combat variety. Ironically, his personal adornments of beaded necklaces, multiple bracelets and rings were reminiscent of the Boomers' heritage of

MTV—making its point clear

A radio station builds an identity

the 1960s. The copy headline read: "Buy This 24-Year-Old And Get All His Friends Absolutely Free."

It continued with the most descriptive copy about Generation X that I've seen:

> If this guy doesn't know about you, you're toast.
>
> He's an opinion leader.
>
> He watches MTV.
>
> Which means he knows a lot more than just what CDs to buy and what movies to see.
>
> He knows what car to drive, what clothes to wear and what credit card to buy them with.
>
> And he's no loner.
>
> He heads up a pack. What he eats, his friends eat. What he wears, they wear. What he likes, they like. And what he's never heard of ... well ... you get the idea.

Case Study: Y-107 FM

In 1996, New York–based Odyssey Communications put together a management team to handle the formidable task of bringing a new radio station to the crowded Los Angeles market. That, in and of itself, would be brutal enough. Now add to it that the alternative rock format would mean selling the station to the 18- to 34-year-old market, while simultaneously convincing advertisers that this was the perfect vehicle to target that same market.

The first task was to create the single marketing identity of Y-107, which plays off the 107.1 location on the FM radio band. This was critical because, unlike most radio stations, Y-107 had been three separate stations. Each had the frequency of 107.1, each covered unique geographical areas of Los Angeles, and each maintained unique, individual identities before being purchased by Odyssey for simulcasting under a singular identity.

"We aimed our format at the 25- to 34-year-olds, acknowledging the younger 18- to 24-year-old market. This means servicing people who grew up with the alternative rock movement, love the music, but don't love the typical disc jockey banter. They want

to hear good music and lifestyle deejays that are intelligent, who can talk about things on an intellectual basis without taking 15 minutes," says general sales manager David Howard.

So how does a new owner take three stations with totally different formats, combine them into one with a brand-new format and build an audience quickly in one of the world's toughest radio markets? The first step was to hit the airwaves without disc jockeys.

Ironically, Howard admits, "This decision was primarily based on security. We couldn't go out and interview on-air talent without leaking our format plans, which would have given the competition time to prepare for us. Yet we also felt that this would give us time to make sure our musical sound was right where the audience wanted it to be. It's a novelty at first—no talk and very few commercials—but eventually listeners want to identify with on-air personalities, and this gave us time to solidify the format and eventually hire personalities that would complement the music."

Y-107 wasn't content with the mere novelty of lots of music and very few commercials. Prerecorded announcements had a computerized edge to the sound. "It's a cool, hip sound—kind of related to the sound you'll hear on MTV sweeps. Our program and production people are pretty young and very *street*. They have a pretty good vibe on what's going on ... kind of on the fringe ... which is really what you want for this kind of market," Howard says.

Getting in touch with the early listeners who found the station on the dial was key to validating the chosen format.

"We did a lot of e-mail the first nine weeks," says Howard. "When we first went on the air, we told people that we were brand new, didn't even have phones, and the only way they could contact us was by e-mail at Y107@AOL.com. After the first day, we started averaging 75 e-mails per night. For a station that wasn't even on the air a week earlier and had an unknown dial position, that was such an incredible response that we then knew we were headed for success. We have a sister station in New York that has been very aggressive on the web, and

Validating the chosen format

Be honest and remember the Three P's

they were only averaging about 25 to 30 e-mails per night."

Y-107's e-mail is now holding at about 50 to 60 messages per night, but that also reflects the fact that listeners are told that they can contact the station by phone, and they can use an 800 line for requests.

Once the station had decided that the sound was right, it was time to develop a marketing campaign to let people know the station existed. Howard remembered a station that came out of the box with a $3 million ad budget that attracted a lot of attention. But it didn't have the staying power because, as Howard puts it, "They had a lot of 50-year-olds driving down the freeway listening to Guns 'n' Roses—who finally woke up and realized it wasn't their station of choice. We wanted to establish our sound and our market—our foundation—before we began investing in marketing expense."

Generation X is a smart and very skeptical audience that doesn't want to be tricked by marketing gimmicks. "That's why we didn't say we were commercial-free. We came out with commercials—not a lot—but enough to let them know we were a commercial station. They appreciate the honesty," Howard says. "In fact, we consciously resisted telling the audience what we were going to have for them. We told them what we did have for them."

Howard believes in the *Three P* law of creating a client nexus: product, price and people.

Clearly, Y-107 has a commitment to creating a product that the listeners want.

According to station executive Sean O'Neill, "As far as price, we believe we've structured a fair price. Odyssey avoided the huge debt load normally associated with the purchase of a major market station, which would normally be about $100 million and a $30 million operating budget for the first year. We're not even close on either count. This puts a lot of pressure on our competitors. We can provide the same audience at a lower advertising cost."

On the people side, Odyssey made a point of bringing on proven market professionals, like Howard and O'Neill.

In order to attract, build and retain the listener base, Y-107 has taken it to the streets to inculcate the station into the lifestyle of the listener. This style of marketing doesn't rely on an expensive television and print advertising budget. It places the emphasis on networking with the potential listeners.

"Our marketing person put together a street crew that will be out at lifestyle events, clubs, concerts, sporting events, beaches. Where our listeners go, so does the street crew," Howard says. "It's a group of 15 good-looking, hip kids that run a gamut from artists to musical purists to just regular nice kids. They're the ambassadors, the front line."

He goes on to give an example: "Before we even had our vans, four of the girls rented a bicycle built for four and cruised the beaches, handing out little flyers. This is really street, it's guerrilla. They said that we were really new, didn't even have a van yet, but wanted to let everyone know that we were here. Everybody always like to see the underdog win!"

Does this type of street marketing work for the youthful generation? O'Neill thinks so. "Our first three-month book gave us a 1.1 share overall, with 1.5 in the 18-to-34 market and 1.0 in the 25-to-54. That was unbelievable—considering that it included our start-up month, which means that our future three-month books will be even better."

So do the Y-107 people have any recommendations on how to reach this market? "Above all, be honest. Tell the truth, but tell it in a way that reflects their lifestyle. You need to incorporate the hipness factor—on the edge, extreme."

The Female Market

Every time I think about targeting the female buyer, Joseph Conrad's comment comes to mind: "Being a woman is a terribly difficult task, since it consists principally in dealing with men."

In the mid-'70s, the automotive industry misunderstood the importance of marketing to women and simply ignored them. Any such marketing aimed at females was secondary in nature and sometimes accidental. The standard line was: Women might have input on the color and the interior decor, but men make the purchase. That was the philosophy

Does your business stand at the brink of change?

and so went the marketing. The auto industry has changed, but many others have not.

Today, the automotive industry recognizes that women are the primary force in more than 50 percent of all automobile purchases. This dramatic shift can be attributed to both the increased factor of women in all levels of the workplace and greater sharing of decisions among married couples.

As a result, we've all experienced the new style of automotive marketing: less dependence on the maxim that "sex sells," more spokeswomen emanating a confident aura of professionalism, less emphasis on raw power and mechanical detail, greater concern about safety and durability.

Does your industry or business stand at the same brink of impending change that the auto industry experienced 20 years ago?

Looking into that chasm of change, I can't promise hard answers, nor a 1-2-3 remedy. I can promise to jar your thinking and perhaps initiate a process of change. All of which brings to mind one of my favorite sayings, "There is no pain in change, only in the resistance to it!"

Here are just a few recent examples from various industries:

- A recent radio ad campaign in Los Angeles: "If you're a woman, (major company) sells life insurance!" At least give the company credit for trying to market to women, but targeting women in this manner will backfire. It reminds me of a recent sewing machine ad in the *L.A. Times* headlined: Wife Wanted!

- Yours truly on the telephone to major financial companies: "May I talk with someone knowledgeable about marketing to women?" I got the following replies:

 1) "We don't have anyone with that background."

 2) "What do you mean by marketing to women?"

 3) "That's an interesting concept. Maybe we ought to look into it."

4) "If you find out anything, let us know about it."

- A Travelers' Insurance advertisement headlined: Mrs. Bloomer Pulled No Bloomer. This addressed significance of the female market, but it has an undercurrent that is almost patronizing. Would you use the historical perspective of slavery to target the black market?

Positioning your company with an effective image in marketing to women clients can be invaluable. Some ways might be to:

- Use the women within your own operation as spokespersons within your community. Don't hide them behind the desk and the phone. Get them out into the public eye. Evaluate their areas of expertise, and promote their participation in these areas at seminars, workshops, community speaking engagements, etc.

- Highlight the women in your organization and their contributions in your public relations efforts. If you show that you value your female staff, it will create a favorable image among female clients.

- Avoid making marketing decisions within what has been described as a "macho-male bonding rite of the Madison Avenue variety." Invite the women within your company to participate equally in the advertising and marketing decisions.

Many businesses use client endorsements within their brochures and descriptive literature. Are you using the endorsements of female clients on a parity basis with male clients? If not, perhaps it's time to update your brochures.

Several suggestions to market more effectively to women are:

1) Use an **educational approach** in both marketing and sales presentations.

2) Adopt an **attitude or sales style** that treats every client with the proper respect. Don't be condescending to the female buyer.

Education—
a key approach

3) Avoid the **high-pressure approach**. It will quickly and surely turn off a female prospect.

Female Vision

Oppenheimer Funds is a leading force in effective marketing to women within the financial services industry. It should come as no great surprise that this emphasis on marketing to women comes directly from Oppenheimer president and chief operating officer, Bridget Macaskill. According to Macaskill, "The cultural barriers are falling. Women have the smarts, the disposition and the confidence to invest successfully; what they've lacked is the experience."

Macaskill knows of which she speaks. Prior to leaving a successful position as the marketing director of a $2 billion-a-year British food company to join Oppenheimer, she was apprehensive about making the change due to a lack of experience in financial products.

Marketers should pay close attention to Macaskill's comment, "The good news is that women know they have to move up on the learning curve, and many of them seem genuinely interested in doing so. In any event, lack of knowledge should never be confused with a lack of ability."

From a marketing and sales standpoint, education will be key. In general, women are more comfortable than men in admitting that they don't know something, then asking the questions that will enable them to learn. This will require a shift from marketing to males, who often fail to admit their lack of knowledge. Assumptive presentations that have worked with men probably will fail with women.

In a recent survey of 2,021 men and women commissioned by Oppenheimer Management Corp., 95 percent of all respondents (men and women) said they generally discuss a major investment before it is made. On an interesting side note, 93 percent of the men felt their loved one would be able to handle household finances were they to die or become incapacitated. Only 89 percent of the women felt their spouse could handle it.

Macaskill also pointed out, "Our survey suggests that the popular notion that money is a constant source of conflict in most relationships is out of date. With the great increase in dual-income households, finances are emerging as a shared responsibility." The survey, however, found that 57 percent of all women respondents felt that women were treated with less respect than men by financial advisors. And 54 percent of the men agreed.

"Financial advisors," says Macaskill, "can play an increasingly important role in helping women to take charge of their financial futures, but this will only happen if women believe they will be treated with the same respect as men. Women don't want special treatment; they want equal treatment."

Overcoming the Negatives

How to achieve this equality in treatment with a difference in approach is the challenge that lies ahead. Perhaps the first step is to reduce the negative assumptions in advertising and marketing. Avoid the blatant "if you're a female" and "for Asian communities" approaches. Look for and discard that which might be patronizing or demeaning.

Turning once again to the auto industry, other manufacturers might learn from Hyundai's recent decision. Based on a consumer protest group's letter advising 60 advertisers in *Sports Illustrated's* Swimsuit Issue that the issue is degrading to women, Hyundai pulled its advertising. Hyundai advertising manager Joe Corey commented, "If this particular issue is of concern to some of our customers, we'd prefer to stay away from it."

Let's hope other companies will learn from Hyundai's action. But at the moment, letters were sent to 60 advertisers; only Hyundai listened. The reply of letter writer Linnea Smith, a North Carolina psychiatrist who started the lobbying effort: "I'll tell you this. My next car will be a Hyundai!" All of which illustrates the importance of carefully evaluating where your advertising and marketing are placed.

Achieve equality with a different approach

Look for sub-groups within groups

Some Final Thoughts

The most encouraging thing about developing a client nexus with targeted demographic groups is that it's cheap. Many minorities have so little attention paid them that the simplest brochure, phone call or jot of customer service will have a much more dramatic impact than populationwide campaigns.

These sub-markets are also well situated for guerrilla campaigns. All you need to do is identify a promising group, hire a handful of members as customer service reps—and then turn them loose.

In case you're wondering about the potential of the female market, these statistics from The Oppenheimer Fund can provide an answer:

- In 1990, the earnings of American women rose to $931 billion, up from $202 billion in 1975. (That's a 461 percent increase in 15 years ... and rising.)

- In 1986, there were 3.3 million Americans with gross assets of $500,000 or more—41.2 percent of these Americans were women!

- In 1990, there were 56.6 million American women in the civilian labor force. (That's more than double the number from 1960.)

- Females born in 1990 will, on average, live seven years longer than males born in that same year.

- In 1989, there were 10.9 million female-headed families in America, up 25 percent from the 8.7 million of 1980.

These statistics only scratch the surface when you consider the increased number of women-owned or -operated businesses and increased numbers of women decision-makers in middle and executive management positions.

What's the real potential of these target markets? The real potential is so big, your future may depend upon it.

CHAPTER FIFTEEN: HOW TO RUN AN EFFECTIVE CUSTOMER SERVICE MEETING AND FIND THE RIGHT PEOPLE TO ATTEND

> *Meeting,* noun. 1. A coming together; assembly. 2. A joining. 3. A hostile encounter, as a duel.
>
> —*Webster's American Dictionary*

> *Meeting,* noun. 1. A potentially effective method for planning, education, training, problem-solving. 2. A forum for selling. 3. A ridiculous waste of time.
>
> —*Jack Burke*

It's amazing that we get any business done with all the meetings that get in the way.

I better make a full disclosure right off the bat: I may not be able to achieve total objectivity in a discussion of meetings. This particular word has engendered a lifelong love-hate relationship. During my prior life in corporate America, I often thought that the true goal of business was to conduct as many meaningless meetings as possible. The generation of profitable revenue was merely an accidental byproduct. Having stated my position and accepted the fact that Meeting Planners International may be planning my lynching, please feel free to continue at your own risk.

In order to gain some perspective, let's use PMS as a guiding acronym for setting up meetings: planning, motivation, sales.

And, in case you feel like screaming at the thought

Don't confuse "planning" with "sales"

of a meeting, let's add AEIOU as the acronym of evaluation: appearance, education, incentive, organization, understanding. PMS relates to the purpose of the meeting, AEIOU to the effectiveness in achieving that purpose.

In taking a look at PMS, it's a good idea to note that a productive meeting is singularly goal-oriented. Non-productivity usually results from criss-crossing goals and creating confusion.

Planning

Planning is probably the most abused, and under-used, meeting category. The first misconception is that "planning" meetings is strictly internal. This is a reasonable myth, since a lot of planning does occur internally. Short- and long-term business planning is a prime example, which should be a compilation of numerous sub-divisions of planning. In fact, every segment of business requires planning.

Although internal planning is significant, this type of meeting can be very valuable externally. For instance, an annual review with a client is really "planning," rather than "sales." Even asking a client to evaluate your service is really planning, because it gathers the information necessary to the development of future action. Don't make the mistake of placing all client calls into the sales category.

Planning is primarily the development of strategy: How are we going to achieve a desired result? It can be the optimism of growth, or the reality of problem-solving. It can be a brainstorming of possibilities or a final pre-implementation review.

Motivation

If you've been thinking that the PMS acronym missed education and training, fear not! They are merely spokes in the wheel of motivation. After all, motivation is incitement to action. And action without preparation (which includes education) can be disastrous. Motivation, again relating to both internal and external meetings, covers even more territory than planning.

Internally, motivation envisions sales meetings from the rah-rah variety to the brow-beating, fear-inducing type. However, motivation also must include ev-

ery type of education and training that is necessary to your operation. Motivation can even include an annual meeting to disclose next year's plans to the general staff. If it incites to action, or provides the tools necessary for the action, it is motivational.

Externally, motivation can easily be confused with sales. Don't make that mistake. Motivation lays the foundation for selling—it is not selling in and of itself. As an example, holding a value-added seminar for clients and prospects is educational, therefore motivational. Yet you are paving the road to a selling opportunity. Likewise, a meeting on a boat or the golf course should be primarily considered motivational. The ambiance of the location or occasion helps to motivate clients or prospects to place or retain their account with you. It helps build the relationship that is crucial to the subsequent sales.

Sales

Sales brings to mind the chicken or the egg dilemma. Is selling the reason behind planning and motivation, or do planning and motivation result in sales? There are arguments on both sides, but I lend myself to the latter—without planning and motivation, there wouldn't be any selling. Selling, though, is not merely external to your clients and prospects. It is a much-required art for smooth-running internal operations, too!

On the outside, a sales meeting can take place within any type of venue, and it's impossible to cover them all. Suffice it to say that the evaluation acronym, AEIOU (which we are about to review), is all-important to successful preparation for sales meetings.

Sales meetings within an organization are not as easily understood. To sell is to convince. A sales meeting is one in which you will convince somebody of something. For instance, you are about to implement a number of changes to reorganize your customer service operations. A sales meeting is in order. The purpose of the meeting is to convince your staff that the change is for the good. The key here is to understand the purpose of the meeting. If you need to convince anyone of anything, it is a sales meeting.

Guidelines for meetings

Preparation is essential to successful meetings. Once you have established the goal of the meeting, PMS, it is necessary to understand how the effectiveness of a meeting is evaluated in order to better prepare.

Appearance

If it walks like a meeting, talks like a meeting and looks like a meeting, it probably is a meeting. If you are going to have a meeting, have a meeting. If you are going to gossip, whine or simply chew the fat, recognize that is what you are doing. Don't try to dress it up and call it a meeting. You'll end up giving all meetings a bad name.

Here are some basic guidelines for calling a meeting:

1) Have a purpose, a goal.

2) Have an agenda.

3) Determine participants.

4) Set a time frame.

5) Keep a record.

6) Follow up.

About 10 years ago, I was visiting an auto dealership and was invited to attend its weekly meeting. Having attended many such meetings in the past, I was looking for a quick exit. My experience was that car dealers didn't know how to conduct meetings. Disorganization, meandering discussions, repetitive discourse, rah-rah and butt kicking seemed to be the mainstays. Fortunately, there was no escape, and this turned out to be a truly enlightening visit.

About 10 minutes before the start, people began convening in a meeting room, and they were all carrying calendar books, reports and notepads. At the precise time, the general manager called the meeting to order and called the roll. For the next 60 minutes, I sat in amazement as the entire meeting processed itself according to Robert's Rules of Order. Minutes were read, action reports were read, old business was put to rest or updated, new business was entered for consideration, and decisions were made. Toward the end, gripes were entertained from the various representatives of each operational

faction within the dealership. Finally, the meeting closed with awards and recognition, for an upbeat ending.

I had never seen such a meeting within the auto industry before, nor since. And it's not surprising that this dealership was immensely successful. The management definitely knew how meetings should appear.

Education

Education is loosely defined as the development of knowledge. Whatever the category of a meeting (planning, motivation, sales), if it does not encourage and develop knowledge, it is wasted time and effort.

Have you ever felt that somebody should have just recorded the last meeting and played it back this time because nothing changed? Nothing was new. That is an example of a meeting that failed to meet the education aspect. Be creative. If you don't have something new to offer, find someone who does. Education adds stimulation and excitement to a meeting.

Picture a salesperson and a prospect that didn't buy. What do you imagine the odds would be of closing that prospect down the road with the exact same approach and material? It didn't work before and probably won't work the second or third time around. Search out new ammunition, new approaches.

Incentive

Will this meeting incite anyone to effort? That is the question! Know what you want to accomplish, then pre-plan a strategy for the meeting so you will achieve your goal.

Have you ever sat through one of those training videos known as the talking head? You know the type. One camera on a single speaker for an hour or two. Kind of hard to keep your attention, let alone teach you anything. Are your meetings like that?

The greatest incentive is participation! Encourage everyone to participate actively in a meeting. Like my friends at that dealership, use meetings to rec-

Organize and distribute an agenda

ognize achievements. Praise before one's peers offers tenfold the benefits of praise behind closed doors.

In a sales or motivational meeting, incentive is most crucial. Educate with the features, incentivize with the benefits. Whatever the incentive, no sale was ever made without one.

Organization

Excuse my repetitiveness, but that dealership meeting was a lesson in organization. Going back to the basic guidelines of appearance, make an agenda and then distribute it in advance to the attendees. The worst-case scenario is to call a meeting that is attended by people who are not prepared because they have no idea what's on the agenda. Ignorance of this nature only results in embarrassment and humiliation—not the greatest incentives.

You've often heard the expression: Plan your work and work your plan. That perhaps is the best wisdom available for a meeting. Without an organized plan to achieve your goals of the meeting, you've wasted your time. So, plan the meeting and meet according to the plan.

Understanding

This final note is extremely simple to understand.

Understand what you want to accomplish with the meeting. Understand how the meeting can accomplish it. Understand what you expect of the meeting. Then utilize the meeting to pass on that understanding, so that everyone in attendance also will understand.

When it comes to the meetings in your future, think in terms of quality time, not quantity. So, let me leave you with a modern paraphrasing of an old Irish blessing:

> May the elevator rise smoothly,
>
> Profits rain gently on your revenue,
>
> Success embrace your endeavors,
>
> And may your achievements be more bountiful than your meetings.

Using Benchmarks Effectively

How you measure your customer service performance is the single most important subject matter you can encounter in a meeting on the subject. There's a lot of confusion—and willful delusion—about how to go about this.

"We have found from our research that most companies grossly overestimate the satisfaction levels they provide to their customers," says James Morehouse, vice president for the supply chain integration practice at A.T. Kearney, a Chicago-based management consulting firm. "Customers are far more unhappy than most companies believe."

I believe him. And this is a major challenge for good customer service.

Unsatisfactory purchases, though varying by product and service categories, appear to be widespread—ranging from 20 percent to 33 percent, according to various studies.

A 1996 poll of 10,700 consumers conducted by California-based AutoPacific Inc. found that more than half of all used-car buyers are unhappy with the way they are treated when they shop on new-car lots. General rudeness and lack of product knowledge were the biggest complaints.

The findings were important for auto retailers and manufacturers. Both groups were dealing with a glut of high-quality used cars coming to market, as a result of the recent increase in auto leasing.

The survey was good news for so-called superstore used-car sellers, such as Circuit City's CarMax and AutoNation, owned by Blockbuster Video founder Wayne Huizenga. Both companies look to win over unhappy car buyers by emphasizing customer service.

"What we found means there is potential demand out there for what those types of [used-car dealers] have to offer," said AutoPacific founder George Peterson.

Peterson said the new superstore dealers also should be concerned about the poll, which he believes is the biggest survey ever to look at the used-car industry.

Use surveys to measure service

Using ACSI as a benchmark

"The problems we're finding are easily correctable," Peterson said. "And, right now, with used cars representing more profit than new cars, there's incentive for new-car dealers to fix those problems."

The remedy, according to Peterson, is for new-car dealers to train used-car sellers in the same manner they train sellers of new cars.

Another relevant measure: The American Customer Satisfaction Index (ACSI) is a national barometer of customer evaluations of the quality of goods and services available to U.S. households. In the ACSI, customers' evaluations of quality are based on actual experiences with the good or service being measured.

The national baseline ACSI score was 74.5 when the index was first released in 1994, and it has declined steadily since.

On the positive side, during the 1990s, the gap closed dramatically between U.S. and Japanese automotive companies. In 1994, the gap was 3.3 points; in 1995, it was 1.2 points; and in 1996, it narrowed to 0.7 points.

"These results provide a clear indication that the efforts by auto manufacturers to listen to the customer are reaping dividends," said one auto industry watcher.

An important point: Product quality scored higher than service quality for all automotive companies—domestic and import.

ACSI results for the automotive industry have been comparatively steady—79 in 1994, 80 in 1995 and 79 now (down 1.3 percent from last year). Overall, a small drop in customer satisfaction with manufacturing durable products, coupled with declining satisfaction with government agencies, has brought the ACSI to its lowest level in three years, 72.4 on a 0-to-100 scale.

Some more specific points:

- Despite the increased capabilities of personal computers, satisfaction with them dropped 2 points (-2.7 percent) between 1995 and 1996—and 5 points between 1994 and 1996. Most industry experts ar-

gued that the drop was attributable to lower service quality—not product quality—and perhaps to the broadening of the marketplace to include less experienced computer users.

- Satisfaction with television sets and VCRs and with household appliances remained steady through 1995 and 1996, but was down from 1994. The decline in satisfaction with manufacturing durables is small compared with the drop of 4.4 percent in satisfaction with the public sector.

- User satisfaction with local government services scored higher than that for federal government services: 59 on the 0-to-100 scale for police services in central cities (unchanged since last year); 63 for police in suburban areas (-4.5 percent); and 76 for solid waste disposal in both central cities (+1.3 percent) and suburbs (unchanged).

ACSI is co-sponsored by ASQC and the University of Michigan Business School, and is partially supported by corporate sponsors. The University of Michigan Business School is the home of the National Quality Research Center (NQRC), where the index is compiled.

"It's good news that the auto industry is bucking the trend, but today's ACSI results overall indicate a disturbing decline in the quality of goods and services available to Americans," said Claes Fornell, the University of Michigan Business School economist who designed the ACSI. "With consumer prices up and productivity down, this drop in quality is cause for concern about the state of the economy."

The Internal Revenue Service (IRS) showed marked declines in customer satisfaction during 1995 and 1996, receiving the lowest American Customer Satisfaction Index score ever.

Satisfaction with the IRS dropped 7.4 percent, from 54 in 1995 to 50 in 1996. (The IRS scored 55 in late 1994, when the ACSI baseline was established.)

"It may be unfair to measure customer satisfaction with the IRS—they're selling a product nobody

A decline in quality available to the Americas

Downsizing leads to a decline in satisfaction

wants—but it is important to note that after remaining stable from 1994 to 1995, satisfaction has dropped significantly this year," said Jack West, head of the customer service trade group that publishes the ACSI.

The same downsizing issues that impact other industries came into play with the IRS rating, too. A number of watchdog groups predicted that consumers would be in for more disappointment with the IRS—since the agency had announced it would cut 5,000 jobs beginning in early 1997.

"Typically, we see that when jobs are cut in customer service areas, satisfaction declines," said West. "However, in the case of the IRS, we could see that customers might actually be more satisfied if the probability of being audited goes down."

Surveying Car Buyers

Saturn and Lexus owners had the best car-buying experiences at dealers in 1995. But consumers have gotten harder to please in the showroom, according to a report released in 1996 by California-based automotive research company J.D. Power & Associates. The report also found that consumers' buying satisfaction had declined slightly for the first time in 10 years.

The survey measured the customer's satisfaction with the salesperson, delivery of the new vehicle and the condition of the car or truck upon delivery. J.D. Power surveyed 52,066 buyers of new cars, minivans, pickups and sport-utility vehicles bought in November and December of 1995.

The report focused on a measurable indication of consumer frustration with the traditional approach to new-vehicle sales. One reason: Buyers have access to more information on new cars and prices through the media, including the Internet.

According to Jon Osborn, a senior project director at J.D. Power:

> An informed shopper may have as much, if not more, knowledge going into a dealership than some salespeople. The expectations that these individuals have regarding what they want and what they are willing to pay are greater than ever.

The increased research consumers are doing before they enter a dealership also may be contributing to a five-year trend of buyers shopping at fewer dealers and looking at fewer brands before making a decision, the J.D. Power report said.

Partly in response to the J.D. Power report, Nissan Motor Corp. USA's Infiniti division announced it had restructured its relationship with dealers "to meet the challenges in the new era of automotive retailing."

The new structure would build on Infiniti's customer-care program, called the Infiniti Total Ownership Experience, with:

- a **"consumer-based" pricing** plan that brings Infiniti's Manufacturer's Suggested Retail Price (MSRP) closer to actual retail transaction prices, and is designed to reduce the amount of time typically spent on price negotiations;

- an expansion of **roadside assistance** and service loaner car support to include both new and previously owned Infiniti models purchased through the Infiniti Premier Pre-Owned Vehicle Program;

- a new **price assurance** policy that assures consumers that, if the nationally promoted price of a new vehicle by Infiniti is reduced within the 30-day period after purchase, the difference will be refunded;

- a three-day **purchase guarantee** from the dealer on Infiniti pre-owned vehicles;

- expanded attention to customer service, supported through an enhanced level of **comprehensive training** for all Infiniti retail personnel; and

- a new **"Thinking of You"** advertising campaign.

Roger Jolicoeur, a vice president at Infiniti, said:

Customers in the 1990s have a variety of alternatives to visiting a dealership—from the Internet to car brokers to used-car superstores. While these alternatives are a legitimate challenge to the dealer franchise system, we believe nothing is more effective in

Infiniti restructured its relationship with dealers

Retailers and buyers should not be adversaries

meeting the needs of the "new consumer" than a true bond between a manufacturer with a strong brand identity and a group of dealers who have established an outstanding reputation for customer service. Infiniti and its dealers are in the right place, at the right time, with the right programs to lead the industry into the new era of the consumer.

Infiniti marketing studies showed that the typical new-car buyer drives to several different dealerships because of price concern. This concern, in large part, was spurred by the industry's reliance on extensive marketing measures—which often cloud a vehicle's actual purchase price.

Infiniti sought to eliminate this concern with a new consumer-based (in other words, lower) pricing plan.

Jolicoeur concluded his announcement of the new customer service plan by saying:

> By starting the negotiation process closer to the finish line, our sales consultants can focus on what's really important—meeting our customers' needs. Consumer-based pricing is just one more way to empower our salespeople to be advocates for our customers. Retailers should be advocates for the buyer, rather than adversaries. Infiniti and its retailers must create an innovative relationship which serves our customers. Enhanced training is an important tool in empowering sales consultants to make every customer contact completely satisfying. We've thought about every aspect of how customers shop, purchase, own and enjoy their new and pre-owned Infiniti vehicles. We've thought about the relationship between manufacturer, retailer and customer. We believe we're leading the way into the next century by working with the customer instead.

Wouldn't it be nice if the next page in this book was a form that enabled you to accurately identify and gauge valid performance standards? Well, as that HBO series was titled, *Dream On*. Every company, even within similar industries, has a different set of standards that apply to a different set of products and people.

However, I would like to suggest "What Counts?" as an agenda topic for your next staff meeting. In preparation, I might also suggest that each of the attendees be assigned the task of reading this book beforehand. The purpose of this meeting is to determine your exact standards of performance. Subsequent meetings can then work on application and evaluation of these standards.

What Counts?

1) **Divide** your business into specific categories, such as sales, service, manufacturing, shipping, warranty, general operations.

2) Within each category, **determine and itemize** the various activities that impact your customer. For instance: Warranty or claims service might include answering the phone, claim initiation form, review, authorization, resolution.

3) Within each identified activity, **discuss and ascertain** what are the critical components in the mind of the customer. For instance, let's take one that could apply to a number of categories: answering the phone. How long does it take for the call to be answered by customer service? How long does the average call take? How much time does the customer spend on hold?

4) Once you've identified the measurable specifics, **expand** through some general brainstorming. For instance, should customer service personnel be provided with telephone headsets to free up their hands? Would it be beneficial to have an integrated telephone/computer system with a *screen pop* feature (the computer identifies the customer as he or she picks up the phone and all relevant information appears on the screen)? Could information be given to the customer over the hold system of the telephone? Do we have enough line capacity for the demands on the customer service telephones?

5) **Prioritize** the data. Under each category and subcategory, rank the activities accord-

What are the specific activities of your business?

Reward repeat sales

ing to the importance you believe is placed upon them by the customers.

6) **Verify** your findings with reality. Develop a questionnaire listing your "performance activities," and ask your customers to rank them according to importance.

7) **Establish** a final ranking based on your findings and customer reality.

8) **Identify** any actions the company can take to improve the performance of each activity that are beyond the normal scope of the individual employees.

9) **Select** ongoing evaluation teams to monitor progress in improving performance.

10) **Monitor** the evaluation teams on a monthly basis, and hold a full staff performance review meeting at least once per year—preferably twice.

Who Should Be in This Meeting?

The skills required to make a sale are sometimes very different from the skills needed to service that sale. Thus, there is sometimes a need for additional sales support positions within a company. All too often, a high-performance salesperson will relinquish his or her post-sale responsibilities. This leads to a lot of one-time sales from customers who feel they were hung out to dry.

As for the ideal profile of a customer service rep, you want the innately curious—people who want to know how things work. When a customer calls, the support person should be educated enough to hear more than the customer is telling and see the question behind the question.

Another helpful trait: The ability to move away from striving to increase market share and toward getting more share of each customer's business. One thing companies need to do is rethink the commission systems they use to pay salespeople, which currently tend to reward them for the closing of one sale. Companies will need to think of ways to reward a salesperson when a customer comes back again and again.

Interviewing Potential Reps

The interviewing and hiring process for customer service personnel can be difficult, as is filling most positions. Depending on your exact customer service operation, these people often are dealing with clients who are presenting you with an opportunity to resolve a difficulty that they are experiencing—in other words, handling complaints.

I am a firm believer in testing services and background checks to help you in the evaluation process. But often, it all boils down to a final decision that someone just "feels right for the job."

To lend some consistency to this process, here are some things to keep in mind:

- Does your candidate have a pleasant, outgoing personality?

- Does your candidate have a pleasant voice with good speaking habits?

- Have you had a telephone conversation with your candidate to assess his/her telephone voice and mannerisms?

- Does your candidate have experience with your automation systems?

- Has your candidate had prior experience in customer service?

- Does your candidate have a good memory? Does he/she retain information well?

- Do you sense that this candidate can "take the heat"? Does he/she operate well under pressure?

- Does your candidate listen well when you talk?

- During the interview, did you role play with your candidate to see how he or she would react on an extemporaneous basis?

- On introducing the candidate to other employees, did the candidate seem to interact well with them?

- Has this candidate's immediate supervisor interviewed him/her?

Evaluating candidates for customer service jobs

- Have you compared notes with that supervisor?

- Is this candidate someone that you want to represent your company?

If you can answer *yes* to most of these questions, and are comfortable with all of the other research and data on this individual, he or she might make a good customer service employee.

Some Final Thoughts

As much as I dislike meetings, they are crucial to effective communication. How you conduct a meeting can build credibility, or destroy it. Here are some basic, common-sense guidelines that can give you an edge.

- **Be prepared**. The Boy Scout motto goes a long way toward the success of a meeting. Have your agenda, presentation material and notes in ready-to-go order. Fumbling costs you credibility points. If you are going to address shortfalls in customer service performance issues, make sure you have detailed performance data, letters from customers, etc., in order to be specific. Nothing is worse than a generalized tirade on poor performance.

- **Rehearse**. Once your material is in order, rehearse your opening comments. These initial words set the tone for the remainder of the meeting. If they are too severe or too jocular, the meeting can get off on the wrong foot.

- **Be punctual**. Arrive at least 15 minutes early, check that everything is in order, and start the meeting at the scheduled time. Your punctuality establishes punctuality in others and eliminates wasted time. Don't wait for late arrivals. It penalizes those who made the effort to be on time.

- **Follow the agenda**. The agenda should control the meeting. Getting off the agenda can jeopardize the purpose of the meeting and cause the meeting to veer out of control.

- **Stay on schedule**. The best agenda will allot time for each item. Stay within those time limits. Once you start running late, attendees become anxious and you've lost their attention.

- **End on time**. The mind can only accommodate what the seat can tolerate. No one enjoys being kept later than anticipated, and resentment builds over the interference with attendees' own schedules.

- **Be precise**. Particularly on performance-related topics (problems), be precise about the specific situation or problem (e.g., our customers have been experiencing an average wait of five minutes on hold). What can be done to minimize this? (Or here are the changes that will be implemented to minimize this.)

- **Reward performance**. Everyone likes a pat on the back, especially if it is received in front of others. If there are any accolades, bonuses or awards for performance, schedule them into your meeting agenda.

- **Answer questions**. If the meeting allows, answer questions promptly as they are asked. It that is disruptive, schedule a time slot for a question-and-answer period during the course of the meeting. If a question is not of general interest to the meeting, ask if you can discuss it on an individual basis after the meeting.

- **Encourage participation**. The best meetings are interactive. Solicit, even urge, participation by every attendee. People want to feel that they have added value to the meeting. It also intensifies their concentration and attention to the matters at hand.

- **Project professionalism**. Dress and act professionally. This includes any material that you intend to use as a presentation aid. If such material is not well done, it could be embarrassing. Plus, the level of professionalism that you project serves as the benchmark for the level of professionalism that your staff will project to customers.

Interaction adds value to a meeting

Invite a client to speak at the meeting

- **Maintain eye contact**. Establish a connection with everyone in the room by making eye contact as you speak. Let everyone feel that you are talking personally to them.

- **Invite experts**. Meetings are the perfect symposiums for education. If there is an expert who could be beneficial to your attendees, invite him or her to make a presentation. In customer service and sales, the expert might be one of your top clients. What better opportunity for your staff to get to know and understand the needs of your client? Believe me, if you offer a client the chance to speak to your troops, you are truly working on a nexus relationship.

CONCLUSION:
THE FUTURE IS NOW

> My interest is in the future because I am going
> to spend the rest of my life there.
>
> —*Charles F. Kettering*

Throughout this book, I've alluded to some of the
new technology that is available for marketing and
communications as we watch the building of the
Information Highway—computer databases, auto-
mated telephone systems, interactive television,
home shopping networks, etc. Regardless of the
technology, the basics of marketing and customer
service always will apply to the client nexus.

These basic issues of marketing and communica-
tions also involve the image of your business. In-
dustry has made tremendous strides in the evolu-
tionary process of computerizing operations. The
computers have provided information immediacy
and drastically improved record keeping and bill-
ing procedures, inventory, claims processing, stan-
dardization, etc. However, our purpose is not to look
at the wonders of automation. We know its impor-
tance and rely on it daily.

The question is how much of this technology is be-
ing utilized in our marketing efforts? How auto-
mated is our sales staff? Would Kevin Costner have
ever played the role of Robin Hood if this legendary
hero of the bow and arrow had been born into the
mayhem of the 20th century's automatic weapons?
Would Henry Ford have sold the nation on afford-
able cars if he'd driven a horse and buggy to work
every day? How well would a laptop computer sales-
person be doing today, if notes were taken with pad
and pencil?

Fantasy? Obviously! Outlandish? Not necessarily!

Many sales professionals are like the computer
salesman with a No. 2 lead pencil. They must daily
do battle with clients who are considerably better
armed than they are.

Have laptop, will travel

Business today demands efficiency and immediacy. Does your sales staff have the tools to meet these essential requirements?

Cincinnati Insurance, for example, maintains no regional offices. Its 49 marketing managers manage their geographical territories from their home and serve a multitude of functions for their agencies. In 1987, each marketing manager was set up with a personal computer for his or her home.

In talking with other companies about automation of their sales staff, there seems to be several layers of thought. For instance, concerning laptop computers:

1) The most advanced are currently outfitting outside sales personnel with laptop computers—or a combination of PC and laptop.

2) Some are spot-testing laptops prior to determining viability.

3) Some are in the planning stages for a laptop program.

4) Some feel that automation within the office provides enough tools for use when on location.

5) Some still don't see the need, or the benefit.

I believe that the day will be here soon when sales departments are outfitted with laptops in order to expedite the sales process and establish a higher degree of professionalism. "Let me get back to you on that" will disappear from our vocabulary, because all pertinent data will be readily available.

Sales calls can be consummated immediately, orders downloaded to factories or shipping centers and delivery schedules arranged. Problems can be resolved without delay. This will make the client nexus more immediate than ever.

Let me give you an example. A client has recently moved into the world of CD-ROM in order to provide its members with a complete library of data at their very fingertips. In developing an audio training program, the CD-ROM expert arrived at my office with his own laptop. He plugged it in and within several minutes was working through a complete

training program while we recorded it. If he had planned to use our computers, we might still be trying to record the training program.

Barriers to Understanding

Consider the highly competitive world of radio advertising in Southern California. I was talking with a very successful time salesperson; at first he couldn't understand how he could benefit from automation. After a short discussion, he agreed that most of his accounts are highly automated and consider information immediacy to be normal. Yet when he takes an order, he must return to the studio, enter the order, arrange scheduling times, encode the rates and print an advertising contract for approval. All of this takes a day or two—before the client sees the actual contract.

Now imagine sitting with that same client with a laptop to input all the information. A modem connection to the station would access the main computer, set the schedule and prepare the contract, which could be printed out immediately in the client's office. Sale consummated!

At a recent convention, I had the opportunity to operate an interactive kiosk for the financial industry. I sat at the modular booth and picked up the phone. It automatically dialed and connected me with a service center representative, who came up on a television screen in the kiosk. Three thousand miles away from each other, we were talking and watching each other over a televideo linkup. I then pushed a button to indicate interest in retirement packages. The screen went to graphic data, with the rep's picture shrinking and moving to the upper right corner. After I completed a survey on the video screen and answered questions while the rep input information, the computer provided several suggested insurance plans. When I had decided on one, the kiosk printed out the policy. Meanwhile, a scanner had transmitted a picture of my driver's license to the rep for identification, and a signature pad recorded my signature for the contract. Finally, a credit card swipe paid the first premium.

This is the future. This is the technology that will improve or destroy the image of a company with its clientele. Price and product are not enough to sur-

Technology will improve or destroy a company's image

Customer service—the cornerstone for survival

vive in today's market. Service, professionalism, accuracy, speed and image all come together on the client nexus. Whatever your company is currently doing in the way of field automation, two things are certain:

1) Every sales department eventually will be automated, because no one can survive on a superhighway in a horse and buggy.

2) Regardless of new technology, old attitudes will be much harder to upgrade than existing hardware and software. Motivation and training will be paramount.

Above all, no matter what the business, customer service must be the cornerstone of every facet of your operation—if your company is to survive and prosper.

High-Tech Can Be Low-Tech

A business doesn't have to be high-tech to use the Internet.

During the summer of 1996, shoppers in Cedar Rapids (Iowa), Eau Claire (Wisconsin) and Grand Junction (Colorado) could buy potato and corn chips made with the much-hyped fake fat olestra—and find out what all the fuss was about. Would the new fat-free snacks taste like the real thing? Would people be tempted to pig out, knowing they're getting only half the calories? And, perhaps most important, would they suffer intestinal cramps and diarrhea?

The olestra-laced chips were being test-marketed only in three small towns. But people in the rest of the country could join the debate, too—over the Internet.

Texas-based snack maker Frito-Lay Inc., which was selling six kinds of chips using olestra, set up a customer-service number that people could call for information or to register comments.

The Center for Science in the Public Interest (CSPI), a Washington-based nutrition advocacy group, set up a toll-free number for complaints.

CSPI and Procter & Gamble (the company that makes olestra) also set up dueling sites on the World

Wide Web which were available to anyone with Internet access.

P&G's colorful source of informational and promotional material about olestra included positive comments by health experts; answers to questions about olestra's composition, safety and taste; and a space for comments to the company.

CSPI's less colorful site also included some pithy quotes from experts—and information not found at the P&G site, such as the brand names of all the products containing olestra being sold in the test-marketing areas.

That's a whole lot of high-tech space devoted to potato chips—a seriously low-tech product.

Some Final Thoughts

At a recent convention of the Association of Image Consultants International, former association president Christina Ward presented the coveted *Immie* awards. "This award," said Ward, "does not honor the heights that have been attained. It honors the thousands of steps that have been taken in the journey. And it challenges the recipients to shine their light on others that are following in their footsteps. After all, a prism that does not reflect light is just a piece of glass."

Throughout the pages of this book, I have concentrated on the "thousands of steps" that must be taken on the journey of customer service in order to achieve the destination of nexus. Like a prism, management must shine its light on employees in order to light the path and guide them on their journey. In turn, the prism will reflect the light from your staff onto your clients.

As I hope you noticed, I've used the term *customer service* on an interchangeable basis with such other words as *sales* and *operations*. The point is that in a company with a client nexus, customer service is inculcated within every regimen of your business. Customer service is not three people with telephones located in a rear room.

Customer service is the very essence of your corporate being, and every corporate effort must be directed toward customer service. Like the analogy

The key is to implement these new ideas

of the prism, the customer service light must reflect on your sales, marketing, advertising, product quality, packaging, shipping, accounting, facility, operations—in short, everything. The process of serving your customer—customer service—is the path to nexus.

I've concentrated on the steps that move you toward the development of nexus with your customers. Although this is a never-ending journey, there is a promise for those who commit to its path: The seekers shall be the finders!

If you commit to the principles found within this book, you will position your business to endure as you partake in the fruits of its profitability. When confronted with a fork in the road, take the path that best serves your clients. Serve your clients well and they will, in turn, serve you.

On a final note, wherever I go—conventions, meetings, educational seminars—my initial goal is to bring back one new idea. If I can do that, my attendance has been justified. The rub is that I must return and implement that idea. I wrote this book in the hopes that my experience and research could provide readers with at least one new idea that would help them to nurture and grow their business.

I hope that I have surpassed that goal and offered you numerous ideas. My challenge to you is to implement them. If not, you have merely read another book. The proof is in the action, not the thoughts, not the words. Take action today without delay, and secure a place in the future for your business that can grow beyond your wildest imagination if you build it on client nexus.

An anonymous quote in a client's newsletter read, "Things may come to those who wait, but they will have to accept what's left over from those who hustle." I like to think that anyone who has bought this book will hustle.

May your business and personal life be blessed with every good thing life has to offer.

APPENDICES

The following worksheets, forms and checklists are drawn—both directly and indirectly—from the issues discussed through the course of this book. Some will be usable immediately in your business; others will require some modification or tailoring. Feel free to use these forms as you see fit.

APPENDIX ONE

Sample Image Survey

Note: Distribute this survey to management, staff and customers. List common words and phrases from each group according to frequency. Compare the findings of each group to see whether your customers view your image in the same way that management and staff do. (See Appendix Two.)

In order to serve the needs of our clients well, we would like your input on the level of product quality and service we provide. Please answer the following questions as honestly as possible—on a confidential and anonymous basis.

1) Please list 10 words or phrases that you feel describe our company in overall practice and product/service (list in order of importance to you):

1._____

2._____

3._____

4._____

5._____

6._____

7._____

8._____

9._____

10._____

2) What is the single most important factor in your decision to purchase our product or service? (Employees: What do you believe is the most important factor in the customer's decision?)

3) Is there any factor that would need to be improved in order for you to keep your business with us—or increase the amount of business you do with us? (Employees: What factors do you think would need to be improved in order to increase the amount of business our clients do with us?)

4) What is the most likely reason that you would move business elsewhere? (Employees: What do you think is the most likely reason our customers might move business elsewhere?)

5) Please add any comments or suggestions that you feel would enable our company to better serve our customers.

APPENDIX TWO

Sample Client Survey

Note: This survey is based on a manufacturing company with retail distributors. You may need to alter it to fit a service business or other combination of goods and services.

In order to best serve your needs, we need your input. Please answer the following questions as honestly as possible. This is a confidential and anonymous process. Upon completion, please return your survey to:

Contact name _____

Company name _____

Address _____

City, State ZIP _____

1) Overall, please rate your experience with our company:

 [] Excellent [] Good [] Average [] Fair [] Poor

2) Overall, please rate your experience with our product line:

 [] Excellent [] Good [] Average [] Fair [] Poor

3) On a scale of 1 to 5, with 5 being the highest, please rate the importance to you of the following items:

 _____ Ease in Placing Orders

 _____ 3-4 Week Lead Time

 _____ Warranty

 _____ Technical Support

 _____ Quotation Assistance

 _____ On-Time Deliveries

 _____ Field Service

 _____ Product Quality

 _____ Product Training

 _____ Product Brochures

4) In your opinion, what is the single most important factor in your decision to represent our line of products?

5) What is the biggest problem, if any, that you have had in doing business with our company?

6) Are you experiencing any problems with our product?

[] Yes [] No

If so, please elaborate.

7) Would you be interested in a tour of our manufacturing plant?

[] Yes [] No

8) Do you feel that you and your employees would benefit from increased product training?

[] Yes [] No

9) Would you consider it beneficial if we could provide additional information and material on insurance, workers comp, banking and other topics that are generally related to your business?

[] Yes [] No

10) Please relate any suggestions that you feel would enhance our mutual relationship in any way (new products, revisions to the policy and pricing manual, changes in customer service, etc.).

Although this is an anonymous survey, if you would like to identify your company or request that someone contact you for further discussion, please proceed:

Contact _____

Company _____

Phone (___)_____

Thank you for your cooperation.

APPENDIX THREE

The RED Cycle

Research, Evaluate and Determine

RESEARCH

List the five most common words or phrases used by management, staff and customers in defining company image, ranked by frequency of matches between the three:

 1._____

 2._____

 3._____

 4._____

 5._____

EVALUATE

Do the research findings correlate to your mission statement? [] Yes [] No

If not, what are the three major differences?

 1._____

 2._____

 3._____

Do the findings correlate to your advertising efforts? [] Yes [] No

If not, what are the three major differences?

 1._____

 2._____

 3._____

Do the findings correlate to the concrete aspects of your company image—operations, customer service, physical plant, signage, personnel, etc.?

[] Yes [] No

If not, what are the three major differences?

 1._____

 2._____

 3._____

DETERMINE

Identify the most important changes that need to be undertaken to align your desired company image more closely with reality:

1._____

2._____

3._____

4._____

5._____

APPENDIX FOUR

Customer Understanding Questionnaire

Understanding the customer/product interaction

1) Why does this customer use our product?

2) How does this customer use our product?

3) What customer problem does our product solve?

4) What additional or new problems does our product create?

5) How could our product be easier for this customer to use?

6) How could we expand our service(s) to reduce this customer's problems?

Understanding the customer's values

1) How does this customer define success?

2) What does this customer see as its distinctive competence?

3) What are this customer's problems?

4) How can we make this customer more successful?

5) What does this customer value?

6) What changes does this customer see coming in his or her environment?

Understanding the customer connection

1) How does this customer make his or her selection decision?

2) How much of the total product budget does this customer spend with us?

3) What would we have to do to increase our percentage of this customer's budget?

4) How do we compare to our competition?

5) What does this customer see as our distinctive competence?

6) Under what circumstance might we lose this customer?

Sample Fax Cover Sheet

Date _____

Cover + _____ Pages

Voice: 1-800-451-8273

Fax: (805) 241-8522

SOUND MARKETING, INC.

To: _____

From: _____

Message: _____

✔ Full Service Audio & Video Production

✔ Duplication, Packaging & Fulfillment

✔ Telephone Messages-on-Hold

✔ Convention Recording & Duplication

1454 Calle Alamo

Thousand Oaks, CA 91360

e-mail: 71736, 3547@compuserve.com

APPENDIX SIX

Tips for Building an Effective Customer Service Staff

Note: As an employer, you want to find people who have a knowledge of and an interest in your product—and who want to work with customers to solve problems. Another issue is keeping them trained and up to speed with the times. Then there's the issue of keeping them happy, so they don't get frustrated with their work environment.

The following are some useful suggestions:

1) Treat customer service staff as professional problem-solvers instead of switchboard operators.

2) Give them room in which to grow and advance career-wise.

3) Don't pigeonhole them by putting them on incoming calls eight hours a day—integrate other functions, like making outgoing calls and doing basic market research.

4) Let technical support people find where their product-related interests lie and follow them.

5) Encourage service reps to do research, write technical bulletins, teach classes to external customers (as well as in-house employees) and do other activities related to customer service.

6) Emphasize constant learning as a prerequisite to career advancement.

7) Avoid—whenever possible—the traditional tier system of directing service inquiries from least informed to most informed service rep.

8) Integrate the customer service department with other business functions. (Some computer companies actually rotate customer service reps to other divisions for temporary assignments to keep them up-to-date on product issues.)

APPENDIX SEVEN

Fee-for-Service Feasibility Checklist

In order to determine whether fees should be charged for support services, it is first necessary to investigate your internal operations.

1) What are the actual expenses for your support services (wages, benefits, telephones, allocated space)?

2) How much of your sales revenues are allocated to support services?

3) Is your product properly priced for the market and the support services you provide? [] Yes [] No

4) Can you justify a price increase on the basis of service? [] Yes [] No

5) Have any of your competitors implemented fees for services?

 [] Yes [] No

 If so, what impact has it had on their sales and position in the marketplace?

6) Does not charging fees provide you with a competitive advantage that would be lost if you charged for support? [] Yes [] No

7) Have you discussed this with your top customers? [] Yes [] No

 What has been their reaction?

8) Do you currently offer support through a toll-free 800 number?

[] Yes [] No

If so, could you avoid charging fees if you switched to a regular line where the customer absorbed the cost of the call? [] Yes [] No

9) Are there other ways to provide support that would reduce demand on the support team (e.g., a technical support newsletter, technical service bulletins)?

10) Will the generated fees be reinvested in support service improvements?

[] Yes [] No

11) Based on current levels of technical support service, if you were one of your customers, would you be willing to pay for this service?

[] Yes [] No

12) Will you need to improve service beforehand to justify the charges being contemplated? [] Yes [] No

How much investment will be required by the customers?

13) Can you differentiate levels of technical support required by the customers?
[] Yes [] No

14) At what point will you charge a fee? (Would you charge a new buyer a fee for support in getting your product up and running?)

15) Is there a more cost-effective alternative to your current process of technical support (e.g., e-mail, Internet web site, support forum)?

[] Yes [] No

APPENDIX EIGHT

Ten Questions about Value-Added Customer Service

Does your customer service operation build trust and security with your clients? Although we generally gauge success by the reaction of our customers, it is first necessary to look within to see if our customer service staff has the proper tools with which to work.

Here's a simple checklist. If you answer *yes* to fewer than seven of these questions, you probably need to re-evaluate your commitment to building a client nexus.

1) Does your customer service team know the history of your company, enabling members to convey a sense of tradition and heritage to the client?

 [] Yes [] No

2) Has each member of your customer service team been introduced to key management and operational staff? [] Yes [] No

3) Does each member of your customer service team understand how the company works and who is responsible for what? [] Yes [] No

4) Do you have a training program enabling customer service personnel to actually work in, and become familiar with, the various operations in the sales, manufacturing and shipping departments? [] Yes [] No

5) Does top management occasionally spend time in the customer service department? [] Yes [] No

6) Are customer service personnel empowered—on an operational level—to resolve problems? [] Yes [] No

7) Is creativity in customer service rewarded or recognized in specific ways?

 [] Yes [] No

8) Does senior management participate in the recognition of customer service personnel? [] Yes [] No

9) Is your customer service team kept abreast of marketing campaigns, particularly with regard to advertised promises or assurances?

 [] Yes [] No

10) Are customer service personnel invited to attend other departmental meetings that might have an impact on their performance?

 [] Yes [] No

Four Maxims for Making the Right Sale First

Throughout this book, we have seen examples of how customer service is merely one part of a client nexus, which starts with the way goods or services are sold in the marketplace. Here are four guidelines for making sure your company makes the right kind of sale—the kind that allows customer service reps to win repeat business.

1) **Create value before quoting price.** This goes for follow-up sales, as well as initial sales. Price alone is merely indicative of the product and doesn't convey the entire picture to the client. By creating value, I'm not talking about the product. Take the time to sell the benefits and values that are unique to you and your company. Others might have the identical product or service, maybe even a lower price. But you and your company can provide the unique difference.

2) **Never quote price to an unsold buyer.** If you haven't made the first sale, you aren't ready to proceed to the second. This isn't such a problem for the kind of follow-up sales that a client nexus generates—but customer service professionals need to remember that the nexus comes first, before the follow-up sale.

3) **A client sold on price will shop future business.** If all you are offering is price, that is the only thing your client can compare. Loyalty in this case is only as good as the lowest price. Although you may retain the business, you will fight for every renewal.

4) **Performance is the scorecard of your client's expectations.** Once you've made the first sale, it is essential to make good on what you've sold. In selling yourself, you create expectations that must be met and should be exceeded.

APPENDIX TEN

Costing Customer Service

There is no simple rule or formula for building the cost of customer service into your pricing. Every business, every product is different. Obviously, every product or service has an innate hard cost—the material, labor and immediate overhead that constitutes your cost.

Beyond that, there are three *burdens*:

- **Sales** (the costs relating to your sales department);
- **Service** (the costs of servicing customers and product); and
- **Operations** (all other expenses, such as management and office overhead).

Your challenge is to calculate these costs.

Let's assume that your hard costs are $1 and build a typical pricing model:

Hard Cost	$1.00
+ Initial 50% Markup	$0.50
+ 25% Sales Burden	$0.25
+ 55% Operational Burden	$0.55
+ 15% Service Burden	$0.15
= True Cost	$2.45
x 1.75 Retail Markup	$4.29 Retail

If you already know your hard cost, sales burden, operations burden and appropriate markup margins, the question is how to place a numerical value on customer service.

The answer comes in two steps.

First, have your customer service team determine the cost of the average customer service call. This should include such items as telephone expense, labor and travel expense, if necessary. If you have a sophisticated cost analysis system, general overhead and office space allocations could be added to this.

Second, have your customer service team establish a weight number for each product or service you offer. Based on a scale of 1 to 10, with 10 being the highest, let team members rate the customer service demand.

	Guide	Example
Hard Cost	$_____	$1.00
Retail Price	$_____	$4.29
Monthly Sales	$_____	$35,000
Weight Factor	_____	5
Average Service Cost	$_____	$12

$_____ x _____ = Weighted Service

Average Service Cost Weight Factor

(Example: $12 x 5 = 60)

_____ ÷ _____ = Customer Service %
Per Sale

Weighted Service Retail Price

60 ÷ 4.29 = 14%

$_____ x _____ = Customer Service
Cost Per Sale

Hard Cost Customer Service %

$1.00 x 14% = $.14

This formula is not an absolute—every industry has its own standards—but it may serve as a general guide for your assessment of customer service expense in building your price structure. Common sense and judgment will be the final factors in making this determination. A continuous process of review should be instituted to track actual customer service expenses against the allocated budget from your price/cost structure.

APPENDIX ELEVEN

Three Questions that Measure Performance

Customer surveys, questionnaires and one-on-one discussions are all important tools—but a client need only answer three questions to help you determine where questions should be asked during every single client contact, particularly if the contact was the result of a complaint.

1) **Based on our performance, do you plan to continue doing business with us or purchase additional products or services from us?**

 If the answer is yes, you have met the minimum expectations of this customer and laid the groundwork for continuing contact and selling opportunities.

2) **Do you know of anyone else who could benefit from our services?**

 If your customer is willing to provide you with a referral, you then know that you have met the majority of this customer's expectations.

3) **Would you be willing to endorse our product/service to others?**

 If your customer is willing to personally endorse and support your company to others, pat yourself on the back—you have exceeded this customer's expectations and established a client nexus.

Note: Aside from helping you to determine your effectiveness in meeting and exceeding the expectations of your customers, I also can guarantee that you will immediately experience increased sales if you are steadfast in asking these three questions during the course of every customer contact. Referrals are the most effective source of prospecting, and the failure to ask for a referral is the most common mistake made in business.

APPENDIX TWELVE

What to Do When a Customer Complains

1) Shut up and **listen**—"I'm here to help, please tell me about your concerns ..."

2) Acknowledge his or her **feelings**—"I can understand you are angry, frustrated, inconvenienced ..."

 Regardless of whether the customer is right or wrong, you should acknowledge his or her feelings in the matter.

3) Reiterate the **facts**—"Now, as I understand it, this is what happened ..."

 Once the customer has vented and you've acknowledged his or her feelings, restate the complaint and probe to make sure that you fully understand the details. This lets the customer know that you've cared enough to listen and that you want to resolve the situation.

4) Find out what the customer **expects**—"Let me ask you a question. What would you like to see us do to resolve this for you?"

 Often the customer doesn't want you to do anything. The simple act of having the complaint heard was enough. However, if action is required, the customer's solution may be the easiest and least expensive. You won't know unless you ask.

5) Provide the **solution**—"We value your business and want to resolve this as quickly as possible. Here's what can be done ..."

 Depending on company policy, a) you may be able to do exactly what the customer requested; b) you may offer a solution according to the policy of your company; or c) you may be empowered to create a solution.

6) Confirm the **resolution**—"Will that be satisfactory, or is there anything else you would like us to do?"

 If you haven't resolved the complaint, now is the time to find out. If the solution is beyond your authority, bring in the proper management that can make the necessary decisions.

7) **Follow up.** Either in writing or by phone, follow up with a thank you to the customer for having brought the problem to your attention, and verify that the necessary actions were taken to resolve the problem.

Four Steps for Managing Customer Expectations

A key element in the process of managing expectations occurs at the time your product or service is delivered to your client. The days and weeks when a purchase is new offer the best opportunity to gauge customer satisfaction—and expectation. The following tactics may help you take advantage of this opportunity systematically:

1) **Institute a delivery policy** that includes a questionnaire (or at least the delivery of a questionnaire) and reviews all relevant paperwork.

2) **Review and explain exactly what has been purchased**. If you offer guarantees or warranties, they should be explained in detail.

3) If there is a customer service procedure for communicating future problems, **make it known clearly**—and encourage the customer to use it.

4) If there are ancillary or optional items or services that the client might assume are included with the purchase, **clarify them**. (A classic illustration: Clerks in most electronics stores remind customers what batteries are needed in battery-operated items. This avoids frustration later and generates additional sales immediately.)

APPENDIX FOURTEEN

Customer Service Skills for Handling Problems

Good customer service is also the best defense for handling a "challenging" customer. Always respond in a civil way—no matter how difficult the situation. Treat your "challenge" as you would like to be treated in the same situation.

The following are service skills that may lessen the chance of having a problem with a challenging customer.

1) Listen carefully. Note the tone of voice and the body language.

2) Use the customer's name.

3) Remain calm and respectful.

4) Don't interrupt.

5) Show empathy with words, tone of voice and body language. This is vital to validating a person.

6) Apologize.

7) Acknowledge any anger.

8) Follow through on all promises. If a commitment is made to call the customer at a certain time or day, be sure the commitment is kept.

9) Offer an alternative.

10) Don't ask why or say, "Why didn't you ...?"

11) Don't debate the facts. What is reality to the customer is the reality that needs to be addressed.

12) Don't jump to conclusions. Understand the entire situation.

13) Don't evade responsibility or say, "That's not my job," "I'm not allowed to do that," or "But the computer says ..."

APPENDIX FIFTEEN

Eleven Tips for Encouraging Repeat Business

1) Identify your best customers, and develop new incentives to get them to return repeatedly.

2) Build the company, from the ground up, around the idea of repeat sales.

3) Help your sales force spend more time thinking about your customers' big-picture needs.

4) View your effort to improve customer relationships as something that is constantly evolving.

5) Make a mailing to past customers, thanking them for their business and enclosing a discount coupon good for the next 60 days.

6) For more expensive items (or items that are delivered to the home, like pizza), consider delivering a 10 percent discount coupon with each item; these could be used individually or combined on the next purchase (so 10 coupons would equal a free pizza).

7) If you have an item that sells for a few dollars or less, punch (or stamp) cards are a good idea (just be sure to secure a unique punch or stamp to keep customers honest).

8) Schedule an annual customer appreciation day at your place of business with food, door prizes and special discounts, but invite your regular customers before the published starting time.

9) Consider having your customers complete questionnaires on their buying habits for your product or service; not only can this help sales, but it also can help you tailor future incentive programs to your clientele.

10) Don't ever have your business phone answered by a machine during working hours. If you do, you are eliminating the personal contact with incoming callers, and it is this initial contact that says you care about them.

11) Consider installing a separate phone line exclusively for customer service calls, giving the number only to existing customers. When this phone rings, you know it's someone who needs help, so pick up the phone and say, "Customer service, how can I be of help?"

APPENDIX SIXTEEN

Two Surveys for Determining Customer Needs

Note: Service reps dealing with customers are in a unique position to assess each customer's needs. The following questions should be asked. (I've broken this into two lists: one for product-oriented businesses, one for service-oriented businesses. Modify them for your particular business.)

Product-oriented questions

1) How much inventory of our product do you maintain?

2) How would that break down daily?

3) Does that level of inventory meet your operational goals?

4) Is there anything we could work toward that would help you meet your goals (e.g., shorter lead times, easier ordering)?

5) Does our shipping method, product packaging, bulk packaging, etc., meet your delivery and stocking requirements?

6) Do you need assistance in inventory control?

7) When you need assistance, is our customer service department meeting your needs?

8) Does our invoicing integrate well with your accounts payable policies and procedures?

9) Any other comments you would like me to pass on to management, account executives or office staff?

Service-oriented questions

1) How frequently do you need our services?

2) Would you classify these as emergency needs?

3) Does our response time meet your requirements?

4) Is there anything we could work toward that would better serve your needs?

5) Is there a way to reduce your "emergency" calls?

6) When you call for assistance, are your concerns being addressed promptly?

7) Does our invoicing integrate well with your accounts payable policies and procedures?

8) Any other comments you would like me to pass on to management, account executives or office staff?

APPENDIX SEVENTEEN

Customer Service Needs Chart

Use this chart to track the customer service needs of important accounts across their life spans. After receiving tracking reports from customer service personnel, management should then compute the findings.

Chart Worksheet

Customer _____

Sales rep _____

Month/Year _____

Estimated monthly customer service expense $ _____

Sales revenue for the month $ _____

Service expense to revenue _____%

Divide customer service expense by sales revenue:

Standard customer service allocation _____%

This is the percentage built into your pricing.

Ratio of projected expense to actual _____

Divide service expense to revenue percentage by allocated percentage. If this is more than 1.00, then expenses are exceeding budget. If it is less than 1.00, expenses are coming in under budget.

Data Analysis

Based on your ratio of projected expense to actual, is there any action necessary to reduce expense, increase service or adjust your budget factors?

[] Yes [] No

Does the customer service demand within the month correlate to the monthly sales revenue?

[] Yes [] No

Do you need to take into account any unique factors, such as unusually low or high sales?

[] Yes [] No

Based on this summary, do you need to take any actions? If so, identify them.

A Simple Staffing Needs Test

Many experts suggest complicated formulas for determining when to add sales and service staff based on revenue and expenses per employee. I'd like to offer a simplified checklist that can help management determine when to add sales or service staff.

- At the end of any given week, leads that have been supplied to the sales department have not yet been contacted. **Sales**
- Management is receiving phone calls from prospects wanting to know when a salesperson will finally contact them. **Sales**
- Existing clients are complaining that they never see anyone from your company. **Service**
- Clients complain that they never get through to your customer service department; the lines are always busy. **Service**
- Orders are slow in being processed. **Sales/Service**
- Your telephone receptionist informs you that calls to sales or service departments are flashing on hold for lengthy periods of time. **Sales/Service**
- You have unused production capacity. **Sales**

Each of these items can indicate that additional personnel are needed in either sales or service. However, please rate the performance of your existing employees first, since these points also can indicate a performance problem, rather than a staffing problem. If existing personnel are not performing, adding more staff will only complicate, rather than resolve, the problem.

APPENDIX NINETEEN

Twelve Tips for Better Phone Skills

When training customer service reps who will work on the telephone extensively, concentrate on simple delivery tools that can improve an employee's effectiveness on the telephone. These tools can become second nature if you take time to learn them through consistent and repetitive practice.

1) **Vary your speaking speed.** No one likes a single-speed voice, also known as a monotone. Don't use a vocal cruise control.

2) **Let humor shine through.** A chuckle goes a long way in establishing rapport with the other party on the line.

3) **Put some inflection into your voice.** Begin sentences on an upbeat note. Ask questions with a rising inflection at the end. Normal sentences should end with a decisively lowered inflection.

4) **Use your lower ranges.** The lower the tone of your voice, the more sincere and confidential you will seem to the person on the other end of the line.

5) **Acknowledge interest in the caller.** As you listen, sprinkle supportive comments through the other person's narration. When appropriate, you can build concern and sincerity with such simple phrases as "I see," "I understand" and "I agree."

6) **Develop a sense of timing.** Pace your words for maximum effectiveness, slowing down when making a crucial point. A pause, for instance, can indicate reflection. A pregnant pause can even answer a question.

7) You're more likely to become anxious if you're hungry, overly tired or simply have had too much coffee. **Prepare for your scheduled phone times** by making sure you're well rested, have had a good breakfast and have kept the coffee to the essential minimum of your addiction.

8) **If you're angry, reschedule** the phone calls for another time. First, you're more likely to be fearful. Second, even if you're not fearful, the anger will come through the telephone. Not a good time for calling.

9) **If you're making sales calls, know your pitch.** Rehearsal counts and keeps away the jitters. There's nothing more anxiety-provoking than not knowing what you're going to say. As the Boy Scouts say, "Be prepared." If you are not involved in sales, preparedness still counts. Take time, in advance, to familiarize yourself with the topics to be discussed, and I guarantee that you'll feel more relaxed and confident.

10) Take a moment before each call to **clear your mind** by taking a couple of deep breaths. This will help to keep you relaxed.

11) Every so often, **get up from the desk** and walk around the office for a couple of minutes. It gets the blood flowing again and keeps you on track.

12) **Use isometric exercises** to drain the anxiety from your system. Simply pressing your hands together for 15 seconds does wonders.

APPENDIX TWENTY

Things to Look for in Video Training

Note: Unlike other training that utilizes role playing—including telephone exercises—the camera catches everything about a person's responses.

Watch your employee's—and your—body language for confidence and comfort. In the evaluations that follow, ask these questions:

- How is the pitch of the voice?
- Are there any distracting mannerisms in either speech or appearance?
- Is the presentation coherent and intelligible?
- How is the pronunciation of words?
- Is the facial expression happy and excited, showing genuine interest in the client?
- Does the service rep or salesperson stop to listen?
- Are objections overcome effectively, and is the sale made?

Often, the camera will point out mannerisms or speech patterns that can hinder closing the sale. Most people are not even aware of the mannerism. So awareness is the first step in correcting the situation.

APPENDIX TWENTY-ONE

The Ten Commandments of Telephone Work

1) **Smile**. By simply smiling as you talk, your voice automatically becomes warmer, more cheerful. Unlike talking in person, the telephone eliminates normal communication tools, such as body language, gestures and facial expression. All you have is your voice—and a smile for warmth.

2) **Be cheerful**. Every phone call is an opportunity to be of service, to help someone fill a need. Let your enthusiasm at this opportunity carry over in your voice.

3) **Set your mind to your task**. Your voice, like your eyes, can be a window to your soul. Therefore, cultivate a positive mental attitude before picking up the phone. Remember, it is an opportunity to help someone. Listening to a motivational tape on the way to work will help set your mind for the day.

4) **Be easy on yourself**. Take time during the day to recoup. If you've just handled a stressful call, take a moment to refresh your attitude before proceeding on to the next call.

5) **Be helpful**. Reach out and touch the other person with your ability to help them solve a problem or fill a need. They are seeking your expertise. Use it to provide solutions, not roadblocks.

6) **Be courteous**. Good manners are not an option. Treat your telephone contact as you would like to be treated yourself. Avoid using slang.

7) **Your mouth is for talking**. The telephone picks up a lot of sounds other than just your voice. Gum chewing, sipping coffee, smoking, yawning and other such non-vocal uses of the mouth usually come through the phone loud, clear—and annoying.

8) **Be clear**. Successful communication requires clear input of information. Keep your sentences simple and to the point.

9) **Listen**. Communication is a two-way process. Allow time for the other party to state his or her business and to interact with your comments.

10) **Be yourself**. Allow your own unique personality to shine through the telephone. Be personable by being yourself.

APPENDIX TWENTY-TWO

Seven Tips for Getting the Right Direct Mail Lists

When it comes to buying mailing lists, you need to do some investigation. There are some good companies that sell mailing lists—and lots of bad ones. Before choosing one, ask the following questions.

1) Does the vendor just supply yellow page compilations?

2) How often does it verify the lists by phone for address changes, names of key personnel, fax numbers? (I know of one that makes more than 5,000 calls per day just to verify and improve the content of its listings.)

3) What sort of guarantees does it offer?

4) Can you try a test run?

5) Does the company offer list download by modem or disk?

6) Can you get preprinted labels?

7) What about follow-up cards for names and phone numbers?

You also should ask to talk to several customers. Ask these people:

1) What percentage of the list mail was returned as undeliverable?

2) How many entries had bad phone numbers or outdated personnel names?

3) How did the company respond when failure rates were high? Did it do things like offer make-good lists?

Gauging the Manpower Needs of Direct Marketing Support

As you test direct marketing, you'll find that the only thing more frustrating than lack of response is more response than you can handle. If you plan on handling the response internally, here's a basic worksheet that can help you match staffing to response.

Test Results

1) Number of mailings (or ad placements) _____

2) Number of responses _____

3) Average telephone time per response _____

4) Average clerical time per response _____

5) Total manpower time _____

Data Analysis

Divide your manpower hours by your test mailing and you have a manpower factor. Multiply any mailing by this factor and you have determined your manpower needs.

> Example: Company A sent out 100 mailers and received five responses. Each response took 10 minutes of telephone time and 15 minutes of clerical time. Allowing a five-minute margin, this means that every 100 mailers will require 150 minutes of manpower (5 responses x 30 minutes). Divide 150 by the 100 mailers and you have a 1.5 manpower factor in minutes. A mailing of 5,000 pieces will require 7,500 minutes (5,000 x 1.5) of manpower, or 125 hours.

APPENDIX TWENTY-FOUR

Determining Your Demographic Marketing Needs

If the geographic boundaries of your business include some ethnic minority population, you may want to consider the corporate advertising approach. Minority marketing was virtually non-existent in 1980. Most major corporations today have some type of marketing aimed at various ethnic groups. Here are some basic guidelines for ethnic marketing.

1) Check the most recent census for your geographic area and determine the ethnic mix. Major U.S. categories were 30 million Afro-Americans, 22.4 million Hispanics and 7.3 million Asian-Americans.

2) Once you've determined the major ethnic categories within your area, look at the mix within the categories. Don't make the mistake of lumping all blacks or all Asians together into a single group. Haitian-Americans have little in common with American-born blacks. Likewise, major differences exist within the culturally diverse Asian community.

3) Prioritize the ethnic minority marketing you wish to target. This could be by population ranking, income levels, home ownership, educational level or business ownership.

4) Hire, or retain as a consultant, someone who can speak the language—and remember to be aware of the dialect situation with Asian-Americans.

5) Create ethnic-specific advertising. Whether you are using direct mail, radio, television, print or telephone, your message needs to address the cultural realities of the particular group you are trying to reach. For instance, Hispanics react strongly to family security and will be more apt to notice an ad with a family setting. Asians, however, will be strongly motivated by a sense of accomplishment or achievement. With the black community, avoid placing white values within a black advertisement.

6) Investigate the potential media. Many of us are not even aware of publications and media that cater to the communication needs of the various communities. Search them out and discuss your plans and needs with their representatives. Many such conversations can open up a wealth of new ideas for you to contemplate, and most companies will provide translation services for free.

 Note: Be sure to investigate foreign-language yellow pages. Ethnic marketeers swear by the results for such listings.

7) Involve your new customers. As you begin to add ethnic clients to your book of business, invite them to share new ideas with you as to how you can best service their marketplace.

8) Become involved within the ethnic communities you are targeting. Look into community clubs, groups and charities. If you've hired an ethnic producer, support his or her involvement in such activities. Most such communities place a high value on word-of-mouth endorsement, referrals and basically doing business with someone they know and trust.

9) Conduct ethnic sensitivity training for your employees. You may create the most effective ethnic marketing campaign ever, only to sabotage it with inadvertent comments from employees that unknowingly offend. If you're adding ethnic staffing as part of your efforts, this type of training gains in importance. Check with leaders within the specific community for available resources.

10) Give it time. In ethnic marketing, you're the new kid on the street, and they have to get to know and trust you before they buy.

APPENDIX TWENTY-FIVE

What Counts?

This exercise is designed to help you review what's important to your customer service effort. You should plan a regular meeting (many companies do this annually) at which you do each of these things—and solicit input from your service reps.

1) Divide your business into specific categories, such as sales, service, manufacturing, shipping, warranty, general operations.

2) Within each category, determine and itemize the various activities that impact your customer. For instance: Warranty or claims service might include answering the phone, claim initiation form, review, authorization, resolution.

3) Within each identified activity, discuss and ascertain what are the critical components in the mind of the customer. For instance, let's take one that could apply to a number of categories: answering the phone. How long does it take for the call to be answered by customer service? How long does the average call take? How much time does the customer spend on hold?

4) Once you've identified the measurable specifics, expand through some general brainstorming. For instance: Should customer service personnel be provided with telephone headsets to free up their hands? Would it be beneficial to have an integrated telephone/computer system with a *screen pop* feature (the computer identifies the customer as he or she picks up the phone, and all relevant information appears on the screen)? Could information be given to the customer over the hold system of the telephone? Do we have enough line capacity for the demands on the customer service telephones?

5) Prioritize the data. Under each category and subcategory, rank the activities according to the importance you believe is placed upon them by the customers.

6) Verify your findings with reality. Develop a questionnaire listing your "performance activities," and ask your customers to rank them according to importance.

7) Establish a final ranking based on your findings and customer reality.

8) Are there any actions the company can take to improve the performance of each activity that are beyond the normal scope of the individual employees?

9) Establish ongoing evaluation teams to monitor progress in improving performance.

10) Monitor the evaluation teams on a monthly basis, and hold a full staff performance review meeting at least once per year—preferably twice.

Tips for Interviewing Potential Reps

The hiring process for customer service personnel can be difficult. Depending on your exact customer service operation, these people often are dealing with clients who are presenting you with an opportunity to resolve a difficulty that they are experiencing—in other words, handling complaints. To lend some consistency to this process, here are some things to keep in mind.

1) Does your candidate have a pleasant, outgoing personality?
 [] Yes [] No

2) Does your candidate have a pleasant voice with good speaking habits?
 [] Yes [] No

3) Have you had a telephone conversation with your candidate to assess his/her telephone voice and mannerisms? [] Yes [] No

4) Does your candidate have experience with your automation systems?
 [] Yes [] No

5) Has your candidate had prior experience in customer service?
 [] Yes [] No

6) Does your client have a good memory? Does he/she retain information well? [] Yes [] No

7) Do you sense that this candidate can "take the heat"? Does he/she operate well under pressure? [] Yes [] No

8) Does your candidate listen well when you talk? [] Yes [] No

9) During the interview, did you role play with your candidate to see how he/she would react on an extemporaneous basis? [] Yes [] No

10) On introducing the candidate to other employees, did your candidate seem to interact well with them? [] Yes [] No

11) Has this candidate's immediate supervisor interviewed him/her?
 [] Yes [] No

12) Have you compared notes with that supervisor? [] Yes [] No

13) Is this candidate someone that you want to represent your company?
 [] Yes [] No

If you answered *yes* to most of these questions, and are comfortable with all of the other research and data on this individual, he or she might make a good customer service employee.

APPENDIX TWENTY-SEVEN

Customer Service Meeting Tips and Checklist

1) **Be prepared**. The Boy Scout motto goes a long way toward the success of a meeting. Have your agenda, presentation material and notes in ready-to-go order. Fumbling costs you credibility points. If you are going to address short-falls in customer service performance issues, make sure you have detailed performance data, letters from customers, etc., in order to be specific. Nothing is worse than a generalized tirade on poor performance.

2) **Rehearse**. Once your material is in order, rehearse your opening comments. These initial words set the tone for the remainder of the meeting. If they are too severe or too jocular, the meeting can get off on the wrong foot.

3) **Be punctual**. Arrive at least 15 minutes early, check that everything is in order, and start the meeting at the scheduled time. Your punctuality establishes punctuality in others and eliminates wasted time. Don't wait for late arrivals. It penalizes those who made the effort to be on time.

4) **Follow the agenda**. The agenda should control the meeting. Getting off the agenda can jeopardize the purpose of the meeting and cause the meeting to veer out of control.

5) **Stay on schedule**. The best agenda will allot time for each item. Stay within those time limits. Once you start running late, attendees become anxious and you've lost their attention.

6) **End on time**. The mind can only accommodate what the seat can tolerate. No one enjoys being kept later than anticipated, and resentment builds over the interference with attendees' own schedules.

7) **Be precise**. Particularly on performance-related topics (problems), be precise about the specific situation or problem. For example, our customers have been experiencing an average wait of five minutes on hold. What can be done to minimize this? (Or here are the changes that will be implemented to minimize this.)

8) **Reward performance**. Everyone likes a pat on the back, especially if it is received in front of others. If there are any accolades, bonuses or awards for performance, schedule them into your meeting agenda.

9) **Answer questions**. If the meeting allows, answer questions promptly as they are asked. It that is disruptive, schedule a time slot for a question-and-answer period during the course of the meeting. If a question is not of general interest to the attendees, ask if you can discuss it on an individual basis after the meeting.

10) **Encourage participation**. The best meetings are interactive. Solicit, even urge, participation by every attendee. People want to feel that they have added value to the meeting. It also intensifies their concentration and attention to the matters at hand.

11) **Project professionalism**. Dress and act professionally. This includes any material that you intend to use as a presentation aid. If such material is not well done, it could be embarrassing. Plus, the level of professionalism that you project serves as the benchmark for the level of professionalism that your staff will project to customers.

12) **Maintain eye contact**. Establish a connection with everyone in the room by making eye contact as you speak. Let everyone feel that you are talking personally to them.

13) **Invite experts**. Meetings are the perfect symposiums for education. If there is an expert who could be beneficial to your attendees, invite him or her to make a presentation. In customer service and sales, the expert might be one of your top clients. What better opportunity for your staff to get to know and understand the needs of your client? Believe me, if you offer a client the chance to speak to your troops, you are truly working on a nexus relationship.

Before the meeting, run through the following checklist to be sure you really are prepared.

1) Have you gathered all necessary information that you'll need?
 [] Yes [] No

2) Have you proofed and checked all such material for accuracy?
 [] Yes [] No

3) Do you have copies for attendees as necessary? [] Yes [] No

4) Has the meeting room been reserved if necessary? [] Yes [] No

5) Is all required equipment in place and pre-tested? (Overhead projectors, microphones, easel pads, blackboard, computer, television, VCR, audio cassette player.) [] Yes [] No

6) Have you written the agenda? [] Yes [] No

7) Have copies of the agenda been distributed to identified attendees?
 [] Yes [] No

8) Have you verified RSVPs on attendance? [] Yes [] No

9) Have you verified attendance by experts who are presenting material?
 [] Yes [] No

10) Does anyone need to be "on call" in case their presence is required?
 [] Yes [] No

11) Have you rehearsed your opening statement? [] Yes [] No

12) Have refreshments and food, if applicable, been ordered? [] Yes [] No

APPENDIX TWENTY-EIGHT

Sample Letter to the Client Who Leaves

Dear _____:

I would like to take this moment to thank you for the opportunity to have served your needs in the past and express our regret at your decision to place your business elsewhere at this time. Since life teaches us that the only constant is change, I sincerely hope that we may renew our relationship in the future.

In order to evaluate our own performance, service and product, I hope that you will take a few minutes to answer a few questions. Your answers could very well enable us to better serve your future needs.

1) Which was your final decision primarily based on:

 [] Price [] Product [] Service

 [] Other_____

2) On a scale of 1 to 10 (10 being the highest), please rate the performance of company in:

 _____ Quality of Product

 _____ Quality of Service

 _____ Caliber of Personnel

 _____ Overall Meeting of Your Needs

3) Was there anything we could have done to retain your business?

4) What would you require to do business with us again?

Sincerely,

APPENDIX TWENTY-NINE

Sample Letter to the Prospect Who Didn't Buy

Dear _____:

I would like to take this moment to thank you for allowing us to review your needs and to quote on your business. Although you did not choose to place your business with us at this time, life teaches us that the only constant is change. As the future unfolds, changes in your needs and/or changes in our services could very well result in our doing business with each other.

In order that we can evaluate our performance, service and product, I hope that you will take a few minutes to answer a few questions. Your answers could very well enable us to better serve your future needs.

1) Which was your final decision based primarily on:

 [] Price [] Product [] Service

 [] Other _____

2) On a scale of 1 to 10 (10 being the highest), please rate the performance of our sales representative on:

 _____ Assessing Your Needs

 _____ Presenting Our Company

 _____ Presenting Our Product

 _____ Meeting Your Deadlines

3) Was there anything our sales representative could have done to get or keep your business?

4) What would you need to see in our product, our company, our sales representatives or our presentation in order to do business with us?

Sincerely,

APPENDIX THIRTY

Standard Information Sheet

Use this information sheet as a guide for setting fields in database management software or as a template for hard-copy files. Many customer service operations use hard-copy forms to record client information and then transfer the data into computer systems during off-peak hours.

Company _____ Account # _____

Address _____ Account Exec. _____

City _____ State _____ Zip _____

Phone (___) _____

Fax: (___) _____

Primary Contact _____

Title _____

E-mail _____

Salutation _____

Products Purchased _____

Average Order _____

Last Purchase _____

Ordering Info _____

Company Info _____

Personal Contact Info _____

Here's a sample of how this form might be filled out.

Company ___ABC Company___ Account # ___001-094___

Address ___1234 Main Street___ Account Exec. ___BJones___

City ___Anywhere___ State ___CA___ Zip ___90001___

Phone (805) ___241-8122___

Fax (805) ___241-8522___

Primary Contact ___Robert White___

Title ___Purchasing Manager___

E-mail ___Internet: ABC@Qaol.com___

Salutation ___Bob___

Products Purchased: Nuts, bolts

Average Order: $952

Last Purchase: 8/3/96, nuts, $987

Ordering Info: Orders after month-end inventory, purchase order required, demands 48-hour delivery

Company Info: Saul Young, owner; started 1987; 95 employees; pays net 30

Personal Contact Info: golfer; wife, Trudy; twin girls born 6/10/94, Kathy & Jennifer

APPENDIX THIRTY-ONE

Sample Technical Support Audit

Please invest a few minutes of your time to help us provide you with the support you deserve and expect from our company.

1) How frequently do you call for technical support?

 ____ times per week ____ times per month ____ times per year

2) How long do you have to wait on hold before talking to support personnel?

 [] 1 minute or less [] 2 to 5 minutes [] More than 5 minutes

3) Do you ever hang up before talking to a support person?

 [] Yes [] No

4) Please indicate the success our support personnel have had in resolving your problems or answering your questions:

 _____%

5) Most of your calls relate to:

 _____ Problems with our product

 _____ Problems with interaction between our product and another product

6) Before calling, did you attempt to resolve the problem with the information in our operating manual?

 [] Yes [] No

7) On a scale of 1 to 10, with 10 being the highest, please rate the effectiveness of our operating manual in your utilization of our product.

8) What percentage of your calls to technical support would you classify as an "emergency" situation?

_____%

9) Please identify any specific problems that you may have encountered when calling technical support.

10) Please note any additional comments or suggestions you would like to make regarding our technical support.

INDEX